COUNTRY ROADS
of BRITISH COLUMBIA

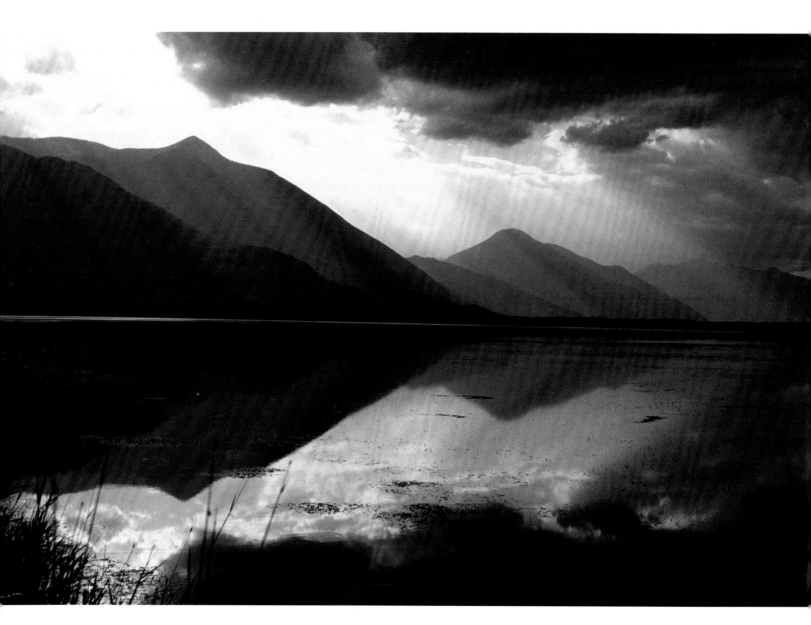

Kootenay evening.

Exploring the Interior

COUNTRY ROADS

of BRITISH COLUMBIA

LIZ BRYAN

VANCOUVER · VICTORIA · CALGARY

To Howard,
for his love and support

Heritage House	Heritage House
#108–17665 66A Avenue	PO Box 468
Surrey, BC V3S 2A7	Custer, WA
www.heritagehouse.ca	98240-0468

LIBRARY AND ARCHIVES CANADA CATALOGUING IN PUBLICATION

Bryan, Liz

Country roads of British Columbia: exploring the interior / Liz Bryan.

ISBN 978-1-894974-43-1

1. Rural roads — British Columbia — Guidebooks. 2. Automobile travel — British Columbia — Guidebooks. 3. British Columbia — Guidebooks. 4. British Columbia — Description and travel. I. Title.

FC3817.4.B792 2008 917.1104'5 C2008-901404-9

LIBRARY OF CONGRESS CONTROL NUMBER: 2008921332

Edited by Marial Shea
Proofread by Karla Decker
Book design by Jacqui Thomas
Layout by Frances Hunter
Maps by Darlene Nickull
All photography by Liz Bryan

Printed in Hong Kong

Heritage House acknowledges the financial support for its publishing program from the Government of Canada through the Book Publishing Industry Development Program (BPIDP), Canada Council for the Arts, and the province of British Columbia through the British Columbia Arts Council and the Book Publishing Tax Credit.

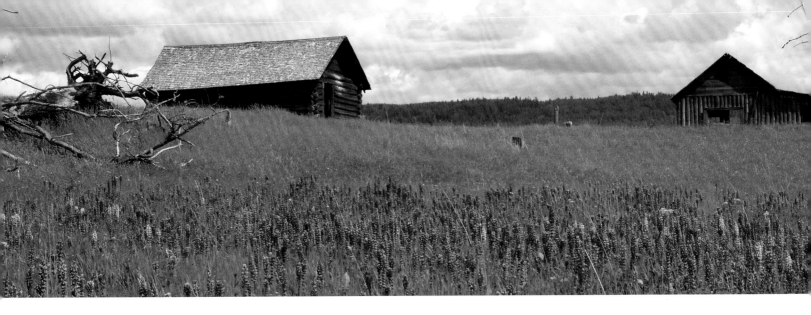

INTRODUCTION

Discovered by Europeans little more than 200 years ago, British Columbia still retains most of its wilderness and wildlife and, fortunately, much of its Native heritage. While the entire province is amazingly beautiful, the B.C. Interior, east of the Coast Range, is considered the most scenic. It is also the most ecologically diverse, with icy alpine peaks, warm lakeshores, meadows, forests, semi-deserts, sagebrush grasslands and badlands. With some of the deepest lakes, longest rivers, highest mountains and lowest valleys, this is indeed a most extraordinary land.

The great variety of the province's landforms and the strong north–south trend of its major features can be explained in part by the way the province was formed. In geological terms, B.C. is not one land but several, created over unimaginable time from strings of volcanic islands, formed far out in the Pacific Ocean and borne eastward by relentless tectonic forces. Crushed onto the bones of ancestral North America, the island continents (geologists call them "terranes") were pushed up and folded into mountain ranges. With each arrival, B.C.'s landmass increased and, where each new terrane joined the existing land, the weaker seams between them became valleys, which later filled with ice, rivers and lakes. Over the millennia, volcanic activity, glaciers and erosion modified B.C.'s bare bones, but the separate island terranes, in north–south blocks like pieces of a patchwork quilt, can usually still be recognized.

Any map of B.C. clearly reveals this strong north–south alignment of mountains and valleys, a topographic inconvenience for road and railway builders who pushed west to connect B.C. to the rest of Canada. The Trans-Canada Highway and Highway 3, both of which head from the coast across the Rockies to Alberta and beyond, provide sinuous and undulating journeys, across several mountain ranges, from one terrane to another. In contrast, B.C.'s early trails followed easier travel routes along the major river valleys. Fur traders were the first outsiders to

Barkerville wheels.

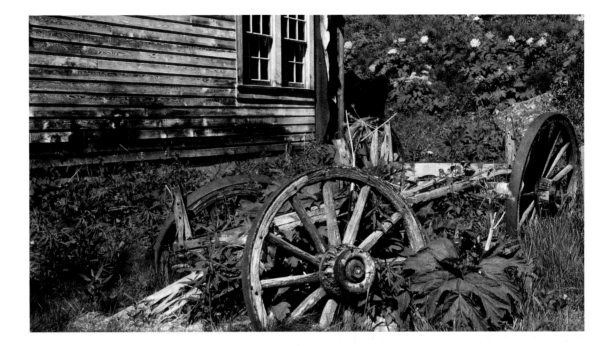

forge paths through the wilderness, but it was the huge rush of gold miners to the Cariboo that first put B.C. in the international spotlight and attracted later waves of resource developers and immigrants. It was their trails that opened up the land for settlement.

Today's cities, towns, villages, ranches and homesteads still lie mostly along the valley seams of B.C.'s fractured landscapes and can trace their beginnings back to the mining boom days of the Victorian and Edwardian eras, the heyday of colonial expansionism and pride—and missionary zeal. Of all the fine 19th-century buildings along the country roads of B.C., the pioneer churches are the most beautiful. All are wonderfully different, whether humble log structures or triumphs of elaborate architecture. Built with love and faith and huge community effort, they are well worth seeking out.

The country roads in this book traverse the province's heartland where the landscapes are always lovely and sometimes breathtaking. Interwoven with strands of yesterday that lie along the highways and byways, the B.C. tapestry has become a lyrical fusion of landscape and history. This is indeed a beautiful province.

A final note: the maps in this book are for general reference; be sure you also have a good British Columbia road map. I also like to have on hand books in the Backroad Mapbooks series; they show *all* the roads, as well as topography and information on parks, trails and recreational possibilities. These spiral-bound books are widely available and can also be ordered online at www.backroadmapbooks.com. ❖

RIVER TRAIL TO GOLD

Like gold rushes everywhere, the one that catapulted the infant colony of British Columbia into world headlines provoked a kind of madness. Men left their jobs and families and made long, difficult journeys to reach the land of possibilities, where a grubstake and a gold pan might be all they needed for instant riches. It was the giant lottery of the Victorian era. Men, most of them greenhorns, arrived in huge numbers at the small, staid colonial outpost of Victoria—and suddenly realized just how far away the goldfields were, through trackless mountains and across raging rivers, through thick forests and swamps, across wilderness where winters were unbearably cold and summers abuzz with flies and mosquitoes. But they pushed on, up the great river named for explorer Simon Fraser and into the depths of the Cariboo Mountains. And here, a few of them—very few—made a fortune. Eventually, the colonial government scratched out trails and supply routes, most of them now today's highways. But some of the original trails remain as footpaths or unpaved country roads where, if you stop long enough to feel the vibrations of history, the greedy grubbing days of the gold rush, only 160 years away, can seem like yesterday.

Perhaps the best of the gold-rush routes, often known simply as the River Trail, follows the Fraser River from Lillooet to Williams Lake. North from Pavilion the road is mostly unpaved, likely muddy in spring and certainly dusty in deep summer. But driving this route though the hills and across the high sagebrush shoulders of the Fraser, you'll experience a heady mix of landscape and history. Barkerville itself, the resurrected capital of the Cariboo camps, might well be the final destination for today's travellers—as it was during the gold rush—but the journey there can be equally memorable.

Lillooet sits at the confluence of the Fraser River and boiling Cayoosh Creek on the site of an ancient Native fishing village. An old town, it stretches long and thin on a high river bench,

On top of Pavilion Mountain and looking south, where gossamer globes of salsify seed heads enliven the autumn grasses. The gold-rush trail runs through high rangeland, with a good mountain view.

8

one of the hottest spots in the province. In 1941, thermometers here topped 112°F (44.4°C). It was also a hot spot in the early days of the gold rush when the two main trails from the coast converged here. By 1860, with its main street peppered with 13 saloons, it sported a shifting population of 16,000. The town became "Mile 0" on the Cariboo Trail, a designation that stayed even when it was later bypassed by the wagon road from Lytton along the Thompson River to Cache Creek. Most of the Mile Houses (stopping places) along this road (now Highways 1 and 97) still took their distance from Lillooet, though others were numbered from Yale or Ashcroft.

The cairn marking Mile 0 sits at the top end of Lillooet's Main Street opposite the museum housed in the former Anglican church. Main Street leads down to the Fraser River where the original ferry crossing was superceded by a narrow wooden suspension bridge. This provided the town's main access until it was replaced in turn by the modern Bridge of the 23 Camels, at the other end of town. (This name immortalizes the camels used for a while as pack animals along the Cariboo Trail. They were soon discontinued: their acrid smell and strange behaviour caused havoc on the trail.) It's worth going down to the old bridge, now reserved for pedestrians, because it is right on the miners' original route north. There's a good view of the river and a pleasant loop walk along the old road.

But to start this journey along the River Trail, double back and drive across the new bridge to Highway 99 and head north. The highway remains narrow and twisting as it tracks high above the Fraser's east bank, past the meadows of Fountain, a gold-rush trail watering hole at the site of a natural spring. The Native village of Fountain (now Xaxl'ip) long ago moved up on the bench to escape the wagon-road traffic. Farther north is the old settlement

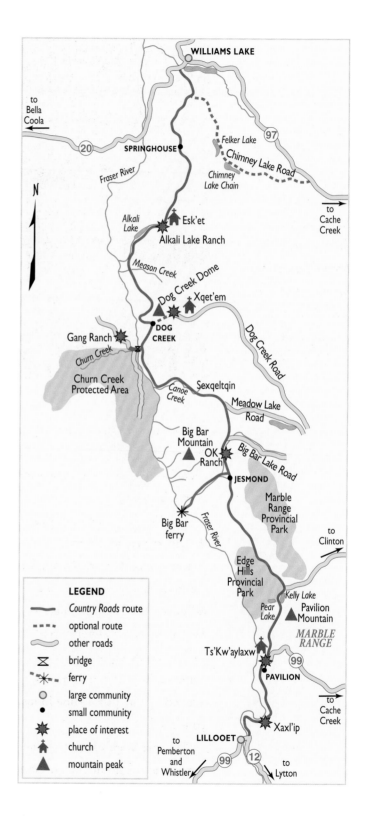

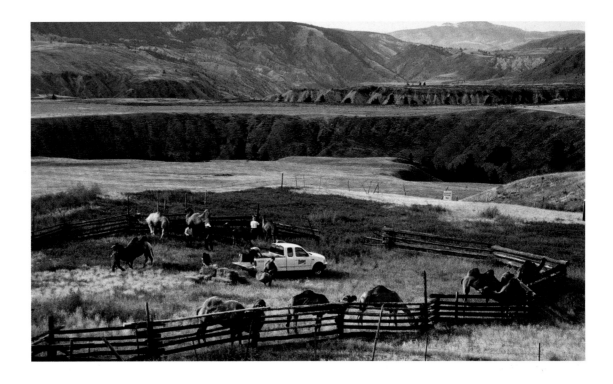

Camels were once used as pack animals along the early trail. More than 100 years later, camels were brought in for a movie production and corralled near Alkali Lake.

of Pavilion. For years, the only building of note was the general store, shaded by a deep veranda, its garden full of flowers; it was as popular a rest stop for travellers arriving by car as it had been for the early wagon drivers. But the store is gone, lost to fire: today only a solitary chimney marks the site.

The Fraser's precipitous canyon here proved too perilous for miners. They veered away from the river, pressing north to 22 Mile House at the site of today's Native village of Pavilion or Ts'kw'aylaxw (Frosty Ground), notable for beautiful Holy Trinity Church built in the 1890s, its magnificent spire ornamented with fretwork and scalloped shingles. The gold-rush trail left the valley at 22-Mile and toiled up from the Fraser onto the shoulder of 2,000-metre-high Pavilion Mountain, a gruelling ascent. Today, it's still a steep road that climbs via a series of switchbacks to play tag with a power-line cut through sagebrush and open forest up to a high, grassy plateau. Stop and look back for a great view of misty blue mountain ridges, a scene only lightly marred by the power-line loops, webs strung across the landscape as if by a gargantuan spider gone mad.

On this huge expanse of surprisingly level tableland, Robert Carson, en route to seek his fortune in the goldfields, noticed the luxuriant bunchgrass, changed his career choice and took up ranching instead. He homesteaded here on this high green aerie to raise hay and pigs for sale to the burgeoning settlements along the trail. Today, the ranch is part of the Diamond S cattle

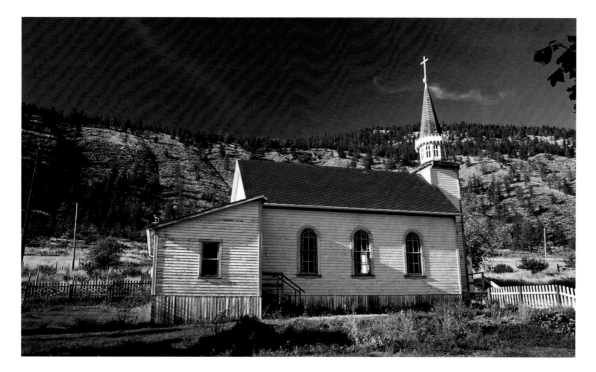

Holy Trinity Church, built in the 1890s at the Native village of Pavilion, marks the start of the steep mountain climb.

ranch. A row of ancient Lombardy poplars and a scattering of buildings mark the homestead site. Beyond, the road undulates through curvaceous fields, with clumps of aspen in the hollows and wild roses along the fences. The flowers up here are lovely. On one of my journeys, a dense dark carpet of blue larkspur covered an entire field, sunflowers brightened the slopes and gaudy gaillardias lit up the hedges. It's a bit of a strenuous haul up to these meadows—and down again—but it's worth it.

For years, even after the Cariboo Road along the Thompson River was finished, miners on foot or on horseback, along with stagecoaches and long trains of freight wagons, made this steep, rough journey. It was, after all, a shortcut, though one best travelled in the summer. These scenic uplands release their winter snow grudgingly: the mountain road is often impassable as late as mid-May. Before you start, check travel conditions in Lillooet. If the road seems dubious, stay on Highway 99 through Marble Canyon to Highway 97, go north to Clinton, then cut back and rejoin the route at Kelly Lake.

Sixteen kilometres along the old road from Pavilion, the route begins a swift, steep and serpentine descent, dropping some 700 metres in less than six kilometres. So dangerous was this section of narrow road, known as the Rattlesnake Grade, that freight wagons dragged heavy logs to slow them down. If you stop along here (and there never seems to be much other traffic), peer out over the edge to catch a glimpse of tiny Pear Lake, twinkling far below. Now preserved

*Historic Coldwell
Ranch was first
called Mountain
House, then
renamed Jesmond.*

within Edge Hills Provincial Park, this little lake in a scoop of flowery meadow provides a small campsite, great fishing and a sense of lonely quiet — unless the CN freight train whistles through along the nearby tracks. At the bottom of the hill, turn left for Pear Lake or right to continue along the gold-rush trail, which follows the western shore of a larger lake named for pioneer rancher Edward Kelly, who settled nearby in 1866. Kelly Lake completely fills the narrow valley, with the road on one side and the railway on the other. At the lake's northern end, Downing Provincial Park, with its small, grassy campsite, is a good place to take a break and listen for the eerie laughter of the loons. There is often a pair of these interesting birds nesting on the lake.

At pioneer Kelly Lake Ranch, just beyond the park, the gold-rush trail (signposted to Jesmond and Big Bar Ferry) turns northwest up Porcupine Creek into the forested valley that runs between the Edge Hills on the Fraser side and the shining white limestone peaks of Marble Range Provincial Park to the east. Devoid of trees, these mountain ridges seem perpetually snow-covered.

Ducking in and out of power-line clearings, and past a couple of guest ranches, the trail continues to Jesmond, where the old lodging house, made of logs and with a comfortable front porch, sits in a shady hollow. This plot was originally settled in 1870 by Phil Grinder, who called his establishment Mountain House. In 1919, when Henry Coldwell opened a post office in the Mountain House store, he was asked to provide a more distinctive postal address and chose

Jesmond, the name of his English birthplace. In drowsy summer, with wild roses spilling over the fences that line the winding road, Jesmond still exudes an old world charm. At Jesmond today (now the Coldwell Ranch) there is no post office (closed in 1965) and no store (closed in 1970); just a row of mailboxes and a quiet, bucolic charm.

North of Jesmond, a signposted road leads west along Big Bar Creek for 19 kilometres to the Big Bar ferry across the Fraser, one of the few cable reaction ferries still operating in southern B.C. It dates back to 1893, operates from April to November (closed for winter ice), and is on call from 7 a.m. to 7 p.m. with a modest break for lunch. The road down to the ferry is worth a detour: along it there's a schoolhouse, amazing blue and yellow cliffs, volcanic pinnacles and a few deserted ranch buildings. Near the ferry, irrigated fields are a brilliant green. Adventurous travellers might like to cross the river here and explore the several routes that lead, somewhat circuitously, back to Lillooet via the West Pavilion and Yalakom roads.

The River Trail, however, journeys on along the east side of the Fraser, crosses Big Bar Creek and continues north. Nearby, Big Bar Guest Ranch has log accommodations dating from the 1940s, but older and of more historical interest are the OK Ranch buildings that huddle among a maze of fences in a sweetly curving dip of the road. The OK is one of B.C.'s first ranches. It was founded by Joseph Haller in 1859, when it did double duty as a roadhouse known simply as Haller's. It has been known as the OK Ranch since 1933. The buildings are made of logs, their architecture is appealing, and the whole aspect of the place is very photogenic. The ranch is active in a provincial program to restore the habitat of the Columbia sharp-tailed grouse, once the most abundant grouse in North America and now the most threatened, because of shrinking grasslands. This species is known for its courtship displays, performed in spring on traditional dancing grounds known as leks.

A few kilometres beyond the ranch, two major back roads connect east to Highway 97, the first leading to Big Bar Lake, the second to White and Meadow lakes. Depending on the condition of the roads and the traffic pattern, either of these might confuse the route. Stay left at both intersections. The River Trail squeezes through a tight limestone canyon, its walls pitted with small caves, then comes out into a wide expanse of irrigated meadow sloping down to the Fraser River and the Native village of Canoe Creek (Sexqeltqin). At the bottom of the slope, though still well above the river, past the old ranch house and barns of the B.C. Cattle Company, the road cuts over a steep, knife-edged, grassy ridge (a glacial esker).

At the top, suddenly the world opens up to a grand view, distant horizons heady with the scent of sage. This first sight of the sprawling Fraser trench is one to be remembered. The river coils through a turbulent landscape of wrinkled hills and immense sweeps of sagebrush. The distance seems endless, the scale magnificent. A car on the snail-trail of the road below seems

The Fraser trench can be seen in the distance, beyond a wide bench sprinkled with sagebrush. The trickle of bright green marks an irrigation ditch.

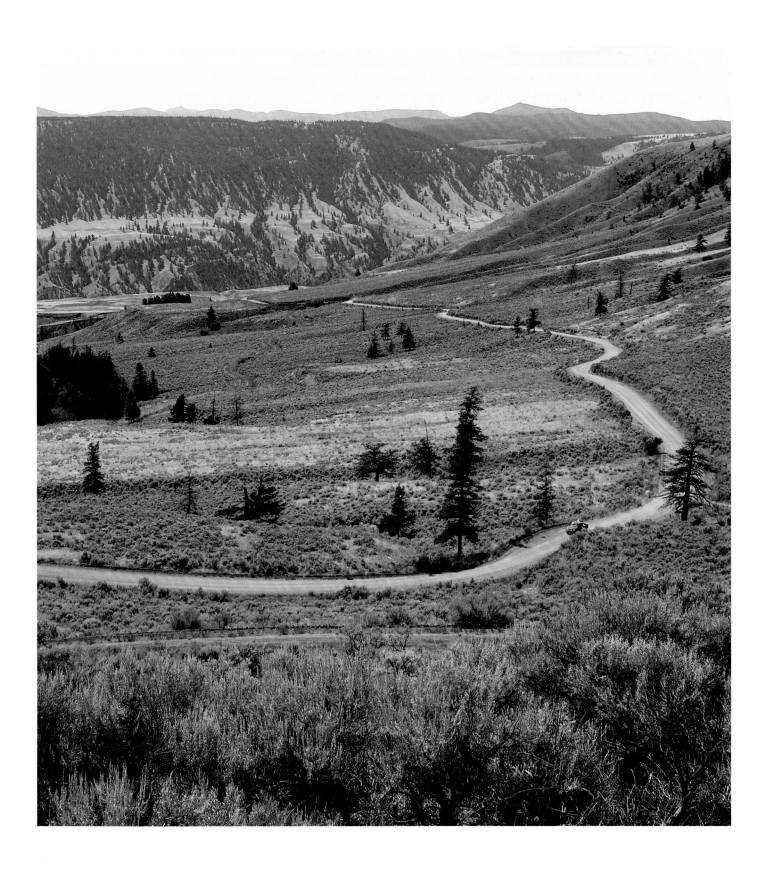

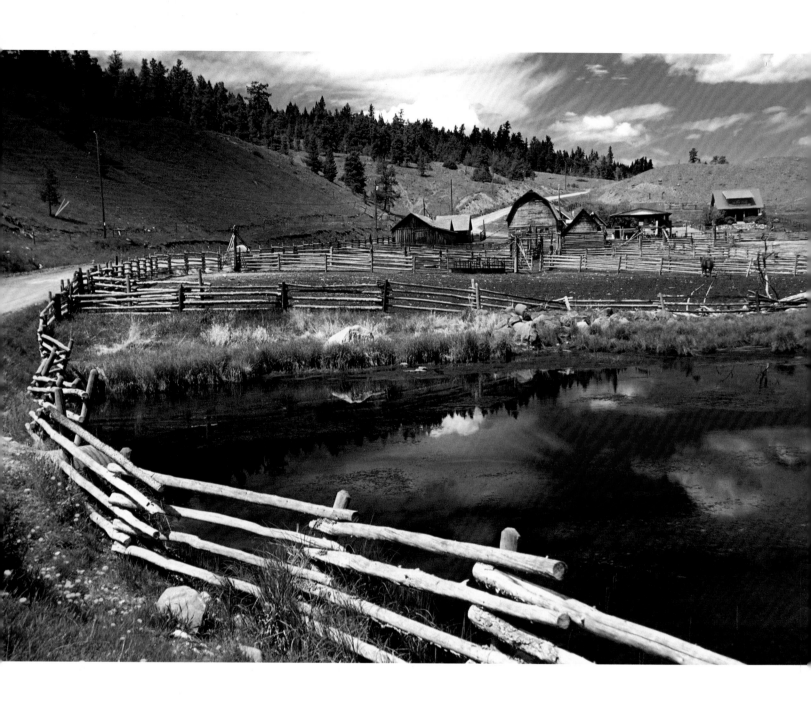

*Nestled along a curve of
the gold-rush trail, the
OK Ranch was once a
stopping house known
as Haller's.*

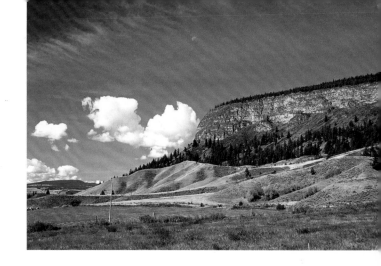

Basalt escarpment of the Dog Creek Dome, at the eastern edge of the Fraser trench. A hidden cave at the base of the cliffs is painted with Native pictographs.

only a tiny speck, a puff of dust. This dramatic landscape is quietly arrayed in sombre shades of ochre, grey and soft green, with fiery rocks across the river and sudden jolts of colour according to season—the flaunt of a fall aspen, a strip of vivid green beside an irrigation ditch, a tuft of rabbitbrush. You'll likely want to stop at the top of the hill to admire the view across the 15 kilometres of scenery ahead.

The Fraser River, mostly hidden from view at the bottom of its deep trench, is supercharged. You can hear it roar. The closest the gold-rush trail comes to the river is along the bluffs opposite Churn Creek, where a long, narrow bridge now connects the Cariboo to the Chilcotin Country by way of the Gang Ranch. An excursion into the lands of this historic ranch is well worth an hour or so of your time and, if nothing else, will give you an excuse to drive across the dramatic Churn Creek Bridge and view the landscape on the other side. (See Chapter 7 for side trips into the Chilcotin.)

North of the bridge, the gold-rush trail climbs steeply and circuitously up onto the dry, forested plateau, then slides down again into the Dog Creek Valley, a serene tapestry of irrigated greens backed by the sheer basalt hulk of Dog Creek Dome. The community of Dog Creek (Xgat'lem) claims a venerable history. A roadhouse was built here in 1856 by Mexican immigrant Raphael Valenzuela; Frenchman Pierre Colin took out a water licence for irrigation in 1861; and, later, Comte de Versepeuch, a French aristocrat, built a waterwheel to generate power for a sawmill. The Count built a large, fancy house and reputedly traded his elegant court clothes—his tricorne hat and blue satin jacket—to a local Chief, Alexis, for a string of horses. Later still, a gristmill was installed, the first in the Interior. In 1868, J.S. Place took over the roadhouse, advertised "the finest wines, liquor and cigars," provided stabling for 25 horses and started the Dog Creek Stage Lines, the first in B.C. to be officially licensed. After the building of the Cariboo Wagon Road far from the Fraser, Dog Creek kept going when other settlements on the River Trail faded. Right up until the 1970s, there was a well-loved general store and post office here, and the Dog Creek Stage still made twice-weekly trips to Williams Lake, albeit in

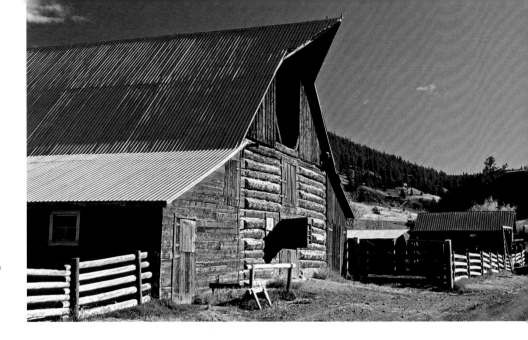

Huge log barn at Alkali Lake Ranch, one of B.C.'s oldest ranches.

an old blue bus. Today, as with other gold-rush settlements along this forgotten highway, everything has closed down. But hidden in the tousled grasses of the old orchard beside the creek, the wooden wheel of the ancient gristmill still survives.

Turn right here to visit the Native village of Xqet'em, a thriving small community with a school, gas station, general store and a beautiful old church, painted a deep and vibrant blue. The Native presence at Dog Creek goes back long before the gold rush. The first people here had villages and preferred fishing sites all along the river. At the back of a cavern hidden at the foot of the sheer basalt escarpment that marks the edge of the Dog Creek Dome there are ancient pictographs. Painted in red ochre, these figures of men, a dog and perhaps a ruffed grouse are enigmatic links to a past so distant, the gold rush seems as yesterday. The cave is huge, its mouth a yawning 70 metres wide, yet it remains hard to find, and requires a tough scramble. The cave and paintings are sacred and can be visited only with a Native guide.

Return to the River Trail and continue north. The road meanders through irrigated meadows below the Dome, then climbs onto high benches above the river. In summer, hiding among the sagebrush are pale purple mariposa lilies, which look like three-petalled tulips. Keep a lookout for traces of history: old fences, barns, corrals. The derelict ruins of Captain Meason's ranch, founded in 1870, stand gaunt on the canyon lip near Meason Creek. The house itself burned, but a couple of old cabins and corrals still remain of this once-splendid holding that stretched for 25 kilometres along the river. One fall, camels were brought in for a movie production (this part of the Cariboo is similar in looks, it seems, to semi-desert areas elsewhere in the world) and were being fed in a corral above the river. Did the movie producers realize that camels were used as pack animals along the Cariboo Trail during the gold rush era? Did they hear the echoes of history?

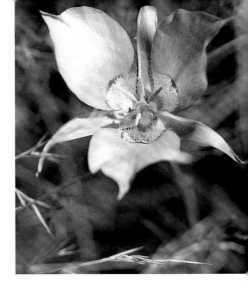

At about 30 kilometres from Dog Creek, the road leaves the river trough and swings east into the valley of Alkali Creek, where irrigated fields of grain and alfalfa provide a vibrant contrast to hills the soft colour of buckskin. Alkali Lake, a large dimple in this bowl of green, has been set aside as the Reidemann Wildlife Sanctuary. Here you can see many different species of ducks and geese, and even white pelicans flying through on migration. Around the lake, watch for bobolinks, northern orioles and long-billed curlews.

Mariposa lily.

The log buildings of Alkali Lake Ranch are strung along both sides of the road near the head of the valley, a photogenic cluster of red roofs. Established in 1861 on the site of an earlier gold-rush roadhouse, the cattle ranch claims to be the oldest in the province. The main ranch house itself, shaded by a long line of poplars, is set back from the road, but jostling your elbows as you drive through are sturdy old barns (a beam in one of them is inscribed with the date 1891), sheds and fences, a log house that for many years was a store and post office, and a pretty Victorian cottage. A short distance up the road, on a bluff overlooking the valley, the Native village of Esk'et celebrates its roots with an annual powwow, sweat-lodge ceremonies and drumming and dancing. There is a store here, a small café and a fine old church, St. Theresa of the Child Jesus, built in 1890 to replace the earlier log structure of 1862, a building that many of the gold seekers must have seen. Notice the large-as-life crucifix on an exterior wall.

Beyond the village, the road climbs out onto the breast of the Cariboo Plateau, a relatively flat area of meadowland and forest. Twenty-four kilometres from Alkali Lake, the dusty (or muddy) dirt road yields finally to blacktop. At the end of a long day, it might be tempting to drive the rest of the way to Williams Lake without stopping, but the countryside is lovely. Along with several small lakes loud with ducks in nesting season, there are log fences, meadows and old buildings to catch the eye. At Springhouse, there is an airstrip for small bush planes, and a pioneer school, now a community hall. Side roads lead off to other areas, many now settled as outriggers to the large community of Williams Lake. The road up Chimney Creek to Brunson, Felker and the Chimney lakes is well known to birders; sandhill cranes are often seen there. The earliest gold-rush trails went this scenic route, heading not for Williams Lake but for Likely, by way of 150 Mile. But our version of the River Trail continues for 10 kilometres down the road and enters Williams Lake via Highway 20. This town, with its cowboy ambience, offers a fitting end to the day. ❖

BACK ROAD TO BARKERVILLE

After leaving the Fraser River, the first Cariboo gold-rush trail pushed north and east to the lakes and rivers beyond Quesnel and Horsefly, encouraged by reports of bedrock covered by deposits of blue clay, a geologic convergence similar to that found in the richest gold strikes of California. East of the river the miners found a landscape very different from the dry open river benches. Thick with jack-pine forest, spruce swamps and a maze of creeks, lakes and turbulent rivers, this obdurate mountain country made travel very difficult. Despite the hardships, miners pressed on, hacking out crude pack trails. Lieutenant H. Spencer Palmer of the British Royal Engineers, dispatched from New Westminster in 1860 to survey an official wagon road to the goldfields, sent back a description of these trails: "Slippery, precipitous ascents and descents, fallen logs, overhanging branches, roots, rocks, swamps, turbid pools and miles of deep mud …" They were perhaps the worst part of the journey.

The gold-rush trail struggled northeast to the confluence of the Quesnel and Cariboo rivers, then followed the Cariboo River upstream to Keithley Creek, one of the earliest of the Cariboo gold camps. From here, the way led over the Snowshoe Plateau and Yanks Peak to the gold creeks of Antler and Williams, where, a few years later, the lusty town of Barkerville was born, screaming itself into existence. The official Cariboo Wagon Road, hacked out at a hefty six metres wide several years later, never came this way: the topography was far too difficult. From Lillooet the road made a beeline for the riverside settlement of Soda Creek, at the start of navigable water on the Fraser. Here, paddlewheelers provided service upstream to Quesnelmouth (today's Quesnel), and a road went on to Barkerville by way of Cottonwood—more or less the same route as today's Highway 26.

The road to Soda Creek had been planned to follow the old Hudson's Bay Company Brigade

Log barn in a tangle of fireweed on the road to the Bullion Pit.

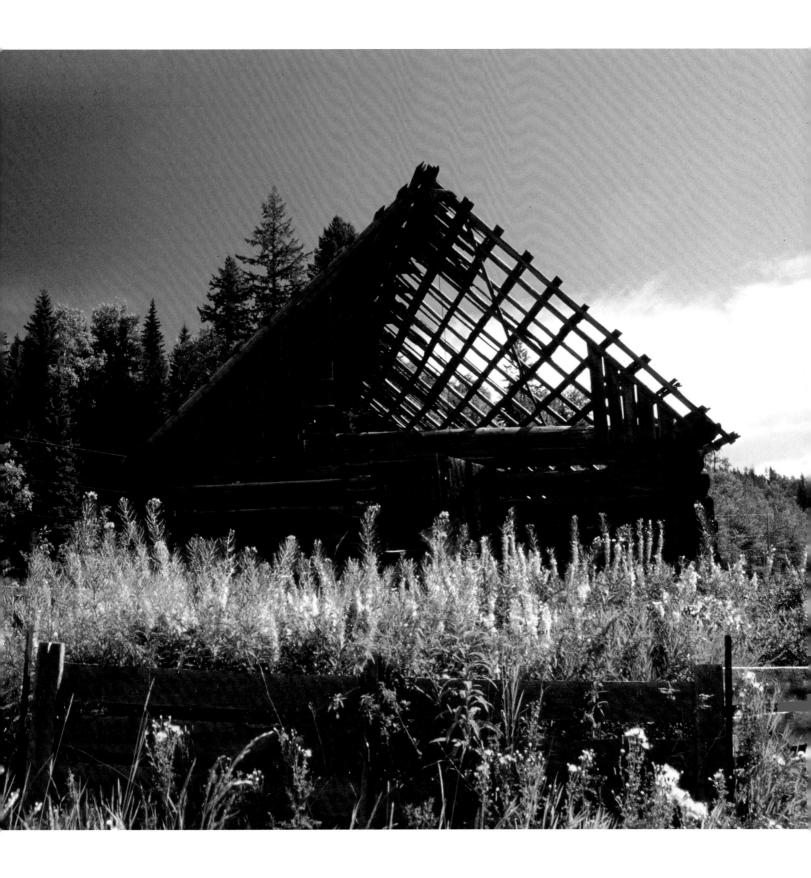

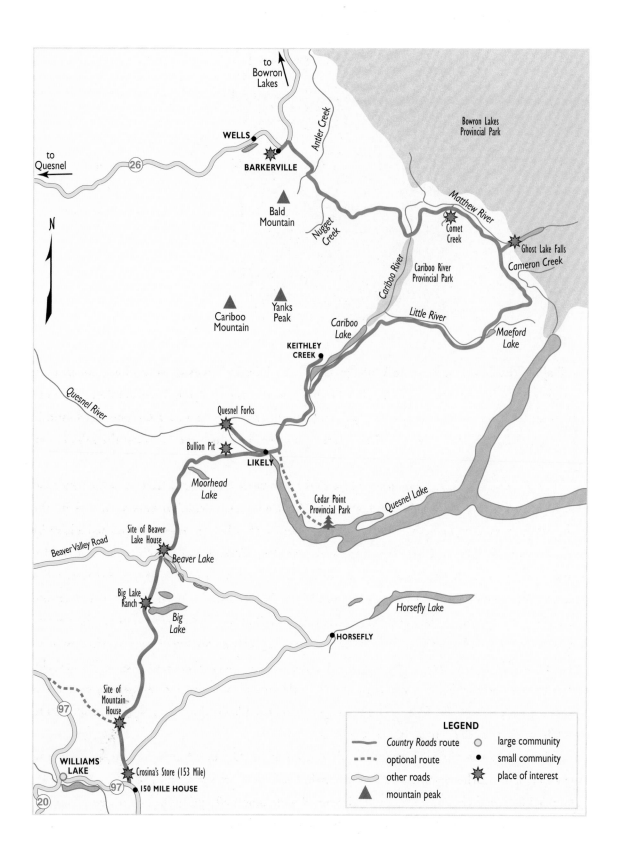

to Bowron Lakes

Bowron Lakes Provincial Park

WELLS

BARKERVILLE

to Quesnel

26

Antler Creek

Bald Mountain

Nugget Creek

Matthew River

Comet Creek

Ghost Lake Falls

Cameron Creek

N

Cariboo River

Cariboo River Provincial Park

Little River

Maeford Lake

Cariboo Mountain

Yanks Peak

Cariboo Lake

KEITHLEY CREEK

Quesnel River

Quesnel Forks

Bullion Pit

LIKELY

Moorhead Lake

Cedar Point Provincial Park

Quesnel Lake

Site of Beaver Lake House

Beaver Valley Road

Beaver Lake

Big Lake Ranch

Big Lake

Horsefly Lake

HORSEFLY

Site of Mountain House

97

Crosina's Store (153 Mile)

WILLIAMS LAKE

97

150 MILE HOUSE

20

LEGEND

— Country Roads route
- - - optional route
— other roads
▲ mountain peak
○ large community
● small community
✶ place of interest

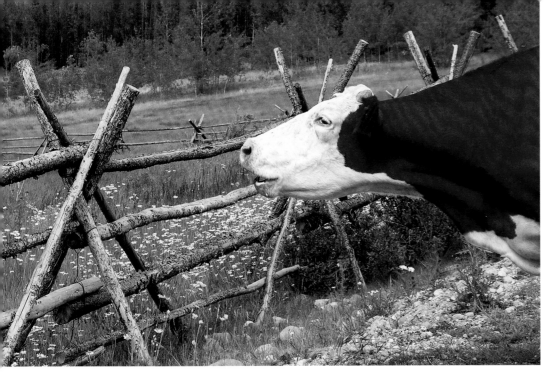

*The Cariboo is synony-
mous with old pole fences
and cattle ranching.
This cow bawls for her calf
among the summer daisies.*

Trail along the San Jose River to Williams Lake, which by 1863 was already a lusty community, complete with jail and courthouse, a mail depot and the only judge and constable in the area. But road builders instead turned east at 150 Mile and took the road over Carpenter Mountain to the Soda Creek boat terminus. This route bypassed Williams Lake, leaving the inhabitants stranded.

Why this sudden change in plans? Some said it was more than coincidence that the new road ran right beside Deep Creek Roadhouse, an establishment half-owned by Gustavus Wright, the contractor in charge of construction. Others contended that Wright had been refused a loan by the owner of a Williams Lake hostelry and went the Deep Creek route out of pique. There is also some mention of rivalry between Wright and Captain Grant, the chief surveyor, and even a hint that the new gold commissioner, who had holdings in Williams Lake, tried to influence the route. To be fair to Wright, a quick look at the map will show that the Deep Creek route is shorter (by a good 13 kilometres) and it was said to provide better grazing. No one will know what political chicanery, if any, took place, and today it doesn't really matter. Williams Lake, which had slid into oblivion for a while, was firmly put back on the map; it was just too big to be ignored. For a while, though, 150 Mile House, at the intersection of roads north to the goldfields and west to the Chilcotin, was the centre of Cariboo trade.

This country road follows part of the first, contentious Cariboo Road from 150 Mile House, then tracks the earlier pack trail that led north, heading for the mountain route to Barkerville. The road is paved as far as Likely, straightened and smoothed by modern engineers. You can drive through the same difficult country the miners toiled through, passing some of the old and

intriguing places along the way: the huge hole in the ground that was the Bullion Mine; sites of long-gone roadhouses; the old towns of Likely and Keithley Creek; and the haunting ghost-of-a-ghost town of Quesnel Forks. While the original trail over the Snowshoe Plateau to Barkerville is passable only on foot or by four-wheel drive, there is now another option: a good forest road that goes up the east side of Cariboo Lake and over to Barkerville via the Matthew River, readily passable in a two-wheel-drive vehicle.

The village of 150 Mile, though far smaller than it used to be, is still a crossroads centre. It has a modern roadhouse and a historic one-room school that dates to the 1890s. Turn east beside the service station and follow the Likely road for five kilometres to one of the most interesting of the old Cariboo places: 153 Mile House. The land here was pre-empted in 1903 by Italian immigrant Louis Crosina and his wife, Clara, who at first lived in a small log house where they started a general store. A couple of years later, they built a much larger six-bedroom home, which, because of Clara's good food and hospitality, became a popular roadhouse. Everything—bed, meals, and food and accommodation for horses—was priced at 50 cents. The family enterprise flourished—the roadhouse for 35 years, the store for even longer. In 1914 the store was expanded, selling everything from food to dry goods, clothing, hardware, farm machinery and, later, automobile parts and gasoline.

When the roadhouse closed, the Crosinas' daughter, Lillian, ran the family ranch until she sold the property to the Patenaude family, but Lillian kept the store going until her death in 1963. Stepping through the door today, one can well believe that Lil is still there, behind the counter. The old place keeps not only the essence but the contents of a bygone pioneer era. Everything in the store remains almost just the way it was left, lovingly preserved. The store/museum is private, open only by request. The original log stopping house is also still intact, along with log barns and a blacksmith shop. A section of the original wagon road runs through the property, but it's a working ranch, so please respect the Patenaudes' privacy, and call ahead if you want to prowl around. The store alone is well worth a visit.

Two kilometres beyond Crosina's store, the road forks. Keep left on the Likely road (right leads to Horsefly) and follow the route of the wagon road for another six kilometres to the site of 158 Mile House, once known as Mountain House. Here, the road turns and follows Deep Creek (now Hawks Creek) back to the Fraser and the Soda Creek wharf. Those seeking to retrace the old road will want to turn here. It's a pleasant enough drive, though with little tangible history left. The Deep Creek Roadhouse at 163 Mile (perhaps the reason the road came this way) has vanished, with the property returned to the Crown in 1879 to become part of a Native reserve.

The early gold-rush pack trail—and modern road—veers right and continues for about 15 kilometres through forest and past aspen-fringed Skulow Lake, then breaks out into

Crosina's General Store, which was open from 1905 until 1963, is now a private museum at 153 Mile Ranch.

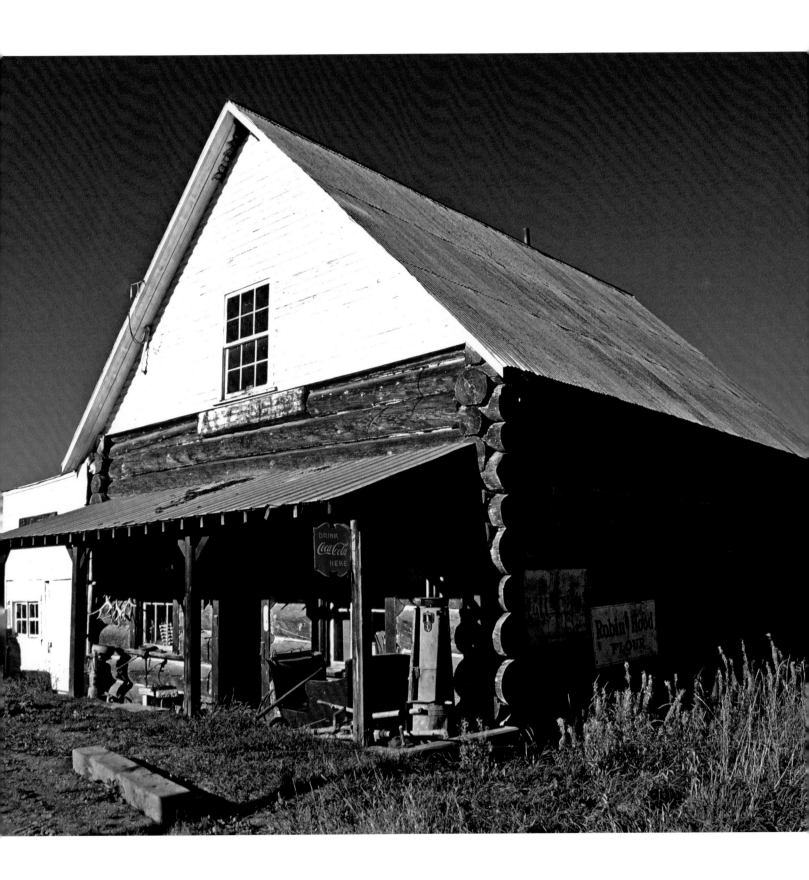

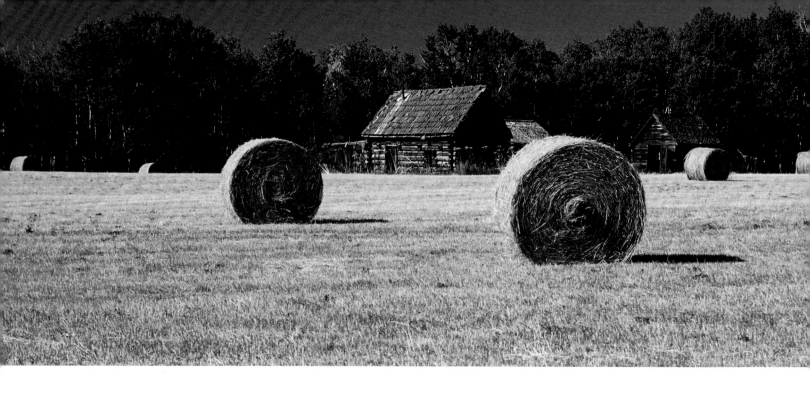

meadows rustic with old snake fences, barns and cabins. The road is paved but quiet, and it is easy to imagine miners and their pack trains clopping along. Past the end of Big Lake (site of yet another stopping house, built in 1896, burned in 1954), the road comes to the small modern community of Big Lake, crosses the hump of Limestone Mountain and makes a sharp bend to cross Beaver Creek. The ranch buildings beside the creek mark the site of Beaver Lake House, one of the most famous of the stopping places along the trail.

Beaver Lake House was established in 1861 by Peter Dunlevy, who made the first gold strike in the Cariboo on the Horsefly River and who later made a fortune as owner of the hotel at Soda Creek. Miner J.C. Bryant praised Beaver Lake House in his journal of 1863: "The hotel is the best between Victoria and the Cariboo, indeed Victoria hotels could not compare with this one in the splendid meals given to the guests." He continued in rapturous praise of the baked meats, fresh vegetables, huge huckleberry pies and cream. Around the hotel were two stores, a gambling hall and a thriving market for pack animals. All these original buildings have vanished, and the site is now occupied by the Hamilton Ranch. Recently, even the old bridge across the creek has been replaced.

The rich meadows in the Beaver Valley are knee-deep in dandelions in spring and neatly stitched around the edges by a graceful log fence. An unpaved side road leads southeast through the valley to Horsefly (a possible return route), but the road to Likely climbs the hill across the creek. From here on, the road runs through forest, passing the UBC Research Forest and a resort on Moorhead Lake. This lake is a reservoir formed to provide water storage for huge hydraulic operations in nearby Dancing Bill's Gulch. The Bullion Mine, once the greatest hydraulic

An old log home-stead, almost hidden behind giant hay bales, sits near the site of Mountain House.

mining enterprise in the world, was so rich and profitable that it was worked on and off from 1897 until 1941. To obtain enough water and pressure for mine operations, nearly 35 kilometres of ditches were dug to carry water from Bootjack and Polley lakes and from the great reservoir behind Moorhead Dam. High-pressure sluicing resulted in a gold-rich sludge that filtered out into millions of dollars worth of gold. Daily, the gulch became wider and deeper. Today, it's a gulch no longer, but a chasm, three kilometres wide and a staggering hundred metres deep, its gravel sides a bright yellow against the forest covering. A rest stop along the highway provides an excellent view.

About halfway between Moorhead Lake and Likely, the gold-rush trail veered north to cross the Quesnel River at its confluence with the Cariboo River. The townsite of Quesnel Forks was surveyed in 1861 on the large flat where the two rivers converged, and it briefly became the largest settlement on the B.C. mainland, strategically placed to become the supply (and recreation) centre for the hordes of miners who moiled on the creeks and lakes to the north. Originally reached by ferry and later by a toll bridge, the town on the north side of the river had 20 well-built log houses, a dozen stores, saloons, a Chinese tong house, government offices, two jail cells and a cemetery. Beyond, the gold-rush trail threaded its way along the Cariboo River to the gold camp of Keithley Creek, then perilously over the mountains to Antler and the creeks "paved with gold."

When it was decided to improve the miners' trail into a wagon road only two years after the founding of Quesnel Forks, this mountainous route was deemed too difficult and the road to Barkerville was built instead from Quesnel (at the river mouth) by way of Cottonwood Creek, a far more practical, if longer, route. After a brief but spectacular heyday of only five years, with most of the traffic to the goldfields gone, Quesnel Forks started a slow decline. With the loss of the river bridge to spring floods, mass desertion began. Chinese inhabitants were the last to leave.

A few years ago, a lonely ghost town lingered here on the river flats, its log buildings weathered a beautiful grey, and one could walk the old streets in the shade of the giant cottonwoods. But without preservation, ghost towns, particularly popular ones, become ghostlier. Every year roofs collapsed, vandals attacked and spring freshets undercut even more of the riverbank. Quesnel Forks today is hardly there at all. A couple of log buildings remain; the rest are in ruins, a jumble of fallen logs, though the cemetery, cared for by the Likely Cemetery Society, is immaculate. Underway is a project to "restore" the town. Volunteers from Likely look after the historic site, officially a Forestry Recreation Site, and are undertaking repairs and reconstructions. It's a most worthy undertaking. (For more information, contact Quesnel Forks Restoration Project, Box 29, Likely, B.C., V0L 1N0.)

With the old bridge to Quesnel Forks long gone, the only way in to the ghost town today—and it *is* worth a visit—is from the relatively young village of Likely, a pleasant little lakeside settlement with a venerable hotel (known locally as the Likely Hilton), a store and a gas station. It was named for John Likely, one of the luckiest of the gold prospectors, who worked in the area during later gold-rush days. Cross the highway bridge over the river at the tail end of sprawling Quesnel Lake, the deepest lake in North America. A good spot for watching spawning salmon in fall, the bridge crosses at the same place where Joseph Hunter and a crew of 500 built a dam in 1897 to hold back the water long enough for them to remove all the gold from the river channel. To reach Quesnel Forks, stay on the road that goes up a hill above the lake, and watch for a left turn. Be prepared for a rough drive. The 12 kilometres of unpaved road lead steeply over a forested ridge, then even more steeply down again to the river fork. Park just before the cemetery and explore by foot. The twin rivers roar, the leaves of the cottonwoods rustle in the wind, the grass in summer is crisp underfoot, and the lingering gold-rush ghosts are made more melancholy by the haunting beauty of the place. You can buy a walking tour guide to the old town at the Likely store.

Return to the Likely road, turn left and then right, and drive along Quesnel Lake to Cedar Point Provincial Park campground, where there is a display of old mining machinery. The office

The newly opened back road to Barkerville climbs high above the Matthew River, with great mountain views and banks of fireweed.

doubles as a tourist information centre where you can obtain a very good map of the backcountry route to Barkerville. With map in hand, drive back the way you came and turn right, heading for Keithley Creek on the west shore of Cariboo Lake. The little lake you pass en route is Paquette Lake, a good nesting place for loons.

One of several gold-rush camps that pointed the way to Barkerville, Keithley Creek started in 1860 with a rich find by "Doc" Keithley on the bluffs above the lake. Others soon crowded in to the rowdy ramshackle camp that optimists called "Cariboo City." Once Doc had cleaned out his claim, he moved on to start another boomtown called Antler Creek, which was superceded in turn by Lowhee, Camerontown and a host of others. Keithley Creek was perhaps the smallest of these flash-in-the-pan settlements, but it has survived, and keeps its sense of history by looking after its tiny cemetery. If you are pressed for time you can bypass Keithley Creek and head straight for Barkerville along the road that begins about four kilometres south. A prominent Gold Rush Circle Tour sign marks the route, which leads east toward the Cariboo River.

The bridge here is a narrow wooden Bailey bridge, typical of logging roads; while this route *is* a former unpaved logging road, it is well maintained, though open only seasonally. A sign at the bridge reads 125 kilometres to Barkerville. The road follows the east shore of Cariboo Lake, but you won't see much of the lake because the forests are thick and access limited. This area

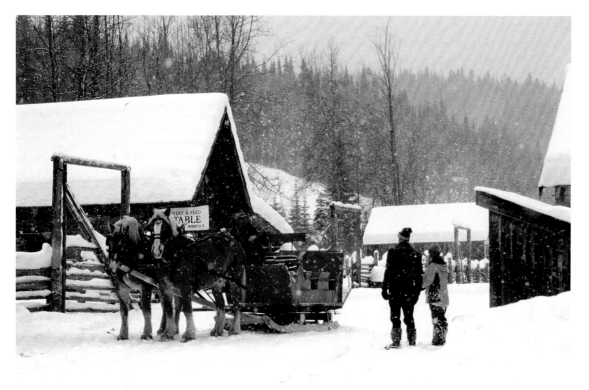

Caleb Higgins and his Percherons, Red and Rusty, prepare for a Christmas sleigh ride.

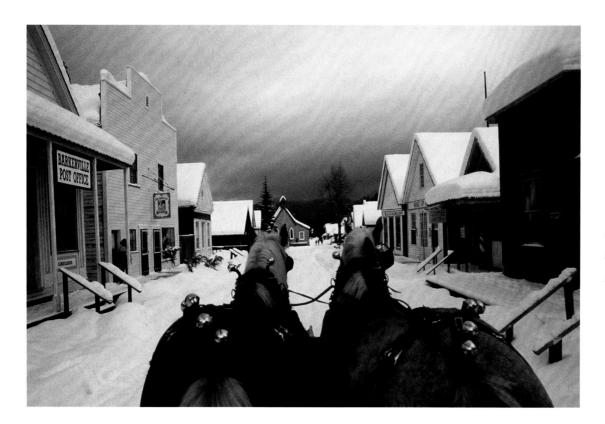

Sleigh ride through the winter streets of Barkerville.

is still very much a wilderness. At about 34 kilometres from the bridge, the Barkerville Road crosses Little River and follows it upstream beside Maeford Lake, a tiny splinter of blue under a granite dome. At the pass, there's a trail sign for Cameron Ridge and several high viewpoints that undoubtedly were familiar to gold-mining prospectors. From here, the road takes a sudden sharp bend northwest and, from its high elevation above Cameron and Connection creeks, allows good views to the mountains of Bowron Lakes Provincial Park.

Around 90 kilometres from Likely, there's a side road you won't want to miss: it goes to a small campsite at the end of Ghost Lake, where a twin-stream waterfall spills boisterously into the Matthew River. There's a good view of the falls from the road bridge, a scenic place for a picnic.

Return to the Barkerville Road and turn right. At Comet Creek, five kilometres along, there's a surprising little restaurant, with octagonal buildings reminiscent of yurts, though made of stone and wood. Another surprise: the place might even be open — but then again, it might not.

From Comet Creek the road turns south past Kimball Lake and crosses the upper Cariboo River before threading its way closer to the goldfields, past such historic places as Nugget Mountain and Antler and Grouse creeks, and joining the main road that links the Bowron Lakes with Barkerville. You'll see from activity at the Ballard Mine nearby that there is still gold in these here hills.

Barkerville, of course, is your final destination. And if you have been sensible enough to make reservations at one of the two B&Bs (the Kelly/King houses) or the St. George Hotel, you can spend the rest of the day reliving life in the most famous gold-rush town in B.C. When the tourists and the actors go home, the empty main street is full of shadows, full of old echoes. By moonlight, the place is extraordinary. Best of all is Barkerville in the winter time, celebrating with the ghosts of Christmas past, or just silent under the snowdrifts. History here really does come alive. ❖

ALONG THE DEADMAN RIVER

British Columbia's Thompson River east of Cache Creek runs through some of the driest landscape in the country: parched craggy hillsides peppered with sagebrush and cactus, knapweed and thistle. In summer, the land is hot, dusty and drab; only a few irrigated fields and small oases in the river's deep trench show any sign of green. This semi-desert is hostile: step off the road and you're in a minefield of sharp stones, spiny cactus and rattlesnakes. But water creates instant fertility. Back around the turn of the last century, a group of British entrepreneurs came up with a scheme to turn this desert into apple orchards. They brought irrigation water not up from the Thompson—at the time there were no suitable pumps—but by gravity feed from lakes at the north end of the Deadman Valley, almost 100 kilometres distant. This name proved to be an ill omen. Wooden flumes fell apart and orchards shrivelled from lack of water when workers left to fight in the First World War. The little settlement called Walhachin turned to dust. The site lies across the Thompson River a few kilometres east of Cache Creek, and there are still a few old apple trees and traces of a wooden flume. Juniper Beach Provincial Park along the river nearby has an excellent swimming hole, a bonus on a hot summer's day. And here in the fall you can watch the Adams River sockeye swim home.

This journey leads north from the dry dusty lands of the Thompson River up the Deadman Valley, where the Walhachin story began. The valley scenery is astounding: gentle green ranchlands beside the river contrast with violently contorted volcanic cliffs the colour of fire, huge sandhills and eroded hoodoos. Deadman Road follows the river, spawning grounds of the famous Thompson River steelhead, north to a string of forest-fringed lakes, an abandoned gold mine and a 60-metre-high waterfall. (Deadman is a fitting name: it was along the banks of this

Four of the five Deadman siltstone hoodoos can be seen from the road, across a fiery volcanic landscape.

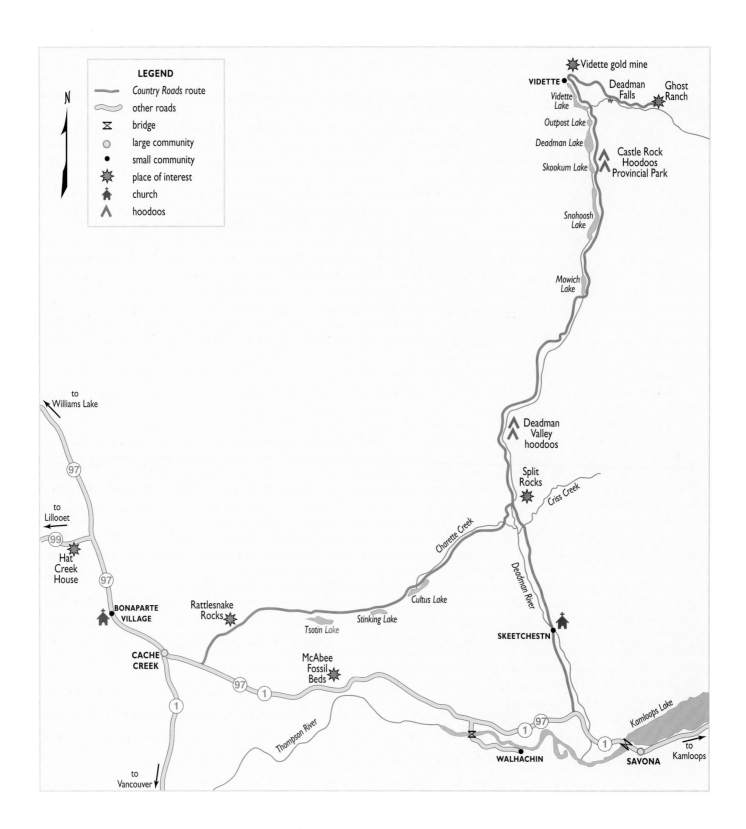

LEGEND

Country Roads route
other roads
bridge
large community
small community
place of interest
church
hoodoos

N

Vidette gold mine
VIDETTE
Deadman Falls
Ghost Ranch
Vidette Lake
Outpost Lake
Deadman Lake
Castle Rock Hoodoos Provincial Park
Skookum Lake
Snohoosh Lake
Mowich Lake
Deadman Valley hoodoos
Split Rocks
Criss Creek
to Williams Lake
97
to Lillooet
99
97
Hat Creek House
BONAPARTE VILLAGE
CACHE CREEK
Rattlesnake Rocks
Tsotin Lake
Stinking Lake
Cultus Lake
Charette Creek
Deadman River
SKEETCHESTN
McAbee Fossil Beds
97
1
Thompson River
97
1
Kamloops Lake
WALHACHIN
97
1
SAVONA
to Kamloops
to Vancouver

34

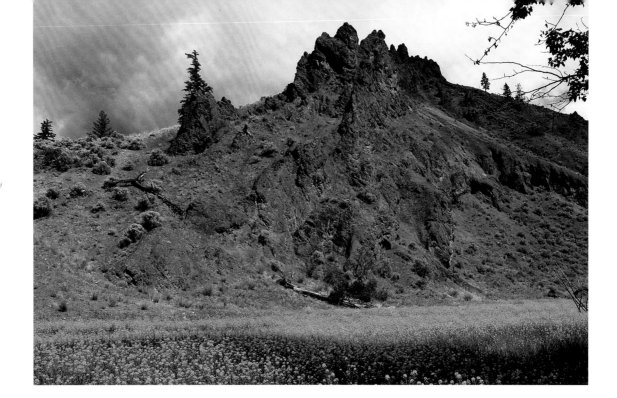

Brick-red pinnacles above a field of canola beside Criss Creek.

river that a fur trader by the name of Pierre Charette, a clerk at the North West Company's Fort Kamloops, was knifed to death in 1817.)

At Savona, Highway 1 bridges the Thompson River at the western end of Kamloops Lake and heads west to cross the Deadman just upstream of its confluence delta. The Deadman country road, signposted Deadman/Vidette, cuts off from the highway about four kilometres west of the bridge. The first seven kilometres, as far as the Native village of Skeetchestn, are paved. The Native presence here has been long established; Secwepemc peoples from as far away as Pavilion and Kamloops gathered near the village for traditional ceremonies and to harvest the once-abundant fish in the river. Today, partly because of such irrigation schemes as Walhachin, river stocks have been depleted. As part of ongoing efforts to revive the fishery, the First Nations operate a hatchery nearby. In the village, historic St. Mary's Church, built in 1910 on the site of an earlier log structure, has been renovated by band carpenters. It's a simple but classic little building, still in use for weddings and other special events.

The Skeetchestn graveyard beside the road is a good place to stop and savour this unique and geologically fascinating landscape. The north-south valley lies on the seam between two separate land masses fused onto what is now British Columbia during different episodes of earth history. Even to a novice geologist, the eastern and western edges of the valley appear very dissimilar. On the west side, the relatively flat and forested Interior Plateau is bordered with basaltic columns, the exposed edge of a thick layer of lava that covers ancient bedrock formed during the Miocene/Pliocene era (five million years ago.) To the east, it seems that all hell must have

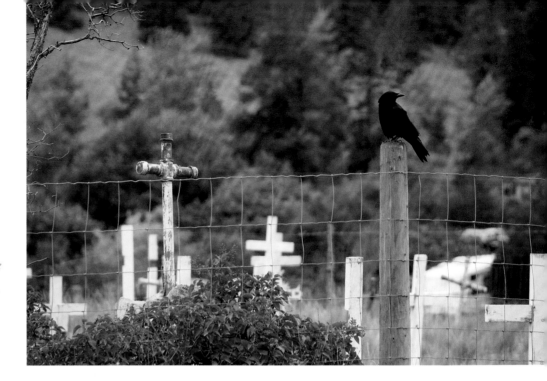

A crow guards the cemetery at the Native village of Skeetchestn.

broken loose. Deeply fractured and fissured, the land dates from the Holocene/Pleistocene era (1.6 million years ago), and the river valley is walled with strange fire-coloured rock formations, mostly solidified from volcanic ash.

Where Criss Creek enters the Deadman River from the northeast (about six kilometres north of the village), it cuts under spectacular serrated cliffs in hues of deep orange-red, a contrast to the green of adjacent irrigated ranch fields. You'll find parking beside the creek bridge in the shade of cottonwood trees, but access to the cliffs is difficult. However, a few kilometres beyond, where the road bridges the Deadman River, a leafy track invites a stroll to the river's edge across from incredible rock formations, 70 metres high and brilliantly coloured in shades of red, dark purple and grey-green. Beyond, the road climbs higher, providing a grandstand view of these spectacular bluffs. Known locally and on some maps as Split Rocks, they are mostly of igneous origin interlayered with sedimentary deposits, which accounts for the differential weathering—and the contorted folds, caves and vertical cracks.

Opposite this geological gem, the Cache Creek road heads west, providing my recommended return route (described later). The Deadman road leads north through peaceful ranchlands, but if you continue to look east you will see that the edge of the valley is still dominated by volcanic outcrops. Less than 10 kilometres beyond Split Rocks, high on the eastern side of the valley, lie geologic formations of a different nature: five eroded hoodoos of sand and clay, each about 10 to 12 metres tall, topped with caps of harder rock. If you drive slowly and scan east with binoculars, you might, if the light is right, be able to pick them out about halfway up the hillside. Only four are visible from the road (the fifth is tucked into the gully) but they stand out clearly, pale

yellow above the deep reds of billowing volcanic formations. A steep, rough trail leads right up to the hoodoos; check at nearby Silver Spring Ranch for directions and permission to cross the property.

Past the hoodoos, the valley becomes tighter, the hillsides more forested. Keep an eye out for the Circle W Ranch: the pretty white bungalow with its shady veranda was moved here from Walhachin. The first of a string of six lakes comes into view just after a second bridge across the Deadman River where it hurtles through a tight rock canyon, about 25 kilometres from the highway. The first lake is Mowich (Native word for deer), where the road skirts around a small lakeside resort. At nearby Snohoosh Lake, a dam was built in 1910 so that Deadman River water could be led to the Walhachin orchards, far down the valley. A few traces of the wooden irrigation flume remain but the original dam is gone, replaced by a more robust version for ranch irrigation.

Past a forest recreation site at the north end of Snohoosh Lake, the road (and the river) runs through fir forest to Skookum Lake, to the east of which sits tiny Castle Rock Hoodoos Provincial Park. Sixty metres high and rising above the skyline, the eroded yellow sandstone cliffs with their crenellated tops do indeed look like a castle. But stay away: boot tracks would damage the fragile cliffs. No camping is allowed here. The valley is well equipped, however, with forestry campsites: there is one on each of the following three lakes: Deadman, tiny Outpost Lake and Vidette. All are well stocked with rainbow and kokanee.

The Deadman River rises in the highlands to the east and flows into the south end of Vidette Lake. The road crosses the river and follows the lake to its north end, just about 50 kilometres from Highway 1. This long, skinny lake was the halfway point on one of the Hudson's Bay Brigade Trails between Fort Kamloops on the Thompson River and Fort Alexandria on the Fraser. Prospectors following this old trail found traces of gold above the lake and staked a claim. This was later developed into the Vidette Mine, one of the big producers of gold in the 1930s. By 1934 the head of the lake was home to a small community, with a two-storey bunkhouse and a cookhouse. Miners were paid 50 cents an hour and were charged $1.50 a day for board and lodge. To bring men and supplies in and gold out, the company bulldozed more than 35 kilometres of road along the lakes—the road you have been travelling. For six years the mine worked at full steam, producing some 28,000 ounces of gold, and then it all fizzled out. The mine workings are still there, if you know where to look, and the buildings have been transformed into a small resort, with a lodge and several cabins, one of them constructed with timbers taken from the old HBC post. If you ask, the Vidette Lake Lodge owners will take you to see the mine tunnels.

On the flower-filled aspen plateau above, there is a high clearing drained by creeks in three different directions. A visiting Tibetan monk decided that this is the "Centre of the Universe." Reputedly, his on-site meditations confirmed this, and the place is now much visited by mystics

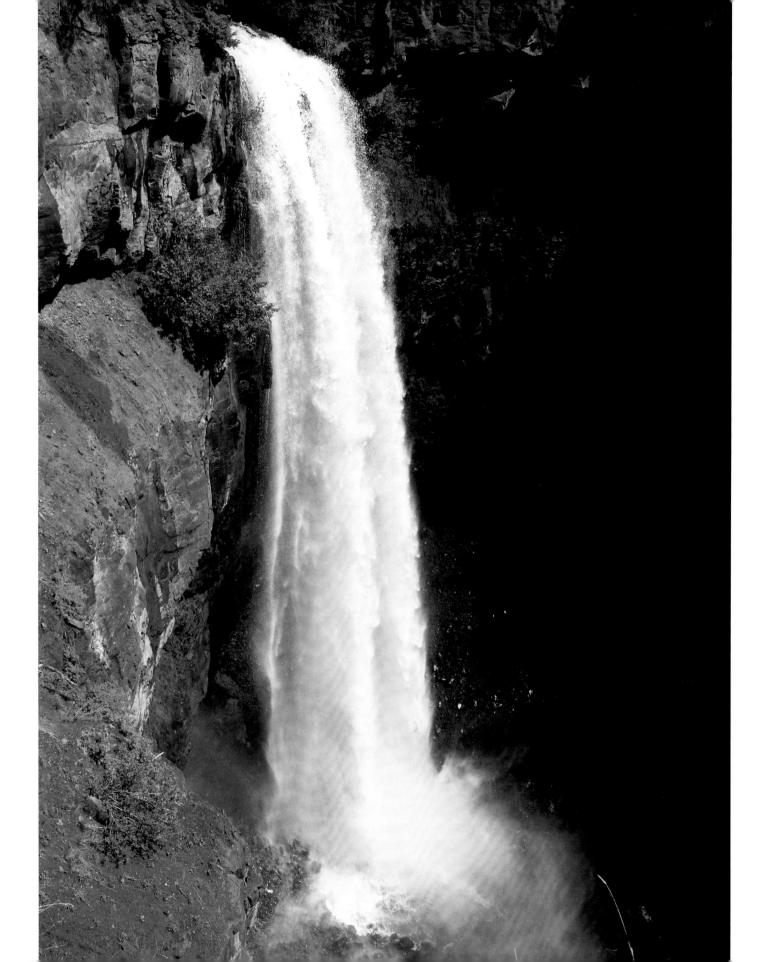

from around the world. Whether the site is mystical for you or not, the high meadow has a fine view south over the lake and this is magic enough.

The Deadman Road turns east at the lodge gate, climbs very steeply up into the open forests of the plateau, then turns southeast to meet the river again. About six kilometres beyond Vidette Lake is Deadman Falls Recreation Site, unmarked at the time of writing. Park beside the road and take a short walk to the waterfalls: just follow your ears. In spring and early summer, the thunder of the falls down 60-metre-high cliffs can be deafening, and the spray is flung so high there are rainbows in the river at its feet. The Deadman is a wild waterfall: there are no official trails or guardrails, and it's a huge drop down the cliffs into the boiling eddy. Tread carefully. With a wide-angle lens, you should be able to photograph the falls, top to bottom, from sky to magical rainbows. Deadman Falls makes a good turnaround point, although if you are interested in ghosts, there is a deserted ranch a bit farther along the road.

Return to Vidette Lake Resort and go south all the way to Split Rocks. The geological treasures along the way are worth a second look, as the shifting sun reveals new facets of their personality. At Split Rocks, turn right and take the Cache Creek road into the Charette Creek valley (Charette, you remember, was the murdered fur trader). This road is a shortcut, at least in distance, wooded most of the way and with three small lakes to add interest. Across a low divide, it follows Cache Creek down to Highway 1 just east of its junction with Highway 97. But just before you reach the highway, there is another cliff of eroded red rocks. If you are tempted to explore, watch your step: the cliffs are known, with good reason, as Rattlesnake Rocks.

The *Country Roads* route ends at Cache Creek, but there are other delights. North of the town on Highway 97 there's a very pleasant fruit winery/bistro, and a Native church and cemetery at the village of Bonaparte. A little farther north is Hat Creek House, one of the last of the gold-rush-trail roadhouses, now preserved as a heritage site. For those in search of an historical conclusion to the Deadman River drive, follow Highway 1 east from Cache Creek and watch for the signpost to Walhachin. The little town is still there, on the east side of the Thompson River, reached by a one-lane bridge. It's such a pretty spot that people seem to be moving in, though there are no town facilities, not even a campsite. The residents have, however, provided a few benches where you can sit high above the river and watch the trains go by. And if you want to know more about the geology of the area—and perhaps to dig for fossils—you might want to take a guided tour of the McAbee Fossil Beds. Here, in an outcropping of sedimentary bedrock formed during the Eocene era (around 50 million years ago), are the fossilized remains of leaves and needles from species of trees still around today—redwood, cedar, pine and ginkgo—as well as flowers, fish and insects. Look for the site on Highway 1, just about opposite the road down to Juniper Beach Provincial Park. ❖

Deadman Falls plummets 60 metres into a river wreathed with rainbows.

SODA CREEK AND SUGAR CANE

TO SODA CREEK

There are some settlements, woven early into the strands of history and seemingly with good prospects for a successful future, that just fade away. You can look at old photographs crammed with buildings and activities, then stand on the same ground and ask, "Where did it all go?" and feel sorry for the people who once lived there, and for their disappointed dreams. Soda Creek is one such place, one of many that the Cariboo gold rush created and then discarded. On the Fraser River at the start of easy river transport north, it was for a brief moment the end of the first Cariboo Wagon Road. All the hopeful traffic bound for Barkerville and the gold mines poured into the little town, where they transferred, after a boisterous wait, to paddlewheel steamers bound for Quesnel and the last rough road haul.

When the gold rush was finished, Soda Creek continued to thrive as the start of river navigation up the Fraser to Prince George and points north, where railways were being built and towns boomed. For 60 years the river settlement was a vital link in the development of northern British Columbia. Here beside the Fraser were hotels and boarding houses, mills for flour and lumber, general stores, a school, a church and all the paraphernalia of an important supply centre—even a jail. Today, Soda Creek is barely on the map. Well away from Highway 97 and reached by unpaved tracks, it has no store, no gas station and only a few homes along the one riverside street. There seems little reason besides curiosity and a feeling for history to make the journey there. But country roads need no greater reason. There is still a road to Soda Creek, though not anymore a continuous one from Williams Lake, since an irreparable landslide knocked out one of the creek bridges. It makes a very good short drive—about 150 kilometres, round trip.

A sod-roofed cabin sits abandoned above the old riverside settlement of Soda Creek.

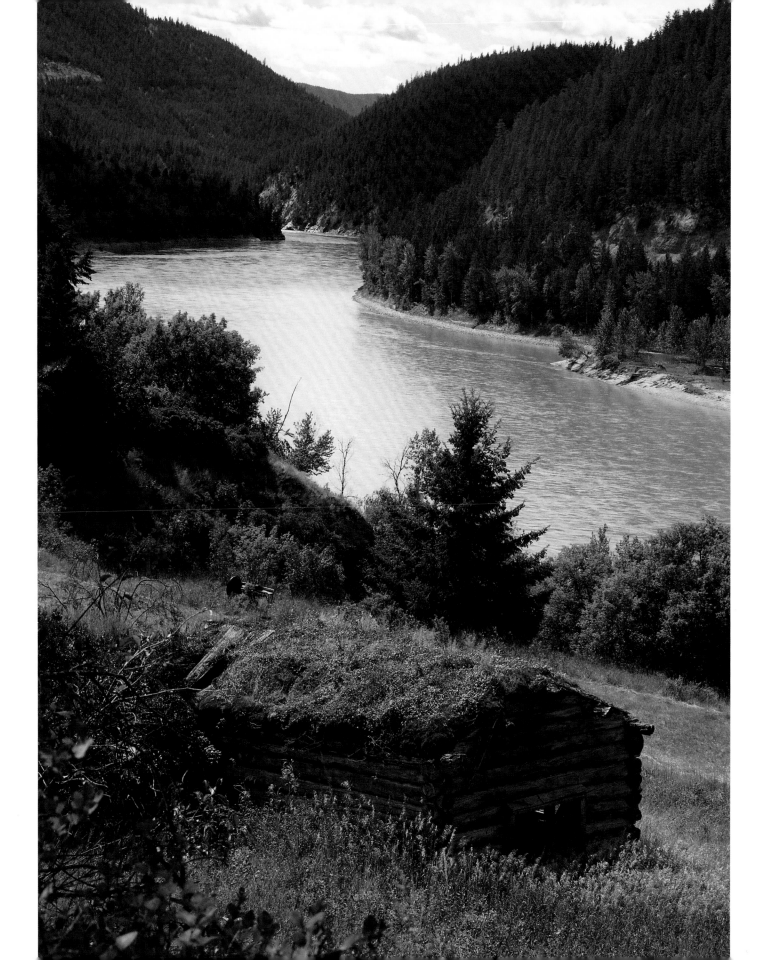

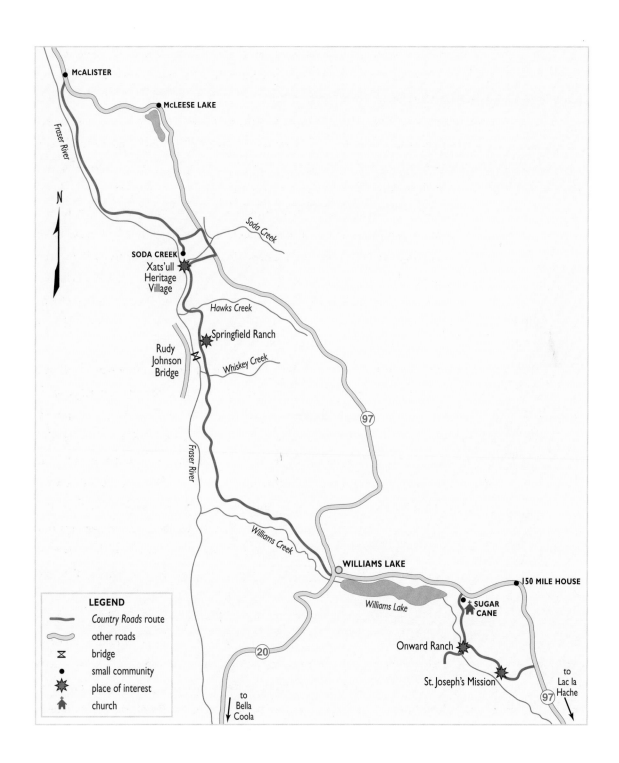

McALISTER

McLEESE LAKE

Fraser River

N

Soda Creek

SODA CREEK
Xats'ull
Heritage
Village

Hawks Creek

Springfield Ranch

Rudy
Johnson
Bridge

Whiskey Creek

Fraser River

97

Williams Creek

WILLIAMS LAKE

150 MILE HOUSE

Williams Lake

SUGAR
CANE

Onward Ranch

20

St. Joseph's Mission

to
Lac la
Hache

97

to
Bella
Coola

LEGEND

Country Roads route

other roads

bridge

small community

place of interest

church

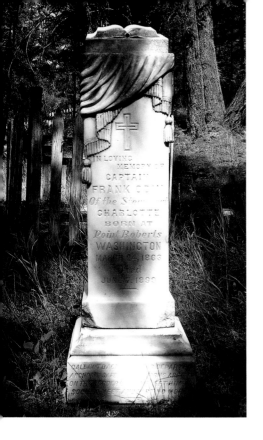

The marble obelisk in the huge
Soda Creek Cemetery is for Captain
Odin, a steamboat skipper.

Some years ago, this drive was far more interesting because there were two cable reaction ferries still in operation on the Fraser, one near Soda Creek, the other at Marguerite, 30 kilometres north. You could drive to Soda Creek, cross the ferry, drive north on the west side of the Fraser to Marguerite and cross back again. But times change. Now there is a small bridge across the Fraser, but it doesn't have quite the same old-fashioned appeal as a ferry crossing.

From the Williams Lake railway station (now an art gallery and teashop) at the end of Oliver Street, turn right and parallel the Fraser through a semi-industrial area for about three kilometres, then make a left turn beside a lumber sorting yard onto the Soda Creek Road. After another five kilometres, the city street becomes a quiet shady road that twists with the river and runs along high terraces made when the river was young and less entrenched than it is today. Across the river, some of these silty terraces have been eroded into hoodoos.

Appropriately for a road named Soda Creek, at 19 kilometres it passes Whiskey Creek, which leads down Buckskin Road to a bridge—a bridge with a history. Once the only privately owned toll bridge in B.C., it was acquired second-hand by rancher Rudy Johnson of the Buckskin Ranch across the river and erected here at his own cost, a total of $200,000. He just grew tired of making the 60-kilometre trip to Williams Lake on dusty forest roads by way of Meldrum Creek and figured he might break even on the deal by charging logging trucks and other commercial vehicles a fee. The financial outcome of his venture is not known, but later the provincial government bought the bridge and now it is part of the highway system: no tolls today. It's good to drive down to the bridge to see this example of local enterprise, and to come close to the great Fraser River as it roars past.

The road to Soda Creek holds to the east side of the river, sharing space with the Canadian National Railway, and sometimes ducking underneath it. The railway is a relative newcomer, first built here in 1914 as the Pacific Great Eastern. Past Springfield Ranch with its big meadows, old fences, barns, homestead and orchard, the road runs alternately through grassland and forest, sometimes very close but always very high above the river on cliffs of glacial sediment. A bridge over Hawks Creek marks the area where the first Cariboo Wagon Road (the one that bypassed Williams Lake) came down to the river on its way to Soda Creek.

About 30 kilometres from Williams Lake, the road divides: straight ahead an arrow points the way to the heritage village of Xats'ull; the right turn leads to Highway 97. The old Native townsite of Xats'ull just above the intersection is today mostly abandoned. The huge landslide

The Native village of Xats'ull, on a bench above the Fraser, was mostly abandoned after a landslide. Some of the log buildings seem sturdy yet.

that washed out the road to Soda Creek also made the townsite land unstable, and most of the people were forced to move. Now overgrown with weeds, it is still an interesting place to visit. It has some fine old log buildings, a church, a graveyard and a village office building, teetering on the edge of the slide.

Below the townsite, Xats'ull Heritage Village, on a grassy bench just above the river's canyon, has only the ghosts of a distant past to contend with. This is an ancient village site, recreated by today's Secwepemc people. The white tipis neatly arranged in a semicircle are not really appropriate to the area, but visitors like to come and sleep in them while they immerse themselves in Native culture. More historically accurate are the two kekulis (semi-underground winter houses), a summer house of willow saplings (covered when needed with evergreen boughs), salmon-drying racks, a sweat lodge and firepits. In such a fishing village, the ancient people of the river lived and thrived long before Europeans set foot in the area.

In fact, archaeologists have determined that this river bench has been a gathering place for at least 2,000 years, and First Nations people still come here to net salmon and participate in sweat lodge ceremonies. Young people of the tribe gather to learn the old ways, the elders to remember them. The heritage village is open from May to October for guided tours of varying lengths, and for cultural immersion sessions. One can also come here simply to camp, and, as one is sung to sleep by the sound of the river, it is hard to imagine a more idyllic location. (For information: www.Xatsull.com or 250-297-6323.)

From Xats'ull, return up the hill to the intersection and continue to the highway, a diversion made necessary by the landslide that took such a great gulp out of the landscape that the bridge over Soda Creek may never be replaced. At the highway, turn north, but only for three kilometres. Turn left on the Soda Creek Townsite Road and head back to the river. Almost at once,

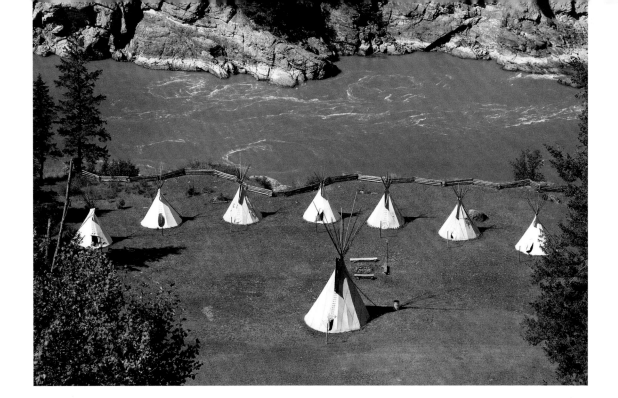

Tipis at Xats'ull Heritage Village, beside the roaring Fraser River.

an intersection looms. Go left for a visit to the remnant settlement of Soda Creek, a community now dwarfed by its enormous cemetery; it must be two city blocks long and one wide. Cemeteries are always worth visiting if you have an ear for history, for ghosts must surely linger here in the whispers of tall grasses that stroke the old grave markers. Travellers come mostly to look at one marker, a marble obelisk carved with typically Victorian flowing drapery, which marks the grave of Captain Frank Odin, who died of a heart attack at the wheel of his ship, the SS *Charlotte*, here in 1899. If you look carefully among the markers in the small older section of the cemetery on the river side of the road, you will find the gravestone of at least one other notable pioneer: T.J. Menefee, who died in 1873.

Continue past the graveyard and stop at the Centennial cairn, at the turn of the road leading into town—or what is left of it. The first Cariboo Wagon Road of 1863 ended here, and G.B. Wright, the contractor, ordered a steamship built to transport men and supplies along the next leg of the journey to Quesnel. The SS *Enterprise*, its engine and boilers transported from the coast by mule train, was built on the river here at a cost of $75,000. But it was money well spent: in less than two years Wright had tripled his investment.

Even before the boat was launched, Soda Creek had two taverns, two gristmills and a sawmill. Soon it had a commodious hotel, a two-storey affair built of logs by Peter Dunlevy. By 1882, with a population of 24, the town had added a second hotel, a telegraph service and a post office. Eleven years later, it had stagecoach service to Barkerville and Ashcroft and twice-weekly boat service to Quesnel, and its 75 residents had the services of a local doctor. It continued to grow,

slowly. By 1945 there were 175 residents and the community boasted of its Everglades Country Club—but six years later, a tourist account of the village described it derisively: only a couple of primitive stores and a gas station.

Today, even these are gone. There is no longer a wharf or a smart hotel or a gristmill. Only a few houses remain, and at the end of the single dead-end street there is a large building that seems to be the relic of the country club. But the town jail, built of sturdy logs in the early 1900s, its small barred windows still intact, remains to tell a story. Its builder, Billy Lynn, became its first prisoner. Apparently, Billy went to his favourite saloon to celebrate the end of his work, imbibed too freely, and was carted off by Constable Robert Pyper to spend the night behind bars in the new jailhouse. Soda Creek, an important piece of the mosaic that is the Cariboo gold rush, is not yet a ghost town. With its attractive location beside the Fraser River, perhaps it never will be.

Return to the intersection and go straight, following the river northwards. There are some old ranches along here (one is the Dunlevy Ranch, with a big log barn and a pretty house) and the fields are well irrigated—watch for rainbows in the sprinklers when the light is right. The Soda Creek Ferry Road branches off about five kilometres from the junction and a drive down to the river here is interesting, though the ferryman's house is now a private residence and willows have overgrown the old landing. There are only a few other relics beside the road, including the Pickard farm and roadhouse, which dates from 1898, and when the country road reaches Macalister it crosses the railway tracks back onto Highway 97. The total distance from Williams Lake is about 60 kilometres.

THROUGH SUGAR CANE TO THE MISSION

This second, even shorter side trip in the Williams Lake area begins a few kilometres south of the town along Highway 97, just past the end of the lake. Only 12 kilometres long, this loop road leads into interesting history. Opposite Chief Will-Yum Campground and heritage village, turn right along Mission Road to the Native village of Sugar Cane, which took its name from the lake meadows where the band settled in 1881. Here the grass grew tall and sweet like sugar cane and provided excellent grazing for horses.

Sugar Cane Church of the Immaculate Conception dates from 1895.

The village centres around the beautiful Church of the Immaculate Conception, known for its outstanding architecture and detailed craftsmanship. Its facade has been described as "the epitome of balanced design," with two Gothic windows flanking a recessed central doorway beneath a bull's eye window. Built in 1895 by the Oblate Fathers, it is very well preserved, both

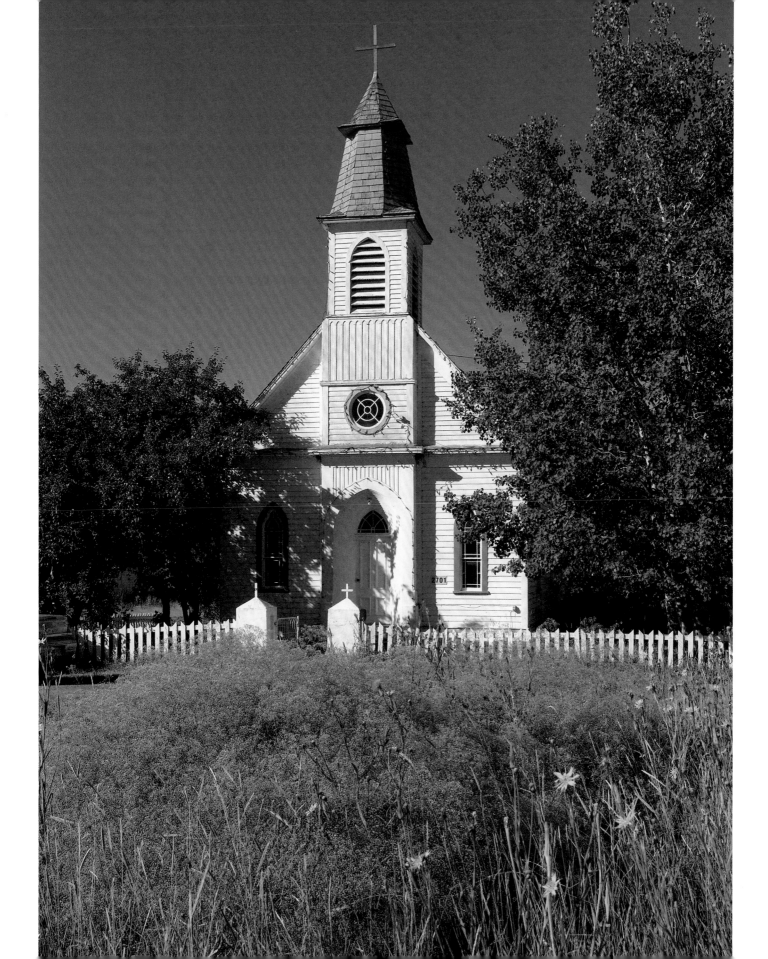

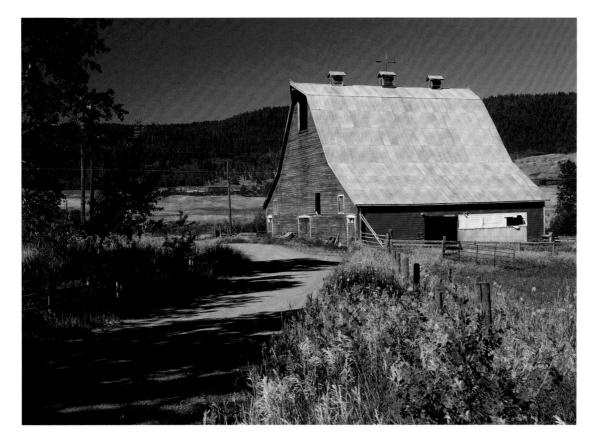

inside and out. With its soft pink roof, jaunty spire and blue trim, this church is one of the prettiest in the Cariboo. Opposite, delicate baby's breath grows wild in frothy clouds, muffling a few old ruined log cabins and the rusted remains of wagons. The road runs along one side of the village, beside the "new" graveyard, where there are several well-carved memorials in the form of clan emblems, an eagle and a bear. A little farther down, the "old" graveyard, its simple crosses of wood and iron smothered in wildflowers, is a more melancholy reminder of faith and mortality, but unlike most cemeteries, during weekdays this is not a quiet place because of the adjacent sawmill, one of the several forestry-related businesses that this band operates.

From the village, the road continues south four kilometres to the Onward Ranch, established in the 1860s. There's a big Victorian-style house here and a red-roofed barn. A road leads west, shaded by old trees, and on the corner sits a small white building, the once busy Onward Store, its front window boarded up, its name barely legible, but still marked with the ranch brand. The side road leads across the San Jose River and through ranch fields to the railway (once the Pacific Great Eastern, then the B.C. Railway, now the Canadian National) and the site of Onward Station.

Today the Onward Ranch is quiet, isolated from the highway mainstream, and one could easily pass by without a second glance. But like other places in the Cariboo, it has stories to tell. Situated beside the first miners' trail, which cut over the hills from Springhouse, the ranch was begun by a character larger than life. Charles George Cowan (a.k.a. Dead-Eye Dick) had a colourful career that included stints as a missionary, a North West Mountie, and a big-game hunter who provided Canadian wildlife trophies for the English aristocracy. He was also a land agent and bought and ran ranches for lordly English friends. It was during this period of his life that he acquired the 150 Mile Ranch and land for the Onward Ranch.

His wife, Vivien, brought Onward to the attention of the art world in the 1940s when, as an art student, she met the famous painter A.Y. Jackson and invited him to the Cariboo. He came to the ranch regularly and stayed for weeks at a time. The Cowans' daughter Sonia married Hugh Cornwall (his family founded Ashcroft Manor), and they managed the ranch when her father died. Always interested in art, Sonia was encouraged by A.Y. Jackson, and her work, well-muscled renditions of ranch life and Cariboo scenery, became well known. When she died in 2006, her paintings were in demand worldwide. The ranch meadows here could very easily inspire an artist: edged with wildflowers and loud with squabbling red-winged blackbirds, they can have changed little since A.Y. Jackson and Sonia Cornwall painted them.

Oblate missionaries entered the Cariboo country far earlier than the gold miners. Hitching a ride north from the Columbia River with an HBC fur brigade, Oblate missionary Father Modeste Demers arrived at Fort Alexandria in 1842, baptized 67 Native children and organized the building of a small church. It was his goal to found a mission in this wilderness, though it wasn't until 1867, when the gold rush was already well underway, that he was able to do so.

The site of St. Joseph's Mission, one of several missions founded by the Oblates in B.C., lies about three kilometres south of the Onward Ranch. Strategically located near the Cariboo Road, it was for a time a bastion of Roman Catholic faith in the wild outpost of empire. In the log mission church, many pioneer couples were married, their children baptized and their old folk eulogized. The missionaries opened a residential school for boys in 1872, and several years later the Sisters of St. Ann arrived to start one for girls. For many years these schools provided the only education available in the area, and local ranchers were pleased to send their children here.

But it was the Native children from outlying reserves that the missionaries were keen to teach and convert to Christianity. English was the only language permitted, and the children were obliged to discard their tribal beliefs and heritage and adopt European customs and dress. The sad story of the often-abusive mission-residential school system has been told many times. It is enough to record that of this once-expansive and influential place, with its houses, dormitories,

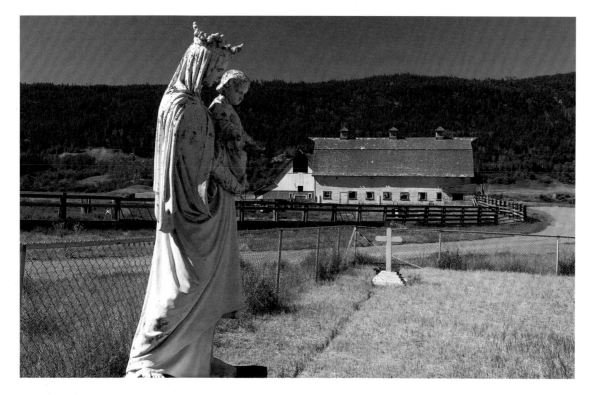

St. Joseph's Mission School has gone, but the huge milking and cow barns remain. And the old cemetery is watched over by a lichen-spotted statue.

schools and outbuildings, today nothing remains but a big white dairy barn, a smaller horse barn and the cemetery. Some of the buildings burned, others were razed, leaving only foundations.

The cemetery is perhaps the best place to contemplate this misguided episode in the province's history. It is tidily fenced, its grass neatly mowed, its stone monuments lovingly watched over by a statue of the Virgin and Child. Several pioneers of the gold-rush era are buried here, including "Little Fred Murphy," only four months old, and the Felker family, who farmed the lands immediately to the south.

It's less than three kilometres from the mission site back to Highway 97 where, a short distance away on the Cariboo Road, the Felker homestead is being restored. One of the few remaining heritage sites in the Cariboo, the 1884 log ranch house (which served for a while as a stopping house), barn and bunkhouse sit on the west side of the road, within sight of the lake near Lac la Hache.

As a side note, it is interesting to record that St. Joseph's Mission ranch owned the first registered cattle brand in the Cariboo, the OMI (for Oblates of Mary Immaculate). ❖

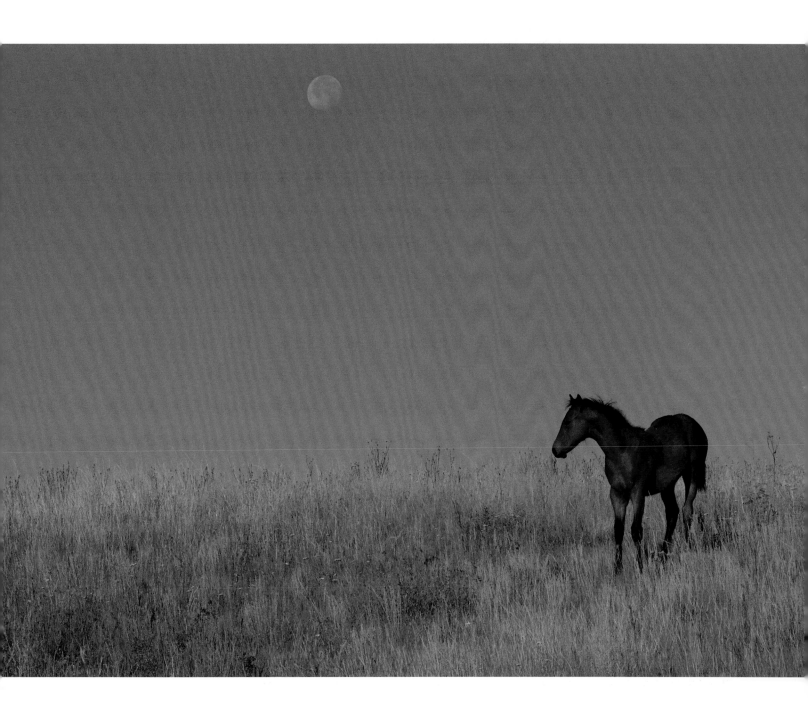

*Young colt and morning moon, on
the Cariboo prairie.*

OF MIST AND MEMORIES

B.C.'s written history happened fast: in the blink of an eye, two centuries have passed since the first fur traders carved their way through the wilderness, bringing the seeds of European civilization. But in the misty heartlands of the Skeena River, history is huge and enduring, recorded on village totems of the ancestral First Nations people, the Gitxsan. Carved here are the myths and memories of an ancient society, with its own laws and world views, and its own very deep roots.

A journey to the villages of the Gitxsan under the great ridge of the Rocher Déboulé range leads into a magical landscape of mist and memories. Halfway between the coast and the Interior Plateau, the Skeena River and its great tributaries drain a land of scenic superlatives: high snow-covered mountains, roaring rivers and deep dark forests. The rivers shaped the land, carving their way through the mountains, and people followed, building trails, roads and, later, railways. Even today, rivers dominate the access routes, controlling traffic because of the bridges needed to cross them, and, in times of flood, completely disrupting transportation.

Because of the difficult access, the land of the Gitxsan remained remote and untouched until quite late in the written history of B.C. While a few fur traders and missionaries had penetrated the mountain fastness, and items such as iron pots, blankets and guns were in early use, the Gitxsan had little direct contact with Europeans until 1866, when the Collins Overland Telegraph to Alaska was hastily constructed so that the first telegraph line from North America to Europe could be laid across the Bering Strait. Paddlewheelers came east upriver from the coast with supplies to meet surveyors and linemen forging their way from the south. They brought huge caches of wire, shantytowns, gangs of men—and confusion. The telegraph scheme fizzled out—a competitor successfully laid a cable beneath the Atlantic—but the barriers to settlement

Totems at Kispiox challenge the stormy sky.

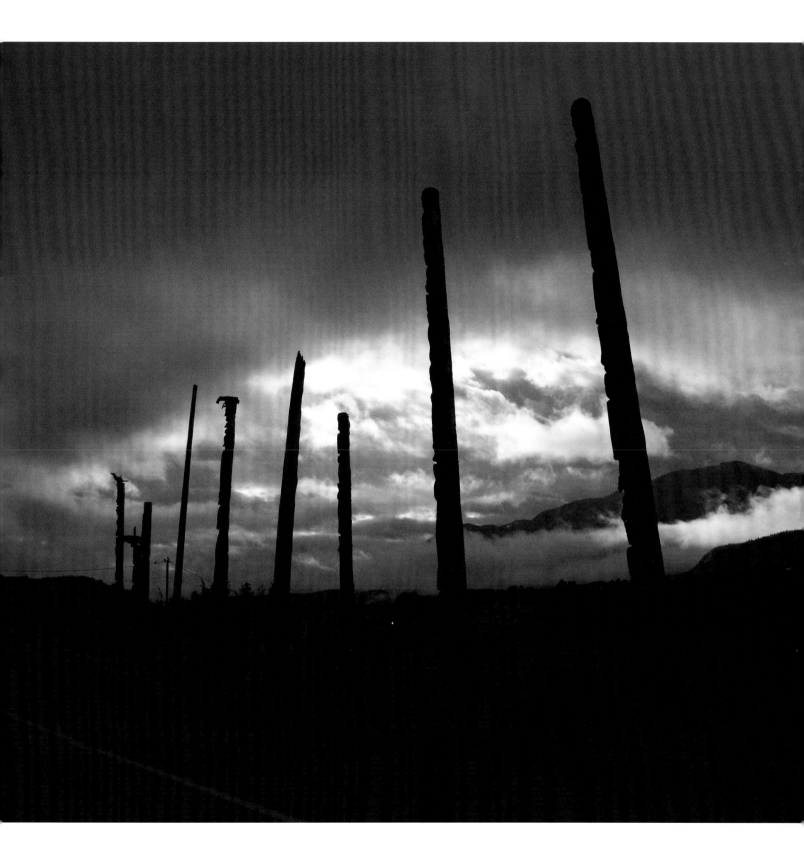

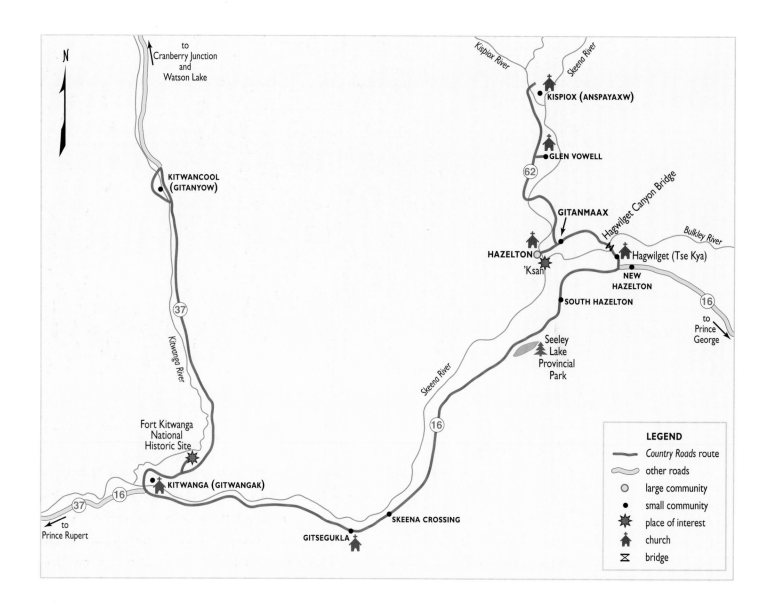

had been broken. Up the river and along linesmen's trails came Europeans in search of their own dreams to clear the land, build their homes, plant their farms. Later the Grand Trunk Pacific Railway (now the Canadian National) and Highway 16 opened the land to mass immigration, to logging and mining and the building of large cities. The Gitxsan way of life, intact for thousands of years, was changed—but fortunately never extinguished.

You'll notice on this journey that most of the places along the route have two names: the newer one, usually anglicized, is most likely to be on the road map, but the original Gitxsan name is often on road signs. It is good to see the old names return, but this can be puzzling for

Fall colours in the canyon of the Bulkley River, from the Hagwilget Bridge.

travellers—and the old names are very hard for English speakers to pronounce. Here, we'll try to give both names.

This journey into the mythic lands of the totem villages begins at Hazelton on Highway 16 where the Bulkley River joins the Skeena. Confusion often arises here, not because of a name change, but because there are three townsites: the original settlement, which was the upriver terminus for sternwheeler service up the Skeena; New Hazelton on the highway; and South Hazelton, a small residential community a few kilometres south. Some histories record that New Hazelton was established when the puritan townspeople of (old) Hazelton, dismayed by the sudden influx and habits of railway construction workers, shut down the town's red-light district. The brothels re-established themselves three miles (five kilometres) outside the town limits, where a new shantytown called Three Mile sprang up, clustered with bars and saloons and other establishments frequented by construction gangs. When the railway steamed in and chose Three Mile as the logical spot for a station, the old bawdy settlement, perhaps seeking respectability, changed its name. New Hazelton was soon to eclipse the riverboat town.

The land at the confluence of the Bulkley and Skeena rivers holds much of interest: The Native settlement of Hagwilget, the pioneer village of old Hazelton and the reconstructed heritage village of 'Ksan. (Translated as "River of Mists," 'Ksan is the Gitxsan name for the Skeena.) From the New Hazelton visitor centre at the intersection of highways 16 and 62, turn north and

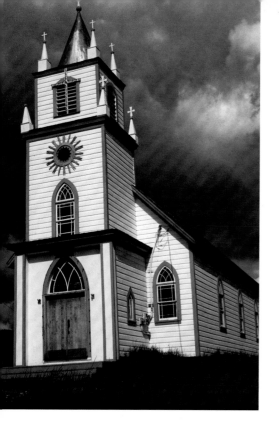

head for the village of Hagwilget, with its eye-catching 1908 Church of St. Mary Magdalene, of architectural interest because of its unique decorated bull's eye window and pinnacled spire. Built on the hillside, the church and the village overlook the spectacular Hagwilget Canyon of the Bulkley River. The highway rumbles across this canyon on a narrow steel bridge, built in 1930. There has been a crossing here for a very long time. Archival photos show earlier bridges as frail, twiggy affairs of cedar poles, lashed together first with roots, then later with dismantled wire from the telegraph fiasco. It's one-way traffic only on this bridge, and there are generous parking spaces on both sides because every visitor wants to walk across. The view from the bridge is heady and exciting, the canyon deep and curvaceous, the tumbling waters a bright, glacial green.

Keep straight on beyond the bridge for five kilometres, then turn left for 'Ksan, the showpiece of the Gitxsan country. While it is a reconstruction, everything about this village is authentic, even the site: there have been villages here for 7,000 years. On a wide meadow between the two rivers are seven communal houses built of red cedar in the traditional style. Painted and furnished as they would have been long ago, lit by flickering firelight and echoing with voices, they summon the spirit of past lives. Take a guided tour of the Fireweed, Eagle and Wolf houses where the treasures are kept and where ceremonies, including the Gitxsan feasts known as *yukw*, or potlatch, are still held. Some of the traditional clothing on display is worn by members of the 'Ksan Performing Arts Group, who put on shows here in July and August. In the Frog workshop house, students apprenticing to become carvers can be seen at work, often outside, and there is a museum, gift shop and small snack bar. In front of the village, totem poles celebrate the four clans of the Gitxsan. But one of the poles sports a most untraditional motif: a White man wearing a top hat and bow tie. This pole was raised to commemorate the village opening in 1970; the man on the top is said to be Premier W.A.C. Bennett. Walk through the meadow to the traditional grave house, and continue down to the river's edge for an outstanding view of the mountain known to the Gitxsan as Stii Kyo Din (Stands Alone) and called Rocher Déboulé ("Mountain of Rolling Stones") by miners who experienced constant rockfall as they climbed the peak. In fall, there will be fishermen here. Both the Bulkley and the Skeena are prime salmon streams.

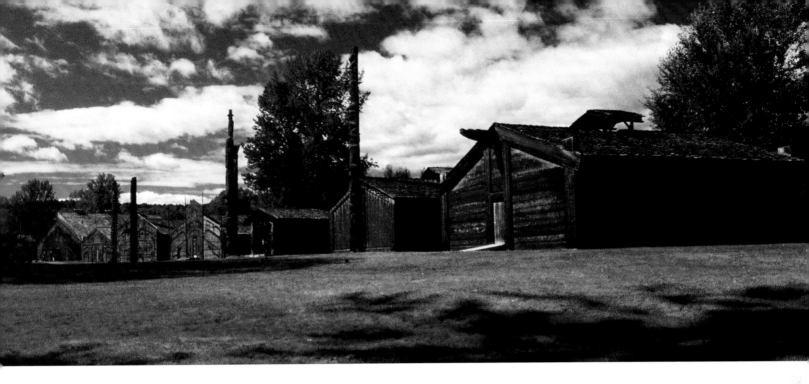

Recreated Gitxsan village of 'Ksan at the confluence of the Skeena and the Bulkley rivers.

Return to Highway 62 and continue north to Hazelton, the old riverboat town started in 1866 and surveyed by Edgar Dewdney in 1871. Hazelton still keeps its pioneer Victorian buildings and attitude very much in evidence. Before the railway came through in 1914, Hazelton was the centre of everything, serviced by a fleet of sturdy steamboats that chugged upriver from Prince Rupert. Today it's a little off the beaten track, bypassed by both the railway and Highway 16, but it has a comfortable, laid-back air—an interesting little town for a walkabout. St. Peter's Anglican Church was built in 1880; the Hazelton Historic Trading Post is now a café, and there is a replica of a paddleboat beside the Skeena River. Wedged between the boat (now a pizza parlour) and the museum is an authentic Frog Clan totem dating from the 1800s. It is called "Nose like Coho," and you can see why.

Drive back along the highway, past 'Ksan, and make a left turn beside a gas station onto the Kispiox Valley Road and head north. Along here is a signboard outlining the history of the area's famous outlaw, Simon Gunanoot. Accused of murder following a roadhouse brawl, he fled into the hills and spent 13 years as a fugitive living off the land. The local police knew he was out there somewhere, but they couldn't catch him. Finally he surrendered, stood trial in New Westminster and was acquitted. But the story of his amazing wilderness survival has made him a legend.

Five kilometres along the Kispiox Road, a turning leads to Glen Vowell, a relatively new village (no totem poles), where the Salvation Army built an elaborate citadel in 1900. And a little farther along is a wonderfully neat and productive market garden, run by the Farleigh family. Across the Kispiox River bridge, a right turn brings you to the village of Anspayaxw, "the

hiding place." On most maps it's called Kispiox, a name given to the community by one of the first Indian agents: it means "loud talkers." Apparently, the agent thought the people here most argumentative. Today, without any argument at all, the village has opted to change its name back again to Anspayaxw.

The community is large, with almost 1,000 people, and there are about 16 hereditary poles still standing here. These tall totems, moved from various village locations, are set up for display near the riverbank. They are magnificent symbols of a society's history, pride and cultural mores, providing glimpses into an ancient world of myth and legend. The poles belong to the different village clans and were raised for several reasons: to honour the dead, proclaim ownership, record encounters with the supernatural and commemorate events in Gitxsan history. If you are interested in learning something about the totems, a local guide would be most helpful. Guides offer hiking, fly-fishing and river-float trips in addition to cultural tours. Also ask to visit The Hiding Place, master carver Walter Harris's studio and gift shop, and take a look at the 1949 Pierce Memorial Church on one of the side streets. Almost drowned in summer by a tangle of fireweed, it has an interesting three-tiered tower decorated with pinnacles. (To hire a guide, ask at the Gitxsan Cultural/Information Centre on your way into town, or email info@kispioxadventures.com.)

Kispiox (or Anspayaxw) also holds the final strands of a piece of non-Native history: it's the site of Fort Stager, where the ill-fated Collins Overland Telegraph line came to an abrupt stop. (The fort was built as an administrative and supply depot, not for defence.) The line had been strung 800 kilometres north, from New Westminster to Quesnel, then west to Hazelton and north again, heading for the Bering Strait. It was already 40 kilometres up the Kispiox River before word reached Fort Stager in August 1866 that the race was lost. A cable had been successfully laid across the Atlantic; there was no longer a need for an America–Russia connection. Operations were suspended, though the telegraph office at Fort Stager continued to operate for the next three years before closing down for good.

There are a few places farther north along the road, including a fishing camp (the Kispiox River is famous for steelhead), but turn around here, head back to Highway 16 and drive west. About 10 kilometres along is Seeley Lake Provincial Park, a swimming and fishing hole with a pleasant campsite. The park is well worth a stop, if only to ponder its Native history, which centres on a legend that appears to have its roots in modern science. A long, long time ago, out of this lake roared supernatural Medeek, an enormous grizzly bear who ripped up mountains and villages in search of the people who had insulted the trout spirits by using their bones as ornaments. In the 1980s geologists found traces in the lake of a 3,000-year-old "great ecological upheaval," a rock slide that buried a village and backed up Chicago Creek into the lake, a disaster

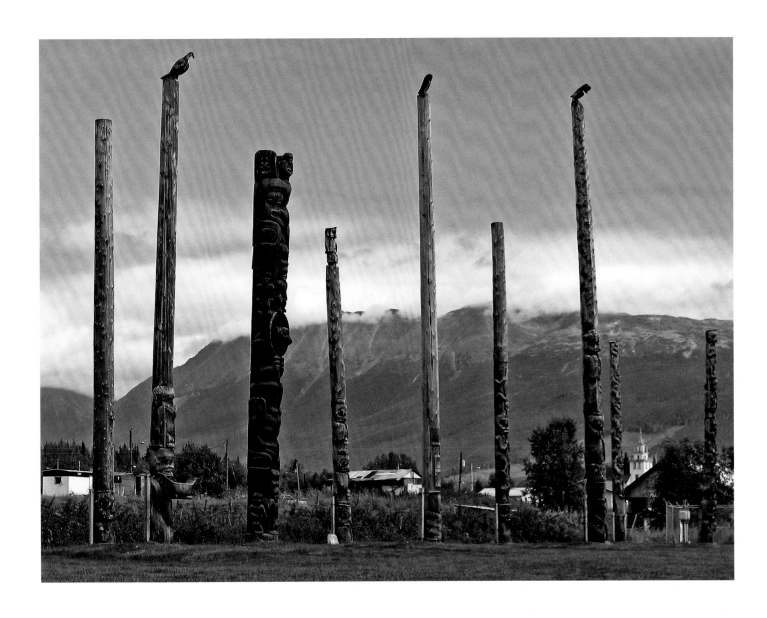

The Kispiox totems in summer.

that apparently lived long in tribal memory. You won't see Medeek here, but there are plenty of birds in the nearby marsh, and if you train your binoculars onto the slopes of the mountain above, you might see a few old mine workings.

There's another place nearby with a similar legend. On the opposite side of the Skeena is the site of Txemlax'amid, a sort of Aboriginal Garden of Eden where all the people of the area once lived in peace. Children tormenting a wild baby goat incurred the wrath of the mountain goat spirit, who summoned a great landslide as punishment. All the people perished except one: the person who saved the baby goat survived to tell the tale, a tale that lives on in local myths. Perhaps the two disasters are simply different versions of the same event.

The Native village of Gitsegukla, six kilometres farther west, was cut in half by the highway. It has a venerable triple-towered church (built in 1930), a clutch of old totem poles and a big new school, replete with paintings of Grouse, Frog, Wolf, Owl and Killer Whale — all the clans of the Gitsegukla. There is even a carving of Medeek. The village holds a pride of place in Gitxsan history. In 1872 a mining prospector's fire destroyed village communal houses, poles and canoes. The people of Gitsegukla blockaded the river, bringing trade and commerce to a halt, until the B.C. government agreed on compensation.

Sixteen kilometres west of Gitsegukla, the Stewart–Cassiar Highway, finished in 1972, shoots north on its 700-kilometre journey to the Yukon. This road, Highway 37, follows the route of the original Kitwankul Grease Trail that linked the Gitxsan villages with the eulachon fisheries on the Nass River. The eulachon, small and like a smelt, was much valued for its oil, which did not turn rancid like other fish oils and could therefore be stored and traded. It was known as the candlefish, because a dried eulachon would burn with a bright light.

The village of Gitwangak (Kitwanga) lies on the Grease Trail just north of Highway 16 across the Skeena River. The name means "People of the Place of Rabbits," though the three village clans are Eagle, Wolf and Frog, all finely represented on the village totem poles that stand beside the river. Spend some time here to admire the workmanship and the lovely worn patina of these ancient monuments. Before you reach the totems, stop beside historic St. Paul's Church, with its tall steeple and Gothic stained-glass windows. Some of these, imported from England, are 400 years old. The church itself dates from 1893. The adjacent belltower, with its extraordinary elaborate wooden embroidery patterns, was constructed in 1979, when the church was restored.

Follow the village road through town, reconnect with Highway 37 and continue north through the Kitwanga River valley. Watch for a road that leads west, signposted to the National Historic Site of Fort Kitwanga (about seven kilometres from Highway 16). You might very easily miss the place because there is nothing at the roadside parking lot except for a few interpretive signs. But the view down across the valley soon shows the "fort," known locally as Battle Hill, a rounded hump some 13 metres high that was the site of a Gitxsan ta'awdzep, or "fortress." The top of this steep hill was once protected by a palisade and ringed by a great stack of huge logs that could be rolled down to crush invaders. Inside were communal houses, with food pits and trapdoors that led to secret escape routes under the palisade. Of these, nothing remains today.

According to Gitxsan legend, this hill fort belonged to the great warrior 'Nekt, one of the tribal heroes. The son of a Haida chief and a Kispiox woman, 'Nekt had been carried off to Haida Gwaii during a raid. His mother killed the chief, cut off his head and escaped with her infant son home across the ocean in a canoe, an event commemorated on one of the totem poles in Gitwangak.

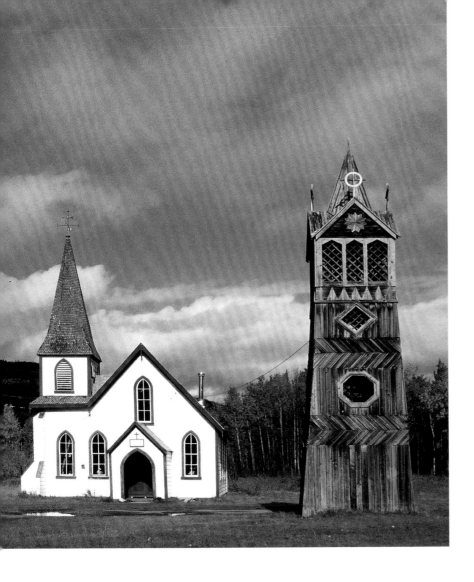

St. Paul's Church (1895) and its elaborate bell tower in the village of Kitwanga.

You can look for it on your return journey. According to the old story, when the baby cried, his mother cut out the chief's tongue and gave it to 'Nekt as a soother.

'Nekt became a fierce warrior who protected himself with the skin of a grizzly bear lined with pitch and sheets of slate. In this armour and with his magic war club, he was believed to be invincible. From the hilltop fortress he led many successful raids to coastal settlements, where he was mistaken for a magic spirit bear. But in his last great battle, fought here in the early 1800s, the fortress was taken and burned and 'Nekt himself was killed, his armour pierced by a bullet, reputedly from the first musket ever fired along the Skeena.

Is all this only a tall story? Archaeologists investigated this site in 1979, and while they have no proof that 'Nekt ever existed, they did find evidence of the palisade, five communal houses and a large number of pits, some of which could have been linked to underground escape routes. Tree ring and charcoal dating established that the hilltop settlement had been in use for at least 100 years and that the site burned in the 1830s when fur-trading posts were established in the area and the first guns arrived.

But why was the fort necessary? Why all this warfare? Anthropologists explain that the influx of European trade goods as early as 1700 from Russia, via the Bering Strait, changed the traditional politics of the northern people and made control of trade routes much more lucrative. The only commodity allowed to travel free on the trails between the Nass and the Skeena was eulachon grease. Everything else, from native copper, obsidian and abalone shells to iron pots and blankets, was subject to tariff. And if you owned a fort or a bridge along the trading route, these tariffs could make you rich.

Feast your eyes on the view east from the parking lot to the historic fortress by the Kitwanga River. The hill is a natural formation, probably of glacial origin. In summer green, it glows like

an emerald; in fall like a topaz as the trees and grasses flaunt their colours. Steps lead down from the highway to a marked trail leading around the hill and up to the summit. Nothing at all remains of the fortifications, but keep the story in your head and it will all come to life. The Parks Canada signs, in English, French and Gitxsanmx, are informative.

The side road to the fort continues north to rejoin Highway 37. About 10 kilometres farther, across the Kitwanga River bridge, is the village that was renamed Kitwancool, "People of a Small Village," after disease and warfare had reduced its numbers. Today it has reverted to its original name of Gitanyow, or "Awesome Warrior People." What is awesome about this village, the

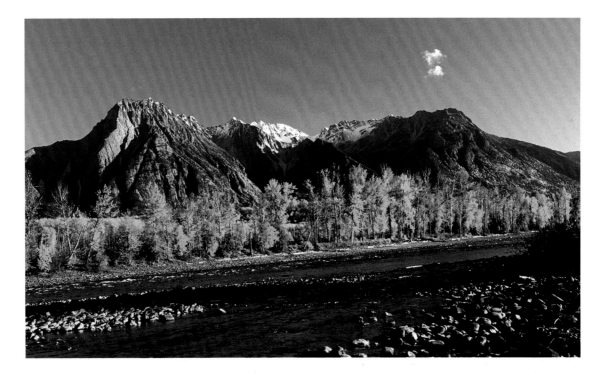

Skeena River and Rocher Déboulé Mountain at 'Ksan.

only Gitxsan settlement not on the Skeena River, are its totem poles. There are 22 major poles, neatly relocated in a double semicircle along the edge of a bushy ravine where ancient grave houses lie tangled in fireweed and thistle. Included here is a faithful replica of the 140-year-old "Hole in the Ice" pole, perforated with an oval opening, one of several that are immortalized in the paintings of Emily Carr, who travelled to the Skeena by wagon in 1928 to capture what she believed was a vanishing art form. Here, as one can see, totem art is strong and flourishing. The poles are splendid. It will take some time just to look at them all. Behind the totems is a carving shed, where old poles are repaired and new ones carved. There is also a small museum and gift shop.

North, Highway 37 continues to the Yukon, and at Cranberry Junction, about 50 kilometres north of Gitanyow, a back road leads west up the Cranberry River and over a low divide to New Aiyansh in the valley of the Nass River. This unpaved route provides an interesting (if rough) link between this country road and the one described in Chapter 12. Keep this in mind when you make your plans. But to call it a day, return south down to Highway 16, check in at Gitwangak again to see the 'Nekt story pole (canoe, baby, mother and, yes, even the tongue) and continue east or west, depending on your overnight destination. ❖

CIRCLE OF SILVER

Kootenay Lake is huge, a long sinuous body of deep water that stretches north more than 100 kilometres from the U.S.–Canada border near Creston. It fills the divide between the Purcell Mountains on the east and the Selkirks on the west (and provides a convenient line for the time-zone boundary between Mountain and Pacific Time). The Kootenay River flows into the lake from the south and out of it, along a short western arm, into the Columbia River. Kootenay Lake's sprawling north arm receives little water from its namesake river, but instead is fed by the Lardeau and Duncan rivers and by many lusty mountain creeks. It is along this stretch of the lake that one finds Ainsworth Hot Springs, the earliest of all the mining towns in the area, and a good starting point for a country drive through the historic silver towns and hot springs of the Slocan.

Founded in 1882 beside bubbling hot springs and mostly destroyed eight years later by fire, Ainsworth has little to show of its historic vintage except for the balconied Silver Ledge Hotel and the adjacent J.B. Fletcher general store, both preserved as museums, and the less-well-known historic Mermaid Inn, built in 1891 as the Welcome Inn and still going strong (though with many changes) after 116 years. You can find the little Mermaid tucked away on the hillside behind the new hot springs resort.

Believed to have medicinal properties, the lakeside hot springs were well known to Natives in the area and, later, prospectors took hot baths and washed their clothes here before heading off into the mountains. One miner, drilling through rock above the lake, broke through into the underground course of the springs. There is no report of him being drowned by the sudden gush of hot water, but it must have been a close call. Years later, when the springs were developed, the old horseshoe-shaped mining tunnel was preserved as part of the hot springs experience,

The north arm of Kootenay Lake, serene and blue.

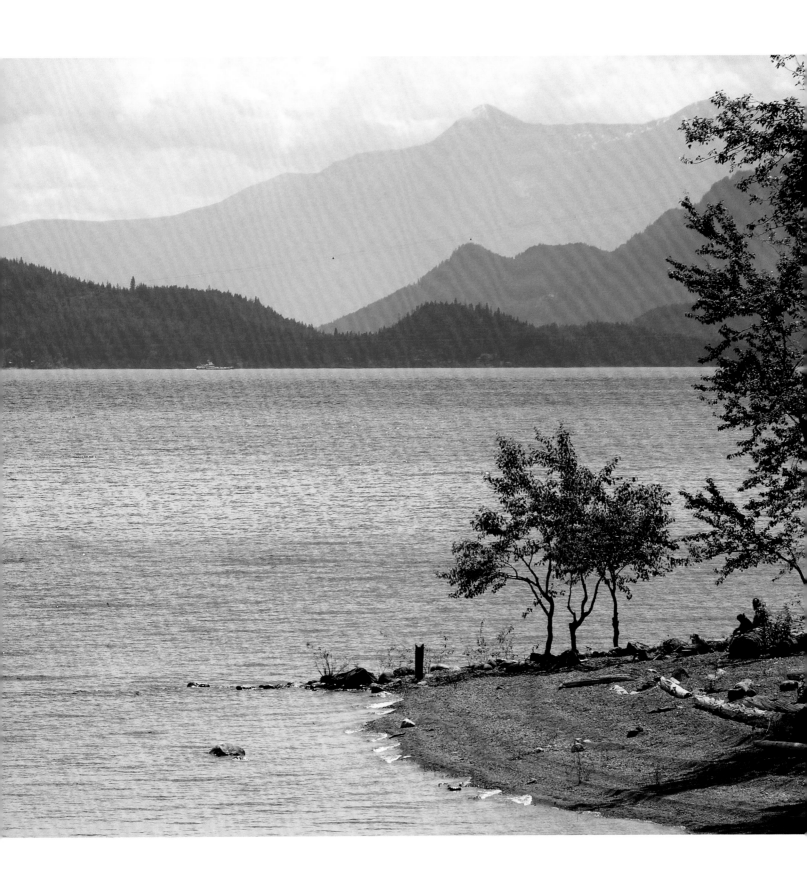

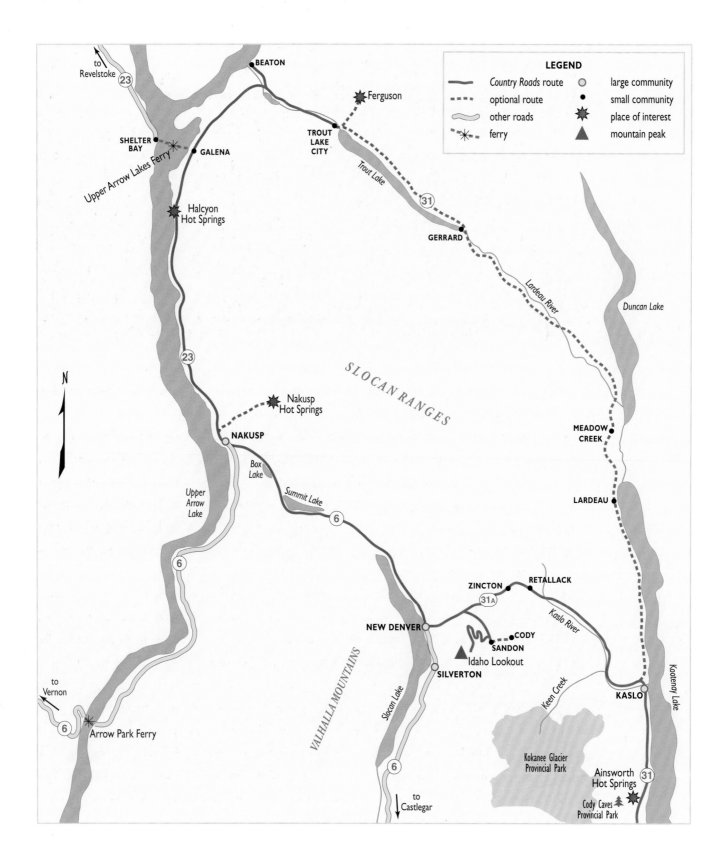

LEGEND

- —— *Country Roads* route
- - - - optional route
- ～～ other roads
- ✳- ✳ ferry
- ○ large community
- ● small community
- ✳ place of interest
- ▲ mountain peak

to Revelstoke

BEATON

Ferguson

SHELTER BAY

GALENA

TROUT LAKE CITY

Upper Arrow Lakes Ferry

Trout Lake

Halcyon Hot Springs

GERRARD

Lardeau River

Duncan Lake

SLOCAN RANGES

N

Nakusp Hot Springs

NAKUSP

Box Lake

MEADOW CREEK

Upper Arrow Lake

Summit Lake

LARDEAU

to Vernon

ZINCTON

RETALLACK

NEW DENVER

CODY

SANDON

Idaho Lookout

Kaslo River

SILVERTON

Slocan Lake

VALHALLA MOUNTAINS

Keen Creek

KASLO

Kootenay Lake

Arrow Park Ferry

to Castlegar

Kokanee Glacier Provincial Park

Ainsworth Hot Springs

Cody Caves Provincial Park

66

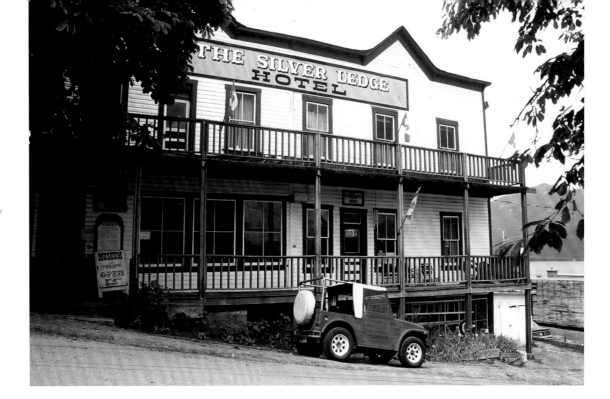

Silver Ledge Hotel, one of the old-timers in Ainsworth, near the hot springs.

providing a natural waist-deep soak under a dripping rock roof. It's a unique and authentic historical feature most appropriate to the area's mining past.

Water for the Ainsworth springs originates high above the lake as a glacier-fed stream in an extensive labyrinth of limestone caverns known as Cody Caves. From here, it disappears deep underground where it is heated, probably by contact with an intrusive mass of molten magma, and emerges, steamy and fully charged with minerals, back at the lakeshore. Cody Caves are contained within Cody Caves Provincial Park, reached by 12 kilometres of rough uphill driving. Fragile and potentially hazardous, they can be explored only on a guided tour. Ask at the Hot Springs lodge for details.

Kaslo lies up the lake about 20 kilometres from Ainsworth. End of steel for the Kaslo & Slocan narrow-gauge railway and home port for the turn-of-the-century fleet of paddlewheelers on Kootenay Lake, this little village was for more than 30 years the thriving supply centre for the Slocan silver mines. The mountain headwaters of Kaslo Creek (now known as Kaslo River) were first prospected in 1891, and ore samples proved extraordinarily rich in galena, a silver/lead/zinc amalgam. A year later, the mining camp on the lakeshore was substantial enough to have its own post office, called Kaslo after the creek. The settlement grew fast, soon reaching a population of 3,000. It was optimistically incorporated as a city and its streets were packed with all the accoutrements of urban life, including, of course, saloons and dancing girls. Ore was packed down to its wharf, at first by mule train, later by rail, and miners trekked down the mountains on payday to buy supplies and whoop it up.

Kaslo was a determined little city, surviving the great fire of 1894, a hurricane, lake floods and creek washouts, quickly rebuilding after each disaster. But when the price of silver plummeted, the mines closed, the railways abandoned their tracks, and Kaslo gradually shrank in both size and importance. In 1957, reduced to village status and with only 700 residents, it received what could have been a death blow: the last of the lake boats made its final commercial voyage.

Once again Kaslo survived, because by this time it was no longer dependent on water or rail transportation. Connected by road to Nelson and the rest of the Kootenays, its idyllic lakeside setting and the charm of its turn-of-the-century architecture were soon discovered. Kaslo outgrew its awkward hippie adolescence to become a popular tourist destination. Its main street preserves the look and feel of the Victorian era, and there are more than 30 heritage buildings (a church, the city hall, the Langham Hotel and many old homes) tucked away on the tree-shaded streets. May Day continues to be celebrated here as it has been since 1893, complete with traditional English maypole dancing. And down by the water's edge, the last of the sternwheelers has come to rest. The SS *Moyie*, built in 1893, was taken out of the water in 1957, the last operating sternwheeler in B.C. and one of only five remaining in Canada. Today, beautifully restored (though not operative), it's a museum, furnished in period style, right down to ladies' nightgowns laid out in the cabins and authentic memorabilia on the cargo deck — lots of old steamer trunks and even a Model T.

Our route from Kaslo swings away from the lake and follows along miners' trails, a wagon road and the K&S Railway up roaring Kaslo Creek to the heart of the Slocan mining country. This is officially Highway 31A, which pre-empted the abandoned track of the railway and runs past the sites of several mining camps and railway stations — all long gone. Three kilometres west of Kaslo, drive up Blue Ridge Road to Mount Buchanan, B.C's. first forestry lookout tower, built in 1920. From the subalpine meadows on the ridgetop at nearly 2,000 metres high, the view is far-reaching over Kaslo and Kootenay Lake to the distant snows of the Purcell Range.

As to mining relics, not even a ghost of a ghost remains, until one comes to Keen Creek (an access route into Kokanee Glacier Provincial Park.) The flat meadow where this creek flows into the Kaslo was once the site of a thriving transshipment settlement known as Nashton, or Zwicky. Today, only one of its log cabins remains, half-drowned in Queen Anne's lace and blackberries. West, the valley narrows, the road becomes steeper, and the chatter of Kaslo Creek becomes a roar nearby. Several tributary streams have thundering waterfalls spilling beside the road.

Through a narrow canyon of black slate, the road passes a group of derelict red-painted, tin-roofed buildings, the former historic townsite of Whitewater (now Retallack), named after a turbulent creek. A flourishing community in 1902, the town was destroyed when a forest fire swept up the valley from New Denver. The townspeople could see the flames approaching, and

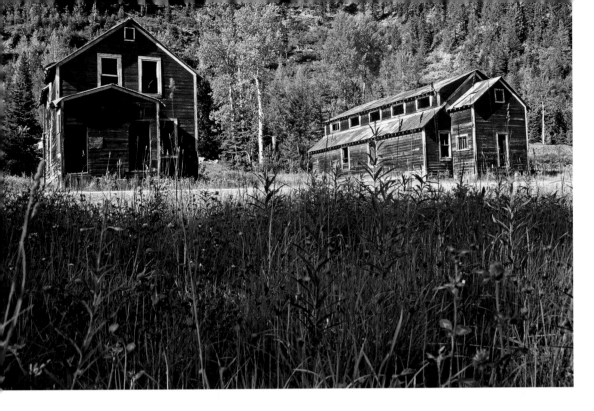

36 of them took refuge in nearby mine tunnels. The fire roared through, burning all the buildings, but the people were saved. Whitewater rebuilt on its ashes and changed its name to Retallack after a local mine developer. The buildings beside the road, however, date from a later era—the days of the Blue Star Mine, which operated here until 1967. Its workers took over bunkhouses built for the Kootenay Belle mine in the 1940s. A small private residence on the meadow flats is said to be the old town schoolhouse.

The highway reaches a pass at 1,000 metres where it runs between two small mountain tarns, Fish and Bear lakes, both kept well stocked with rainbow trout. A stop at the picnic area here will give you a chance to look around, mostly up, at the tremendously steep mountain ridges and peaks of the mining terrain, the heart of the Slocan silver deposits. Over the divide, the road picks up Seaton Creek and follows it beside marshy meadows, made even marshier by beavers. There's a natural–history explanatory sign near an old beaver pond here, and the area is a good spot in midsummer for huckleberries, if you remember to pack your rubber boots. Here was once the town of Zincton, but all the houses, and the ruins of a concentrator, were demolished some years ago. West, down the steep and winding road, you'll find a good view of the snow-capped Valhalla Mountains.

At the top of the steep hill, Seaton Creek meets Kane Creek, and both join Carpenter Creek for its hurtling journey west into Slocan Lake. Here a settlement, appropriately known as Three Forks, lived for a riotous interlude as an important centre for ore shipments. It is noteworthy today mainly as the place where the Sandon Road turns southeast up Carpenter Creek.

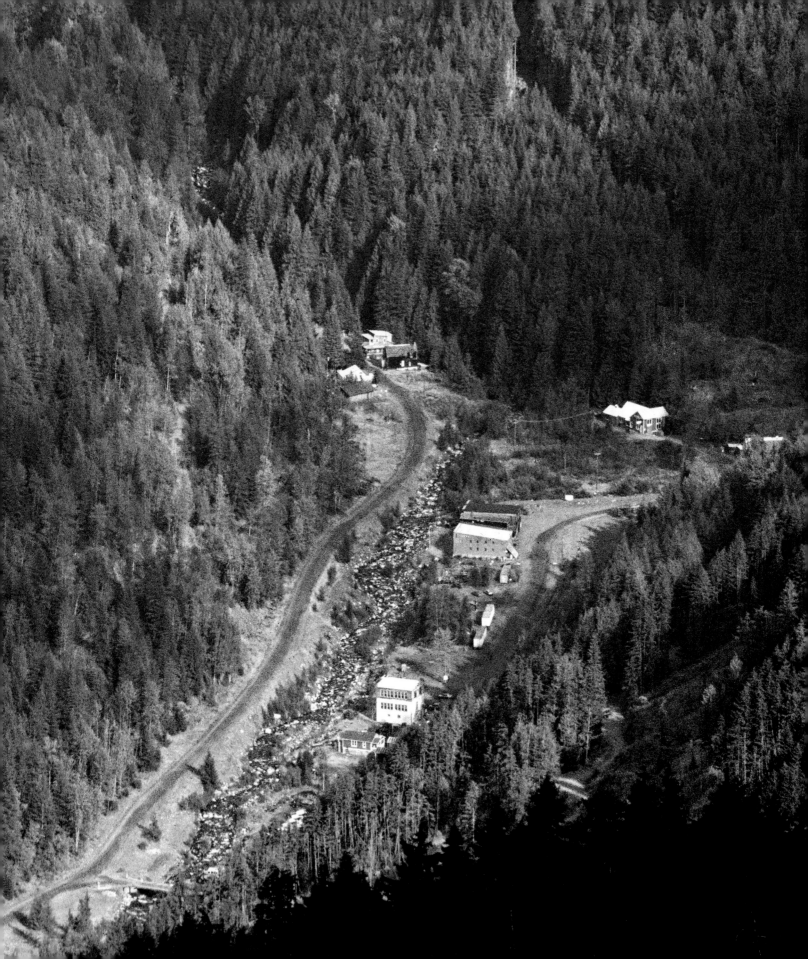

For some reason, the ghost town of Sandon, five kilometres away, has inspired a mythic loyalty among its visitors, perhaps because of its exuberant past and the traumas it has endured. There is very little left of this once-grand city and yet there is something about the ramshackle place that keeps people interested. Its location is certainly part of the appeal. Squeezed into a narrow valley at the intersection of two rushing creeks in the dead centre of the richest silver mining country, the town is utterly dwarfed by mountains and kept lively by a roaring stream. Even in summer, it rests in shadow for much of the day. Sandon was the quintessential mining boom town of the 1890s, planned right from the start as a city, with hydroelectric power and railway connections on two different lines. In addition to a city hall, opera house, two churches, a hospital and a brewery, it also had a plethora of smart hotels, saloons and bawdy houses—everything mining moguls could possibly need. It was for a while the largest and smartest city north of San Francisco. Historic photographs show it in detail: a rich city destined for greatness.

The steep terrain beside the Kaslo–New Denver Road encourages foaming creeks where thimbleberries flourish.

The galena mines were high in the mountains above Sandon and the valley sides were so steep that, before several tramways were built, ore was slid down the mountain in rawhide bags. Miners tramped long distances to work, braving trails that in winter were smothered under colossal and sometimes deadly avalanching snows. The pay was good, and city life was sweet, but over the years, Sandon suffered multiple disasters: two all-consuming fires, avalanches and, finally, floods. By 1955, after several sessions of boom and bust as the price of silver fluctuated, Sandon had become pretty much a ghost town, the mines closed, the fine old buildings standing derelict. That year Carpenter Creek, in roaring spring flood, literally sluiced the city away.

So what is left? Certainly the aftermath of the great 1955 washout is evident: there are piles of smashed wood everywhere, and only two or three of the multi-storeyed city buildings survive along the main street that had been built right over the creek. One of these is the brick city hall (1900), which now houses a small store and general info centre; another is the Mercantile Building, now the official Sandon Museum. Elsewhere there are a few inhabited cottages (privately owned),

Bird's-eye view of Sandon in the valley of Carpenter Creek.

the Tin Cup Café (open sporadically) and, most interesting of all, the Silversmith hydroelectric power station, built in 1897, now restored and fully operational. Privately owned and open to the public in summer, it now feeds power into the provincial grid.

Perhaps it is best to view the forlorn remains of Sandon at a distance. From a bend on the high road that climbs up Idaho Mountain to the west, you can look down on the narrow, forested cleft of Carpenter Creek and the toy-town buildings in the clearing far, far below. If you half-close your eyes, you can picture the city as it used to be, the uproarious centre of the Slocan universe.

Keep driving along this mountain road to a ridgetop parking lot (about 11 kilometres from Sandon). From here there's a fine view over the Slocan Valley, framed in a never-ending sequence of misty blue mountains. If you are prepared to hike higher along the ridge to the Idaho Lookout at 2,280 metres, the view is even better. In July and early August, you can enjoy the flowering alpine meadows along the way. Check road conditions in Sandon before you start: snow comes early and leaves late, and mud often makes the steep, narrow road impassable.

There are several other hikes around Sandon, two of them on old railway rights-of-way. From Three Forks junction, you can walk the Kaslo & Slocan narrow-gauge line for nearly six kilometres right into Sandon, past several of the mine sites. This trail is well marked with interpretive signs, a project of the Valhalla Wilderness Society. Also from the junction, the Galena Trail follows the roadbed of a different railway, the Nakusp & Slocan, downhill to New Denver, a lengthier trip involving creek crossings by cable car. And a stroll up the road past Sandon's Tin Cup Café leads three kilometres to the site of Cody, a ghost town that once housed a huge ore concentrator. Until a few years ago, a few mine buildings and part of a long tramway still stood, along with other relics of the town. Today, one small cabin is all that remains, but if you look carefully, the ghost of the town's name is still there, in faded blue paint. The road to Cody can be driven, if conditions are right.

Back on Highway 31A, the road plunges rapidly through forests and meadows to meet Highway 6 beside Slocan Lake, where another old mining town, optimistically called New Denver, awaits. In its quiet leafy streets, it is hard to find many traces of the rip-roaring town where miners once converged to celebrate (or commiserate) in the saloons. The grand old Newmarket Hotel, a huge building with many gables and wraparound balconies—for more than 80 years the historic focus of the town—met its death by fire in 1974. The main street has a few false-front buildings and a small church, in use since 1892, but its highlight is an elaborate corner establishment that once housed the Bank of Montreal. It is now a museum dedicated to the mines of the Silvery Slocan and a helpful info centre. For history of a later, unhappy time, the Nikkei Internment Memorial Centre has been built on the site of one of the camps that housed Japanese Canadians exiled from the coast in 1942.

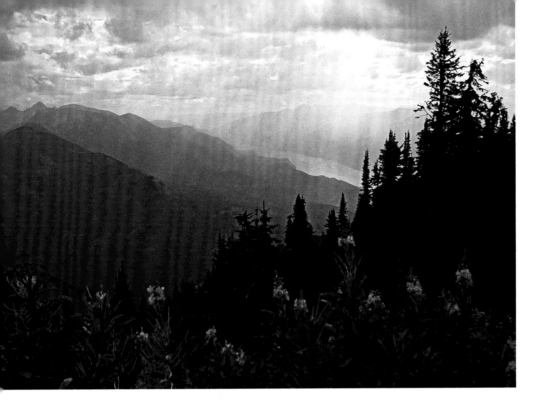

*From Idaho Lookout
above Sandon, the view
encompasses the silver
gleam of Slocan Lake.*

Slocan Lake fills a 40-kilometre north–south valley under the hanging glaciers of the lofty Valhalla range. In the 1890s, the glory days of Slocan silver, there was a string of settlements along the lake's eastern shore, and three of them survive today: New Denver, Slocan City at the lake's south end (today a logging community), and Silverton, a few kilometres south down Highway 6. With a name like Silverton, you would expect the town to be proud of its mining history, and it is: there is a fine old hotel, a good museum and several heritage buildings along the main street.

Slocan Lake is lovely, an appropriately silver gleam between rugged mountains. Our route from New Denver heads north on Highway 6 to the head of the lake, then over a mountain saddle to Nakusp. Along the lake is Rosebery Provincial Park, whose name preserves the memory of the old port settlement where passengers and ore arriving from the Slocan mining camps by train were transferred to lake steamboats for their onward journeys. From the park, the highway climbs east alongside Bonanza Creek to Summit Lake (almost in the subalpine) then drifts down to Nakusp on Upper Arrow Lake.

At Nakusp, Highway 6 turns south down the valley, crosses the lake by ferry and heads over the Monashee Mountains into the Okanagan Valley. Our route, focussed on hot springs and old mining towns, takes Highway 23 north along the Arrow Lakes. Although the Columbia River flows through the valley, you won't see it, as it lies submerged under the reservoir formed by hydroelectric dams that backed up the river, flooded what was once an agricultural valley and drowned several old communities.

Nakusp was one settlement that did not drown, though it lost much of its historic shoreline to the reservoir. From the village, you can look across the water to high mountain ranges draped with glaciers, an attractive view that the village exploits with flower-lined pedestrian pathways and parks along the shore. Just north of town, a 12-kilometre side road leads to the village-owned hot springs pool built in 1973 to replace earlier developments up the Kuskanax River. The springs are in a provincial park surrounded by an interior wet belt forest of cedar and fir.

Twenty kilometres north of Nakusp, Ione Rest Area with its cascading waterfall must be one of the loveliest in B.C., well worth the stop. Farther along, St. Leon Creek and Halfway River almost converge before spilling into the lake. Both valleys contain hot springs. A huge and elegant hotel known as the Gates of St. Leon was built in 1902 at the mouth of the creek and it soon became a fashionable hot springs spa where people arrived by steamboat to "take the waters," which were led in by pipe from the source of the spring. This historic place lost much of its business when railways and highways replaced steamboat traffic on the lake. But it was in the throes of restoration when it was expropriated in the 1950s and scheduled for submersion under the new reservoir. Before inundation took place, however, a mysterious fire totally destroyed the hotel. The springs are still there, about two kilometres up the creek, but as of 2007 they were closed to the public.

Halfway River's two hot springs have never been developed. If you like roughing it, look for them up the logging road on the south side of the river, about 10 and 20 kilometres from the highway. But there are other hot springs far more accessible about eight kilometres north. Local First Nations people knew these as the Great Medicine Waters, and several tribes came to blows over their control. Settlers called the springs Halcyon, and they were first developed for tourists in the 1880s. The place has a history surprisingly similar to that of St. Leon's. A fancy waterfront resort-cum-health spa was built near the springs, its four-storey hotel sumptuously furnished and decorated with treasures from around the world. Destined for inundation, just like St. Leon's, the opulent building came to a fiery end in 1955, along with its owner, ironically named Colonel Burnham. This story has a happy ending. Halcyon Hot Springs Resort came to life again, rebuilt around a series of pretty scalloped pools perched high above the lake. To some, it's the nicest hot springs in the province.

From Halcyon, it's only a short drive to the Galena-Shelter Bay ferry. The ferry crosses Upper Arrow Lake to Highway 23, which follows the Columbia River north to Revelstoke, but before you join the ferry lineup, there are more old towns to visit. Past the ferry junction, the road (now Highway 31) continues along the northeast arm of Upper Arrow Lake and over low Galena Pass. This is very much a wildlife road: one summer journey rewarded travellers with several sightings of deer, and in one daisy-filled meadow, a bear and two cubs enjoying a

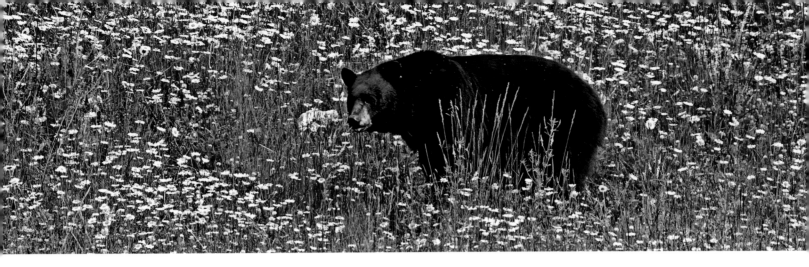

Beside the lonely road to Trout Lake, a black bear in a daisy field.

midday snack. At the start of tiny Armstrong Lake, take a left turn to Beaton, site of a homestead settlement that mushroomed into a town when mines were staked nearby. Like other lakeside settlements, Beaton, by then almost another ghost town, was flooded by rising lake waters; today nothing remains. But the deep, ferny canyons of Beaton Creek and the lonely Arrow Lake meadows, with their eagles and ospreys, are worth the five-kilometre drive.

Return to the highway and head southeast past a few pioneer houses and barns to Trout Lake City, founded in the 1890s at the head of glacially green Trout Lake as a base for mining exploration. It boomed with the expectation of a rail connection south to the towns along Kootenay Lake. The old story repeats itself: the mines ran dry, the railway failed to come and Trout Lake City never did live up to its name. At best, it supported a population of 300, one of whom, an indomitable English widow named Alice Jowitt, kept the town going from her palace, the luxuriously furnished Windsor Hotel, a handsome three-storey building, with gingerbread gables and shady verandas. Guests soon came for the fine English cuisine alone, and while the mining world around her collapsed, Alice stayed on, cooking up a storm, until she sold out in 1945. The hotel, minus most of its fine antique furnishings, has stayed open ever since, a remarkably longlived example of turn-of-the-century optimism and opulence. There are only a few other heritage buildings along the "city" streets, with most lots glaringly empty. Nevertheless, with its thriving general store complete with old-fashioned hand-operated gas pumps, and a growing number of full-time residents, it is definitely not a ghost town.

From Trout Lake, you can return north and take the ferry connection to the Revelstoke road, or continue south, tracing a high and perilous unpaved route above Trout Lake to the old settlement of Gerrard, which gave its name to a species of enormous rainbow trout (they can weigh as much as 14 kilograms). In mid-May, you can watch these giants spawning in the Lardeau River from a viewing platform at the south end of the lake. From Gerrard, the road improves and it's an easy 75-kilometre drive south down the Lardeau valley to the head of the north arm of Kootenay Lake and back to Kaslo. The silver circle is complete. ❖

EDGE OF THE CHILCOTIN

The Chilcotin Country, west of the Fraser River, is huge, sprawling and wild. Highway 20 from Williams Lake to Bella Coola takes travellers through it, but the road provides only an introduction to its many delights. You could spend several weeks exploring the area's immense heart, the crumpled spread of the Interior Plateau and its spectacular interface with some of the highest peaks of the Coast Mountains. But for just a taste of what lies in store, there are a couple of short side trips that individually make great half-day outings from Williams Lake. If you are comfortable driving unpaved and often unsigned back roads, where a four-wheel drive would be helpful, the two routes can be combined into a circle tour. The routes lead first through the lands of the historic Gang Ranch near the Fraser, then to amazing Farwell Canyon on the Chilcotin River.

THE GANG RANCH

This journey begins along the Dog Creek section of the first Cariboo Gold Rush trail (see Chapter 1) where Churn Creek Bridge crosses the Fraser about 80 kilometres southwest of Williams Lake. From a well-marked intersection, take the steep road down to the river, cross the narrow bridge and head up the other side to another junction. South (left), the road leads through the grasslands of the Empire Valley. Take this road for a short stretch if you want to linger by the river where Churn Creek boils its way into the Fraser. The creek was well named: it is always turbulent, and over the years, carrying loads of silt and gravel, it has built up a large, triangular delta, one of the few places where you can easily reach the Fraser's edge, to dabble your toes, walk the

Chilcotin storm.

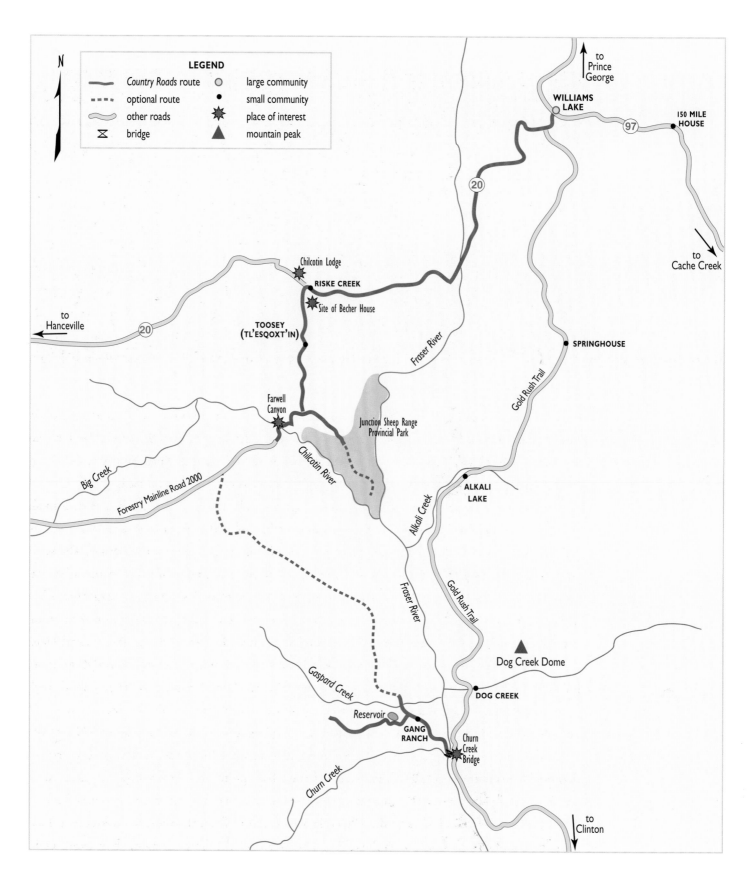

The bright red buildings of the Gang Ranch flaunt the JH brand, a carry-over from gold-rush days.

sandy beach, enjoy the shade of willows and cottonwood and admire the convoluted sand cliffs. This is also a popular rest stop for rafting expeditions on their runs down the river. Much of the sagebrush grasslands west of the Fraser (itself designated a Canadian heritage river) lie within the Churn Creek Protected Area, where travel is restricted to a few ranch roads.

For the Gang Ranch, turn right after the bridge and take the road that ducks across a small creek and climbs up a gully to emerge onto the flat hayfields that perhaps caught your eye as patches of green or gold (depending on the season) from the east side of the Fraser. The road leads through ranch headquarters, beside the barns and the machinery, and a graceful old house. All the roofs are red, giving the place a cheerful appeal. One of B.C.'s oldest and largest ranches, it was so named because it was the first in the west to use a multiple furrow, or gang plow, shipped in from England. It was founded in 1865 by the two Harper brothers, Jerome and Thaddeus, who originally mined for gold at Horsefly (Harper's Camp). The cattle brand, an interlinked JH, dates from this era. The road through the ranch is accessible to the public, though you should drive slowly and stay out of the way of farm machinery and cattle on the move. (If you phone ahead, it might be possible to arrange a guided tour of ranch operations.) Once past the ranch, turn left along Reservoir Road and meander through fields and up the hill to a series of dammed lakes that provide irrigation water. From a high point, the view of tiny red ranch roofs and blue lakes, all swamped in an immense landscape of enfolding hills, is one to remember.

To make the crossing over to the Chilcotin River, return from the reservoir viewpoint, turn left and continue via Forestry Road 2700. Turn right at the first junction, then right again

onto Forestry Mainline Road 2000, which leads east to Farwell Canyon. This is a lonely route through mostly forested land. It is not difficult to lose one's way, and most people would prefer to backtrack to Williams Lake and go to Farwell Canyon by an easier road.

FARWELL CANYON

Highway 20 west from Williams Lake carves through the Chilcotin on its long way to the coast at Bella Coola. It crosses the Fraser River near Doc English Bluff, a huge limestone outcrop laid down in tropical seas some 260 million years ago. The river is a dividing line: once across the river, according to the locals, you have left the lands of the Cariboo behind and entered the wilder Chilcotin. It's a long crawl up to the high plateau of Becher's Prairie, one of the more northerly expanses of dry grassland, noteworthy for its lichen-encrusted log fences and the large number of erratic rocks deposited here by the most recent glacial advance.

Riske Creek is the first stop of interest. The place took its name from a settler, L.W. Riskie — someone just couldn't spell his name right. Here there's a general store and the relic of an old red schoolhouse. Nearby is the site of the once-famous Becher House, in its day the only saloon between 150 Mile House and Hanceville on the Chilcotin Road. Built in 1892, it was for many years a comfortable oasis of European culture, with a conservatory, high ceilings and furniture imported from England. People came from all across the Cariboo to attend its annual three-day horse races, held on the prairie near Horsetrack Lake. The hotel had the first telephone in the Chilcotin and the first automobile (a Cadillac). The original luxurious roadhouse burned in 1915; the second, even more luxurious, kept going until the 1940s, when the highway passed it by. A ghostly derelict by 1981, it was finally demolished. But the era of Chilcotin hospitality continues. Just north of the old roadhouse site, the fine old two-storey Chilcotin Lodge has provided good food and accommodation since the 1940s. You couldn't wish for a better place to stay, if only to achieve the proper relaxed frame of mind for a Chilcotin adventure.

A short distance east of the lodge a road takes off across the fields toward the Chilcotin River, the major artery of the Chilcotin Plateau. The Chilcotin is a pristine, wild river whose waters, draining glaciers in the high Coast Range, are the most incredible shade of icy blue-green, a striking contrast to the muddy brown of the Fraser's. The river alone is spectacular, but at Farwell Canyon the surrounding geology makes this one of B.C.'s most amazing places. From Chilcotin Lodge to the canyon it's only a short drive of 19 kilometres, but you should count on at least half a day for the return trip because the destination is so awe-inspiring that you may well choose to spend some time there.

Farwell Canyon hoodoos.

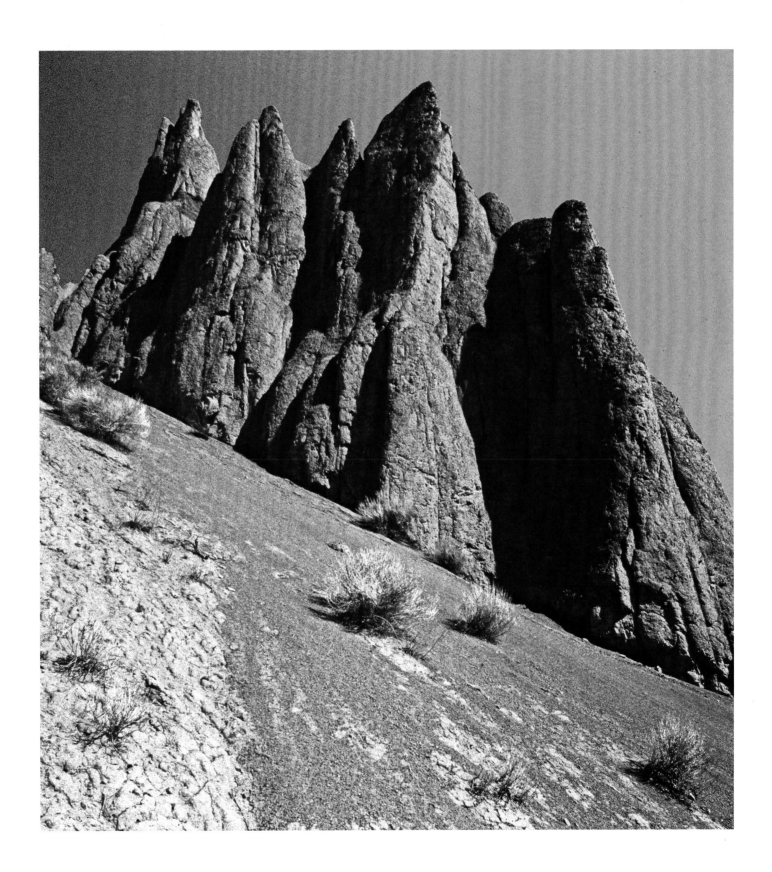

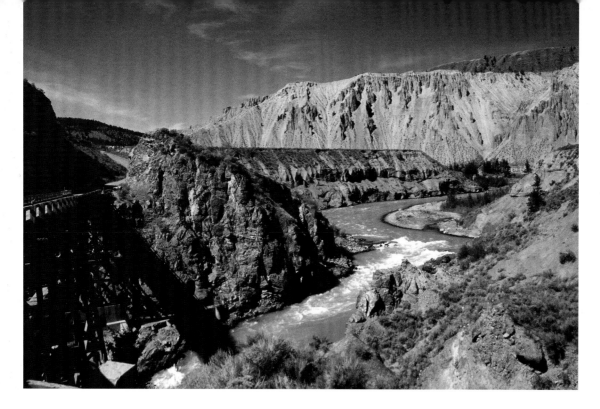

A narrow bridge crosses Farwell Canyon; park here to explore.

From the plateau, past the Native settlement of Toosey (Tl'esqoxt'in), the road slowly drops toward the river. Watch for a Wildlife Viewing sign on your left and a road leading into Junction Sheep Range Provincial Park, wild land set aside in the wedge of hills between the Chilcotin and the Fraser rivers to protect the largest herd of California bighorn sheep in North America. There are no park facilities, just wide open spaces, great views and a chance to see sheep and other wildlife, including coyote and mule deer. Early morning and just before sunset are the best times. There's a rough loop road to drive here, and a connecting trail right out to the junction between the rivers.

The sheep, of course, don't stay in the park. They also forage right around the road as it begins a steep and circuitous descent—a whole series of hairpin bends—down to the bridge in the skinniest part of the canyon. The bridge here is an old one, made of wood and barely wide enough for the loaded logging trucks that sometimes thunder across it. Here the river has carved a sinuous loop through walls of rock and yellow-grey glacial silt. Wind and rain have worked the sediments into spectacular formations: crenellated towers and tapering pinnacles thrust up from talus slopes so steep they could produce instant vertigo. In morning light, their shadows are immense. It's an intriguing place of sand, sagebrush and cactus, softened by the turquoise gleam of the surging river and its greenery.

This beautiful area invites lingering. There are several parking spots, good viewpoints and hiking trails—one to huge "walking" sand dunes and another leading from a meadow viewpoint right down to the river's edge, where there used to be a small ranch. The ranch fields are

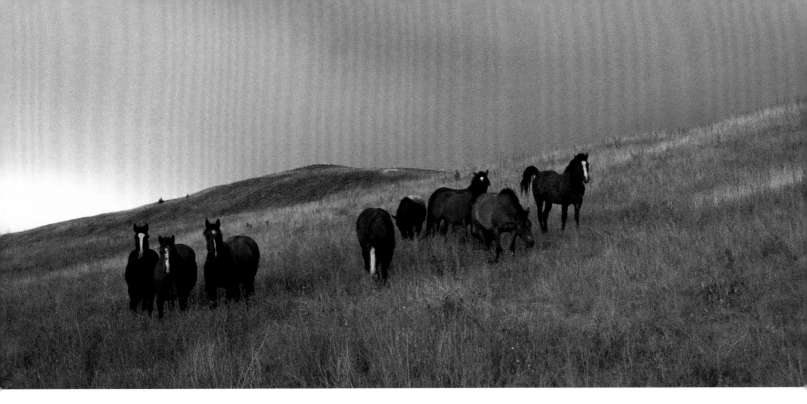

A herd of horses on the Chilcotin grassland on the road to Farwell Canyon.

slowly reverting back to semi-desert. Today, only a few old cabins remain, along with informal campsites in the shade of the willows along the river. Well used by Native fishermen , this is a traditional fishing site, for steelhead in early spring, spring salmon in July and later for sockeye. If you're lucky you might see them dip-net fishing from dizzying perches high above the river. Natives have been living and fishing here for centuries: look for ancient pictographs painted on an overhanging rock just south of the bridge and for depressions of old village pit-houses along the riverside flats.

Stay as long as you like, then take the slow road back again, up the switchbacks and onto the plateau. The forestry road across the bridge leads to the Gang Ranch turnoff and all the way to the community of Big Creek, where a right turn will bring you back across the river to Highway 20 at Hanceville. This loop, a round trip from Riske Creek of about 100 kilometres, most of it through forests, is better done if there are no logging trucks on the road. ❖

HIGH HEDLEY CIRCUIT

Native tribes along the Similkameen River east of Princeton knew this area as Snaza'ist, the "Place of the Striped Rocks." If you look at the cliffs northwest of the town of Hedley, you can see the curiously crumpled strata of multi-coloured outcroppings that prompted the name — and later drew the attention of hard-rock miners. This sleepy river valley has been the land of the Okanagan peoples for many centuries: archaeologists have found sites dating back 7,000 years. The Hedley area was an important centre for trade. An ancient trail ran east to Princeton, where there were bluffs of red ochre, used for paint, and across the valley lay an outcrop of flint, used to make knives and arrowheads. These rock commodities were bartered for goods from as far away as the coast and the prairies. The old Native path from Princeton, later the route of the Dewdney Trail, is now the Old Hedley Road north of the river, where a few faded pictographs can still be found.

In the 1860s, other men tramped along the Similkameen looking for gold. The Dewdney Trail led them east toward known diggings in Rock Creek and at Fisherville in the Kootenays. But some of them stopped to pan for gold in the river near Hedley, and others scrambled up to the Striped Rocks and the red iron stains on the mountain high above 20 Mile Creek. A few claims were staked, but nothing substantial was found until some 30 years later. Then it was bonanza! Here was gold in abundance, some of the richest deposits of lode gold in Canada, plus silver, copper and other minerals. Soon just about every inch of the mountains above Hedley was staked. An aerial tramway was built, along with a stamp mill and a reduction plant. A railway raced in. And the rough mining camp in the valley below was transformed into a town of 1,000, complete with five hotels, two churches, stores, a bank, a school, a newspaper, a hospital and even a golf course. The Welby Stage provided regular service to

The Corkscrew Road's infamous hairpin bends lead up from the valley to the mine.

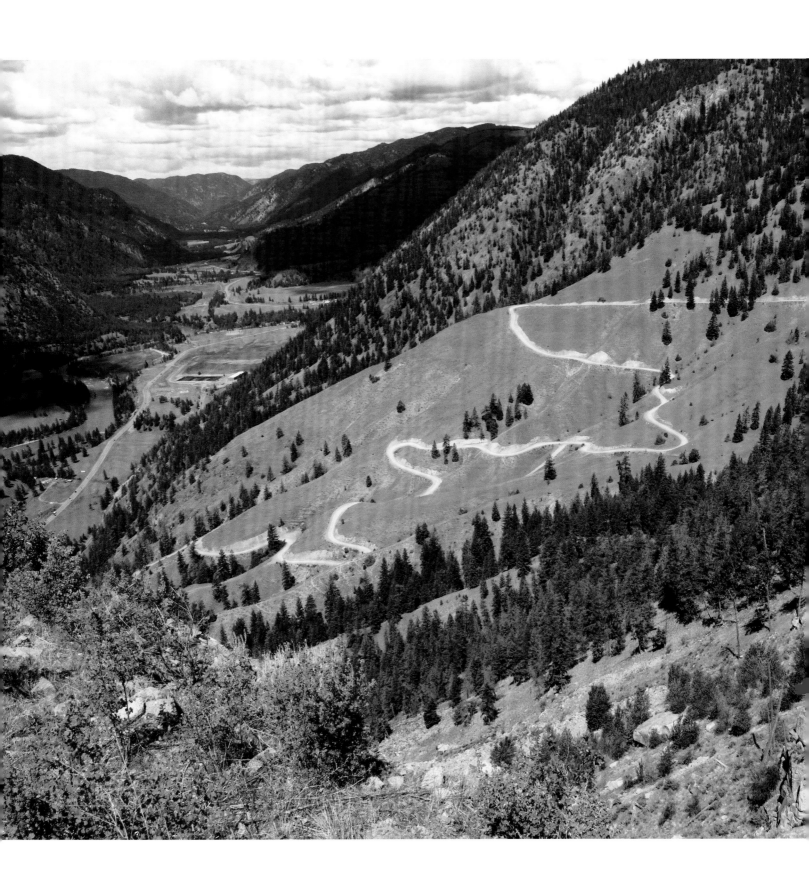

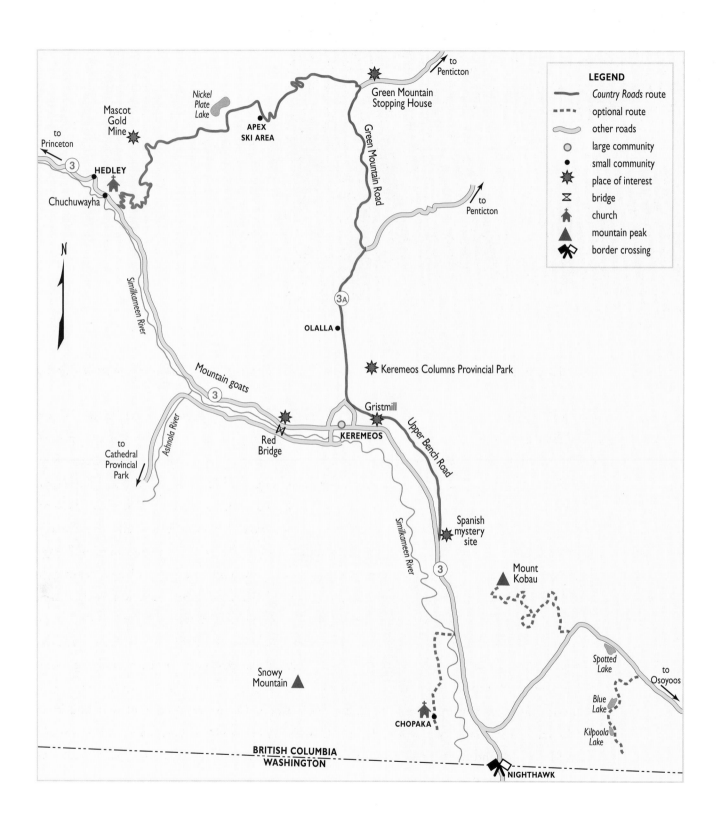

LEGEND

Country Roads route

optional route

other roads

large community

small community

place of interest

bridge

church

mountain peak

border crossing

to Princeton

Mascot Gold Mine

Nickel Plate Lake

APEX SKI AREA

Green Mountain Stopping House

to Penticton

HEDLEY

Chuchuwayha

3

Green Mountain Road

to Penticton

Similkameen River

3A

OLALLA

Keremeos Columns Provincial Park

Mountain goats

3

Gristmill

Ashnola River

Red Bridge

KEREMEOS

Upper Bench Road

to Cathedral Provincial Park

Spanish mystery site

Mount Kobau

Similkameen River

3

Snowy Mountain

Spotted Lake

to Osoyoos

Blue Lake

CHOPAKA

Kilpoola Lake

BRITISH COLUMBIA
WASHINGTON

NIGHTHAWK

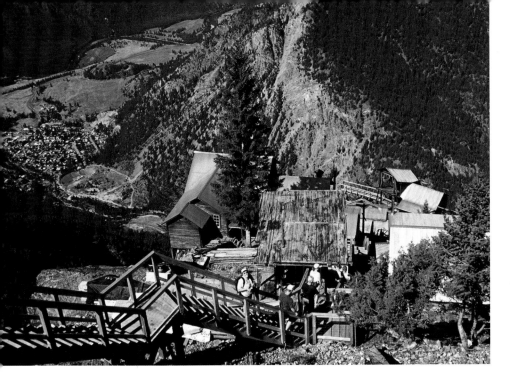

Penticton (12 hours) and, twice a month, carried a cargo of gold bricks from the mill—under heavily armed escort.

Hedley has ridden the roller coaster from boom to bust and back several times in the past century, but recently it has found gold again, in tourist development. During the mining frenzy of the early 1900s, when the whole mountain was being staked, a tiny wedge of land was somehow overlooked. Sharp eyes studying claim maps in the mining recorder's office noticed it, and soon a claim was staked for the Mascot Fraction, perched high on a nearly vertical cliff. This was to become the richest mine of all, yielding 250,000 ounces of gold, 54,000 ounces of silver and nearly 2,000 pounds of copper. In 1949, when the ore was finally exhausted, the mine and its buildings were abandoned. They could be seen from far below, perched like tiny toys beside a straggle of old staircases and the remains of an aerial tramway. Because of their isolation, unlike other B.C. mine ruins, they were not vandalized, burned or bulldozed into oblivion. Today, operated by the Lower Similkameen Indian Band from headquarters in the old Hedley school, the Mascot Mine is open once more—this time as a B.C. Heritage Site for tourists. Buildings have been restored, staircases rebuilt and tunnels opened, and twice a day during the summer a minibus takes visitors up to the site, along the infamous Corkscrew Road: 40 switchbacks in 15 kilometres. From a high parking lot, a total of 588 solid wooden stairs lead down to the old mine buildings and the tunnel entrances. It's a guided tour well worth taking. (For details see www.mascotmine.com.)

This country road travels Hedley's Corkscrew Road to climb high above the Similkameen Valley, then it continues over the mountains via the Apex ski resort and back down to the valley

Church of St. Ann at the village of Chuchuwayha. The old log building was likely the original mission church.

at Keremeos. The journey will require at least half a day—more, of course, if you plan to tour the Mascot Mine.

Hedley lies about halfway between the towns of Princeton and Keremeos on Highway 3. There's a fine museum here, several old stores and restaurants, B&Bs and vintage homes. Sprawled beside the highway are the concrete foundation of an old reduction plant and, beside the river, the remains of a dam and power plant. To see the ruins of the Mascot Mine at a distance, ask to use the museum telescope or scan the ridge with binoculars from the "stop of interest" sign just west of town. For guided tours, stop in at the Snaza'ist Centre, in the big old school at the western edge of town.

The mine tour and our *Country Roads* route begin east of Hedley by the Native village of Chuchuwayha with its restored Church of St. Ann, dating from the early 1900s. Below the church is an old log building, reputedly the original Oblate mission church of the 1880s, later used as a residence for visiting priests. The land here is privately owned, the church kept locked. Just about opposite the village, Corkscrew Road begins its grind up the mountain. Not for the faint of heart, this road is steep and rough and in some places so narrow that meeting another vehicle could pose a problem. However, the Mascot Mine Tour mini-buses, loaded with passengers, negotiate it safely twice a day. The views at every turn are incredible, but wait until you reach the best viewpoint, five kilometres from the highway. Here, just past a skinny section of road under an imposing cliff, is a wide parking place by a cattle guard. Walk out to the bluff's edge, and the whole of Corkscrew Road will unfold before you, with the Similkameen Valley and the tiny Church of St. Ann far below.

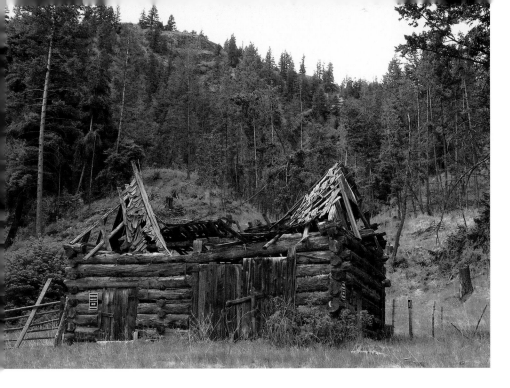

Beyond the cattle guard, the road continues its steep upward climb, but it seems less perilous because there are trees along the outer edge. Tracks lead off into the forest but there are few signs of mining until you come to a flumed creek, steep reclamation slopes and a whole series of settling ponds. A huge open-pit mine (now closed) engulfed the former Nickel Plate townsite, built high on the mountain here in 1937 to house mine workers. Fifteen kilometres from the highway, buildings of the Nickel Plate Mine mark the junction with a gated spur road leading to the Mascot Mine. Tour buses have made arrangements to drive on through; the road to Apex swings right. From here on the road is wider and of good surface because it is the main haul road not only for the mines, but also for logging trucks.

Before the Corkscrew Road was built, supplies for the Hedley mines and the Nickel Plate townsite were brought in this way from Penticton by horse and wagon. Stagecoaches came this way, too, with passengers and the mail pouch. A short distance along, near a logging spur road aptly named Boot Hill, a large white cross in the trees marks the townsite cemetery. The Nickel Plate Nordic Centre is the high point of this cross-over route, and five kilometres downhill, the gravel road turns to pavement for the drive through Apex ski village. From here, you can access a small provincial park on Nickel Plate Lake.

Eleven kilometres downhill, the Apex Road meets Green Mountain Road coming in from Penticton along Shatford Creek. A short distance north (left) lies the only relic of stagecoach days: the log barn of the Green Mountain Stopping House. Its roof has collapsed, but the logs seem sturdy yet. Unless Penticton is your destination, turn around at the barn and head south through the valley, past several little lakes (one with islands for nesting geese) and down through

a rocky canyon once known as the Iron Gates. When you reach Highway 3A, turn right (south) and head for Keremeos, past the old mining settlement of Olalla.

In the hills to the east lies Keremeos Columns Provincial Park, originally set aside to protect dramatic cliffs of hexagonal basalt, but someone made a big mistake. A later survey showed the columns to be outside the park, and this explains why today's access is so difficult. Only a private road up to the transmission towers leads close to this stunning rock formation. This starts as Liddicote Road beside the Keremeos cemetery, but to drive farther than the gate you must have permission from the landowners; inquire at the house at the end of the pavement. The road is very steep and winding, and the last 100 metres to the columns must be made on foot.

Keremeos itself is a compact little village in the Similkameen Valley, known for its steady winds (from the west) and some of the earliest asparagus, apricots and peaches in B.C. Beside the river here is Pine Park, with some magnificent stands of huge ponderosa pines and some restored riverine habitat. From here there's a very good view of the giant K inscribed by intersecting rock slides on the mountain south of the river.

At the Highway 3 junction, you must make a choice: to drive west along the Similkameen back to Hedley past the Red Bridge, the only remaining semi-covered railway bridge in B.C., or to continue southeast in a big loop almost to the Washington border, then over Richter Pass to the southern toe of the Okanagan Valley at Osoyoos.

If you decide on the eastern route, there is much to see. First, head back up Highway 3A and turn right (east) on Upper Bench Road, which parallels the highway for about 10 kilometres through peach, cherry and apple orchards. Along here is the Keremeos Grist Mill, built in 1877, the only one in B.C. where both the building and the machinery are intact. Restored by the B.C. Heritage Trust, the mill has a fully operational wooden water wheel that still grinds flour (for sale in the gift shop). Around it is a garden growing heritage flowers and vegetables, including giant zucca melons. The gift shop (where you can buy zucca melon seeds) houses a great little teahouse.

From the mill, follow Upper Bench Road east (it becomes Lower Barcelo Road) to its intersection with Highway 3. Nearby is the site of a mystery. Spanish conquistadores on a long exploratory journey north from Mexico are said to have reached British Columbia in the mid-1700s and to have camped on the Similkameen River somewhere in this area. Like conquerors everywhere, they clashed with the Natives, killed many of them and continued their journey north, taking with them a string of Native prisoners. Evidence of a brief Spanish occupation is said to have surfaced near Kelowna. The foreign contingent returned south the way they came, but this time the people of the Similkameen were ready for them. They ambushed the Spaniards and killed them all. A Spanish sword and pieces of armour are rumoured to have been unearthed

Red Bridge, the last of the VV&E rail bridges in the valley, crosses the Similkameen east of Hedley and provides access to Cathedral Provincial Park.

Keremeos produces some of the earliest fruit in Canada—and some of the most inventive produce stands.

under a nearby rock slide north of the highway. True or false? No one can know, but it is interesting that ancient pictographs on cliffs east of Hedley show a man wearing a western-style hat and sitting on a horse (horses were not seen in this part of B.C. until fur-trade days) and also a group of men tied together. Were these the prisoners? Is this more evidence of the Spaniards' visit?

Highway 3 continues southeast through orchards and vineyards to a narrow wooden bridge where a road leads across the Similkameen River to the Native village of Chopaka, very close to the B.C.–Washington border. The village still has a fine old church, the 1896 Our Lady of Lourdes, nestling under pine trees beside a group of century-old log cabins. Farther east along the highway, another road leads to the Nighthawk border crossing. The sagebrush grasslands here, a piece of the patchwork that makes up the Okanagan Grasslands Protected Area, are home to rare sage thrashers and Brewer's sparrows, while long-billed curlews and bobolinks can sometimes be seen in the hayfields along the river.

From the Nighthawk road, Highway 3 makes a sharp hairpin bend and starts the climb up and over Richter Pass. There's just one more stop of interest before the road glides down into Osoyoos: Spotted Lake, so heavily saline that its salts (mostly magnesium and sodium sulphates) crystallize out in roughly circular patches, giving the lake its multi-coloured spotted appearance. Traditionally, this lake was used for healing baths by local Natives, who know the lake as Klilok. The property is privately owned and fenced, but there is a small parking place and a good view of the lake from the road. The lookout a little farther down the highway gives a bird's-eye view of Osoyoos and the vineyards and orchards of the Okanagan Valley, showing how little of the "desert" environment is left.

There are two other interesting side roads off this stretch of Highway 3, both of which lead into areas now protected within the Okanagan Grasslands reserve. One heads north onto the shoulders of 1,870-metre Mount Kobau, the intended site of a major observatory but now the venue for a week-long "star party" in August, when professional and amateur astronomers camp near the summit with their telescopes to enjoy the splendours of the night sky. At most times of year, it's a beautiful 20-kilometre wilderness drive up from sagebrush into the subalpine. The second excursion follows Old Richter Pass Road south through forest into the grasslands around Blue and Kilpoola lakes. Both roads are rough and unpaved. ❖

On the road to Osoyoos, Spotted Lake is always worth a stop; the size and colour of the spots are constantly changing.

NICOLA RIVER JOURNEY

Rising in forested highlands above the Okanagan Valley, the Nicola River describes a sinuous course west across the Interior plateau to the Thompson River. Its huge drainage basin encompasses several ecological zones, from high montane forests of Interior Douglas fir to pine-studded bunchgrass meadows and sagebrush semi-desert. In all its reaches, the Nicola is a beautiful river, one that can be followed by road for much of its long passage.

Our travels begin at Spences Bridge, where the Nicola flows into the Thompson at the site of ancient Native fishing grounds. The gold-rush community took its name from the toll bridge (built by Thomas Spence in 1865) that replaced a primitive rope ferry (operated by Mortimer Cook from 1862 to 1865). At the junction of two rivers (Thompson and Nicola) and two highways (1 and 8), this is an interesting place to start the journey. Historically an important stop on the Cariboo Road and later a division point for two transcontinental railways, today Spences Bridge is very much a yesterday's place. But its yesterday included one of B.C.'s famous men: brilliant amateur ethnographer James Alexander Teit, known for his exhaustive studies of the culture and mythology of the Interior Salish. For much of his writing life, Teit lived at the Morens house, which still stands, a stucco cottage with deep verandas, surrounded by orchards on the hill above town. The house itself has an interesting history, first as a homestead, then as a stopping house on the Cariboo Road, accommodation for the station master when the Canadian Pacific Railway came through, and later as a bunkhouse for workers. Today the house operates sporadically as a rustic B&B behind Hilltop Gardens fruit stand.

Spences Bridge was also once famous for its apples. Widow Jessie Smith took over the family orchards here when her husband died, leaving her with seven children to support. Her fine Golden Grimes apples won gold medals at international agricultural fairs, attracting the

Early-morning shadows in the meadows by the Quilchena Hotel's stables.

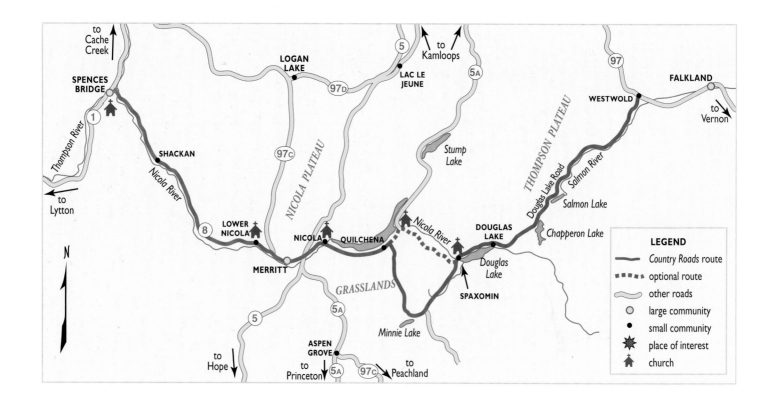

attention, or so it is claimed, of British royalty. The orchards have gone, but the former Smith apple-packing plant is now a popular coffee house.

Highway 1 whizzes by the small town, crossing the Thompson on a sleek modern bridge. But the old narrow wagon road bridge is still in use and leads east across the river to a section of the original road, a tiny Native church and B.C.'s oldest continuously operated hotel, now The Inn at Spences Bridge. Built in 1862 and recently renovated, it is still open as a B&B, with full restaurant and a sundeck perched high above the river. East of here, Highway 8 crosses the railway tracks, skirts a Native graveyard and bridges the Nicola River just above its mouth. A sharp turn east, and the journey upriver along the 1875 wagon road to Nicola has begun.

The land around the Thompson River is hot and dry, very much sagebrush and cactus country—though close to the water there are ribbons of cottonwood and willow and a few ponderosa pines. In late summer, rabbitbrush blazes yellow, and small sumacs flaunt a crimson glow. Before it reaches the Thompson, the Nicola River flows west through a series of tight rock canyons and beside clay cliffs sculpted into arresting hoodoos. There's a good view of them from the first river bridge, a well-known fishing spot for fall steelhead. A few small irrigated acreages in this hot valley grow fruit and vegetables in little "Secret Gardens," as one such place is called. The fields are tiny and sheltered, splendid for growing tomatoes and peppers.

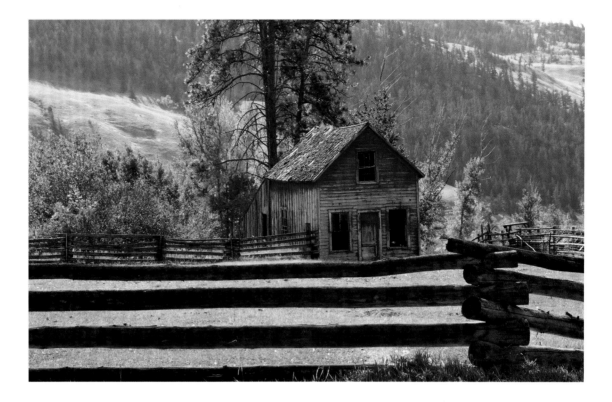

Old homestead on the outskirts of Nicola.

As it gains elevation, the Nicola Valley expands, accommodating farms and ranches, and the highway eases along the side hills. Across the river, the abandoned track of the CPR branch line to Merritt now provides an excellent hiking and biking trail that crosses several of the old railway bridges. About 20 kilometres from Spences Bridge, a large white wooden cross marks the beginning of the Shackan Native Reserve, and a little farther on, a small First Nations nursery garden beside Skuhun Creek specializes in native plants.

When French fur traders came through the area in the 1800s, they knew it as Nicola's Country, named for a famous Chief of the Spaxomin tribe whose tongue-twisting name, Hwistesmetxe'qen, or "Walking Grizzly Bear," was far too difficult to pronounce. The traders called him simply Nicholas, or Nkwala, and the river became known as Nicola's River. John Tod, chief trader of the Hudson's Bay Company at Kamloops, described Nkwala as "a great chieftain and a bold man for he had 17 wives." He fathered more than 50 children and was known as a peacemaker, both between tribes, and between First Nations and the newcomers: the fur traders, miners and ranchers. Unwittingly, the Europeans brought with them disaster: many Natives succumbed to diseases such as measles and whooping cough, as well as virulent strains of smallpox. Throughout British Columbia, the large numbers of Native graveyards packed with simple white crosses are reminders of these tragic events. There are three such graveyards

along here, near a sign alerting people to respect Shackan cultural and heritage sites. (Be careful not to trespass.)

From Shackan, the road travels through forest high above the valley fields of Dot Ranch, then it descends to the river again to a campsite and a bridge over Petit Creek. Farther along, Sunshine Valley Road provides access to Spius Creek Fish Hatchery, open to visitors for self-guided tours. Coho and Chinook salmon are raised here.

The first non-Native settlement east of Spences Bridge is Lower Nicola, with its general store, small graveyard and photogenic ghost of a homestead sitting by itself in a meadow. A much larger graveyard, full of small white crosses, is in the nearby Native community of Shulus, where two very old churches jostle shoulders with a spanking-new dance arbour. The Catholic Church of the Immaculate Conception was built here in 1893. A simple white building trimmed with blue, it has stained glass windows and a fine belfry, roofed with intricate shingles. Almost beside it, the small Anglican church with its jaunty belfry and lych-gate looks older yet, although it was built several years afterwards. Just east of Shulus, Highway 97C turns up the valley of Guichon Creek and makes its way to Ashcroft by way of Logan Lake.

The river and Highway 8 continue east to Merritt, the largest community in the area, though not the oldest. Originally named Forksdale (being at the confluence of the Nicola and Coldwater rivers), Merritt did not begin to grow until coal mines were opened around 1904, followed two years later by the arrival of the CPR. It quickly blossomed into a sizable pioneer community, complete with all the necessities for life in this mining/ranching country, including several saloons and hotels. Soon, it had totally eclipsed the older centre of Nicola, 12 kilometres north. Today, although the mines and the railway have closed, Merritt is still the largest and brawniest settlement in the valley, its pioneer heritage evident in such buildings as the 1903 courthouse, now an art gallery, the 1908 Coldwater Hotel with its veranda and high, copper-clad turret, the Adelphi Hotel of 1911 and the 1908 Baillie house next to the tourist office, housed in an old soda-pop factory.

The Nicola River runs through Merritt, and our route follows along. When you arrive in town, go left at the first traffic light (Voght Street) and follow the river through the outskirts of town, past the signs for the Coquihalla Highway. The old road is a continuation of Voght Street. Soon you're back in Nicola River ranchlands, driving on Highway 5A through huge hayfields and heading north toward Nicola Lake. The settlement of Nicola, founded in the 1870s and once the commercial centre of the valley, lies a few kilometres south of the lake. Its old courthouse (a carbon copy of Merritt's) sits on the east side of the highway, shaded by magnificent old maples. In fall, their leaves spread a crisp carpet of gold in front of the imposing entrance, still emblazoned with the provincial coat of arms. Across the road are several smaller pioneer homes

The Church of St. Nicholas at the village of Spaxomin near Douglas Lake dates from 1889.

and an elegant turreted mansion painted a soft blue. There are two churches: the red-roofed 1899 St. John the Baptist and the little white Church of St. Andrew, built in 1876 and known as the Murray Church after its builder and first pastor, the Reverend George Murray, who made Nicola the headquarters for his huge parish, which extended from Yale to Clinton. The Victorian grave markers here are themselves worthy of inspection.

If Nicola seems a bit too neat for a faded pioneer town, there's a good reason: it's all owned today by the Nicola Ranch; most of the buildings have been restored and several renovated for self-catered use by tourists. You can rent a room in the 1913 courthouse (5 bedrooms, 2 baths) or in the Harness Maker's (1890) or Banker's (1906) houses (2 bedrooms each). The rental fee includes fishing privileges in the river or in private lakes. (For details, ask at the gift shop near the Murray Church.)

Just north of Nicola, the valley is filled by huge, deep Nicola Lake, said to be home to 26 different kinds of fish. The highway stays close to the river along its eastern edges on its way to one of B.C.'s historic treasures, the Quilchena Hotel. Today, seemingly in the middle of no-where, this grand old dame continues the traditions of Edwardian gentility that began in 1908, when rancher Joseph Guichon, firmly believing that the CPR would route its new line north from Merritt through Nicola, built this huge three-storey hostelry to accommodate railway passengers. But the CPR had other plans, and Nicola reached a stalemate. The Quilchena's hopes were dashed. Still, it soldiered on, keeping alive the traditions of Empire: polo matches in meadows alongside Quilchena Creek, fishing derbies, fancy dress balls, five-course dinners, starched tablecloths, four-poster beds, chambermaids in frilly caps, and a barroom, resplendent with mahogany and mirrors. Despite the best of efforts, the hotel was forced to close in 1917 after only nine years of operation, but all the old furnishings and fixtures were kept intact by the family. When the Quilchena reopened in 1958, it was a snapshot of times past: guests could sleep in high mahogany beds in the former ladies' parlour or the bridal suite, socialize in a period drawing room, and exercise elbows in the ornate bar (look for the bullet holes and ask for the story behind them). Today, while it retains much of its original ambience, it has been modernized with up-to-date plumbing and heating, the old polo ground has become a golf course, guests can enjoy tennis and horseback riding, and the cuisine in the still-elegant dining room is rated five-star.

If you want a walk, try the road that leads beside the hotel to the stables. The birdwatching is good here alongside Quilchena Creek: great horned owls and long-billed curlews; migrating sandhill cranes in spring and fall; lots of sparrows and swallows, and maybe even a bobolink. In September, kokanee spawn in the creek mouth. Adjacent to the hotel is an old-time general store where blue jeans, fancy buckles and Stetsons share the shelves with groceries and videos. Gas is available here, too.

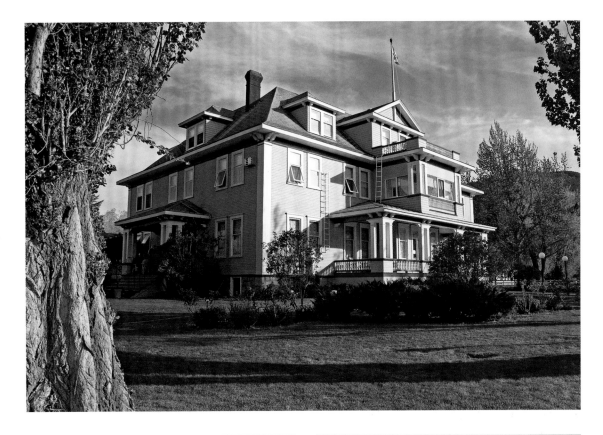

The Quilchena Hotel, little changed in 100 years.

RIGHT
St. Andrew's, or the Murray Church, one of two historic churches in Nicola.

FAR RIGHT
Hoodoos and rabbitbrush along the lower Nicola River, east of Spences Bridge.

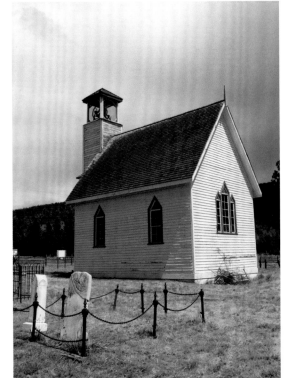

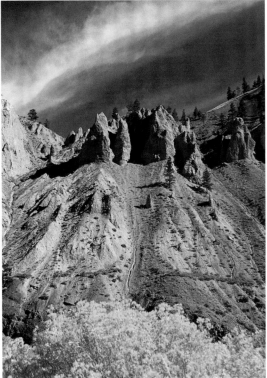

Above Quilchena, huge stretches of high grassland billow toward the Okanagan Highlands, free range for cattle and horses.

The high plateau country east of the Nicola Valley is among B.C.'s loveliest, an undulating sweep of grassland, blue with lupines in early summer, with lakes and drifts of trees in the hollows and a great sense of space and sky. On ripe summer evenings when the valley below is already in shade, up here the grass is golden in the sunset, the shadows long and the rounded curves of the surrounding hills voluptuous. Meadowlarks trill their sharp and somehow lonely songs and, along the meandering ranch roads, scurrying armies of horned larks are forever in retreat. And through this wondrous landscape, the Nicola River runs west from its birthplace in a maze of little lakes high on the plateau into Nicola Lake, a few kilometres north of Quilchena. Blanketed with high-protein grasses, the lightly forested plateau provides superb natural rangeland for cattle. It was bunchgrass "high as a horse's belly" that first attracted John Douglas in the 1870s. He had planned to join the gold rush, but instead settled here to homestead. From these beginnings, the great Douglas Lake Ranch grew to more than 500,000 hectares. Today, it's one of Canada's largest and sustains its own little village for employees.

The main road to Douglas Lake follows the river from Highway 8 just north of Quilchena: an interesting modern log church marks the intersection. This is a good road to follow—it's paved all the way. But there's another route to Douglas Lake that is quieter, a high, wild route through the lonely grasslands of the plateau. This is the recommended way, if you don't mind a slow and dusty 50-kilometre detour. This road leaves the highway just two kilometres north of Quilchena and it's signposted to Stoney Lake Lodge.

The word plateau seems to suggest a fairly level expanse of country, but while the land up

*The Nicola Valley
is cowboy country,
and roundups are
regular affairs.*

here is not as rugged as the surrounding highlands, it is certainly not flat. The road swoops up and around little hills and dips again into hollows, winding ahead in beautiful if dusty curves. An immense sky stretches overhead, giving a sense of prairie light. In May, the grasslands are dotted with small herds of cows and their calves, though later in the summer the cattle are driven to range in the surrounding forest lands. Herds of ranch horses roam freely, and deer and coyotes can often be seen.

Twenty kilometres from the highway, the road comes to the Stoney Lake Lodge gate. Along with nearby Minnie Lake Ranch House, this is one of several guest-ranch and fishing-lodge operations run by the Douglas Lake Ranch. Turn left at the gate and follow the road to Douglas Lake. A second junction two kilometres along is signposted to Pennask Lake, and this is worth a short detour for it leads to Flume Marsh, so called because of the old wooden viaduct that once brought irrigation water to Minnie Lake hayfields. Several stretches of this flume add a bit of human history to this enchanting Ducks Unlimited wildlife site.

Return from the marsh the way you came (the detour will add only about seven kilometres to your journey) and continue northeast—a sign advertising the Douglas Lake Home Ranch General Store provides assurance that you're on the right road. After a relatively flat section, studded with glacial erratics and pothole lakes, the road heads downhill, following the incline of Douglas Creek. Soon, you are poised high above the Nicola Valley again, looking across at the Native settlement of Spaxomin and its 1889 Church of St. Nicholas, a stern little building, its tall bell tower an exclamation mark against the grassy hills.

The village today is a peaceful place, but it played a part in one of B.C.'s most famous Wild West tales. It was in one of the cabins near here in 1879 that the notorious McLean Gang made a stand after shooting Constable John Ussher near Kamloops. The four boys (they were only teenagers) surrendered after a siege of several days, and were taken to the New Westminster jail and later hanged. No historic sign marks this spot.

When you reach the village, turn left to rejoin the main Douglas Lake Road, then right. To see the St. Nicholas church at close quarters and to visit the graveyard on the hill behind, take the road that runs behind the store, or ask for directions. The church is not in use and is kept locked. Spaxomin is an ancient First Nations settlement, already established when the first ranchers settled on the lake, and it was Native cowboys the ranchers relied upon, as they do today, to work with the herds. The road runs beside Douglas Lake, but access is limited except at Prince Philip Point, named to commemorate the royal visit of 1962. This is a good place for picnics and birdwatching. Keep a lookout for osprey along the lake: they nest on platforms specially built to discourage them from using the power-line poles.

The Nicola River flows into the eastern end of Douglas Lake, but the road leaves the river behind, heading through the meadows toward Douglas Lake village, headquarters for the sprawling ranch operations. Past a red-roofed church, an arched gateway leads into the village itself: neat streets of homes, a cookhouse, school, barns, workshops and machinery sheds—and an old Woodward's Department Store delivery truck. (The ranch was once owned by the Woodward family.) The Home Ranch general store and post office have been in business in the same frame building since the early 1900s; here you can get gas and information about ranch tours and accommodation choices. It makes an interesting stop. The serene waters of a small lake known as The Sanctuary creates mirror images of the red-roofed ranch buildings as the road crests a small hill and runs beside the ranch airstrip.

The Nicola River part of this journey is nearly over. Once past the bullpens and the feedlots, the road comes close to the Nicola River again by a cluster of corrals around English Bridge. Across the bridge, the road leaves the river behind and strikes northeast to Chapperon Lake. It was somewhere near here that the final pages of another turn-of-the-century crime took place. Bill Miner, the gentleman bandit who held up and robbed a CPR train near the station of Ducks, east of Kamloops, was apprehended here by a mounted police posse. Miner and his two accomplices were taken by wagon to Nicola, thence to Kamloops for trial. One version of the story was told in the movie *The Grey Fox*.

The road barely touches the end of Chapperon Lake, headquarters for Douglas Lake's eastern operations, then dives briefly into forest for its journey over the divide into the Salmon River drainage. To the west lies Rush Lake, shallow and reedy, noisy with bird life, and farther on,

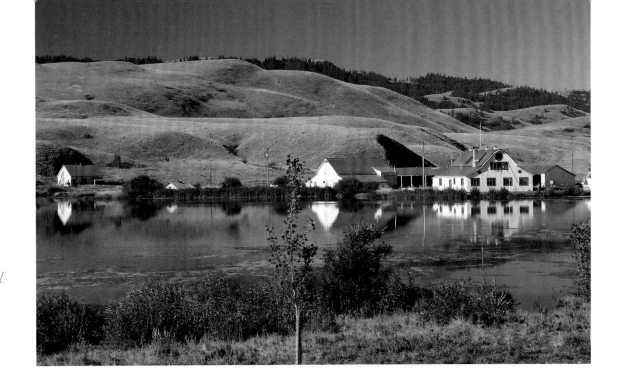

The red-roofed buildings of the Douglas Lake Home Ranch are reflected in the still waters of a little lake known as "The Sanctuary."

the calm waters of much larger Salmon Lake. Two of Douglas Lake's accommodations are here: Twigg's cabin at the south end, and Salmon Lake Resort, with a string of small modern cabins, along the north shore. The resort office has basic snacks, coffee and information. Just past the lake, stop to admire a fine hewn-log house and cabin, long deserted, inhabited today only by a family of yellow-bellied marmots.

The Salmon River has a long way to go before it reaches its destination of Shuswap Lake near the town of Salmon Arm. As it races north, down from the high grasslands and into the forest, it carves a narrow canyon through volcanic rocks, a source of agate for local rockhounds. Once through the canyon, the valley opens up into farmland, and it is along here that the Westwold Heritage Steam Sawmill is open for visits, surrounded by a wealth of old farm machinery. At the junction with Highway 97, the Westwold general store has a most welcome small café. From here, you can go south to Vernon or north to Kamloops. Or you could follow the Salmon River country road all the way to Shuswap Lake by way of Silver Creek.

Westwold has a small pioneer church, St. Luke's Anglican, built in 1898. It was in this lovely wide valley, once known as Grande Prairie, that the last lone Cariboo camel ended its days peacefully in 1905. At the time of the Cariboo gold rush, 23 Bactrian camels were imported from California to haul supplies on the wagon road, an experiment that failed when the camels' strange odour and nasty tempers stampeded other beasts of burden.

For the record, the total distance from Spences Bridge to Westwold is just about 200 kilometres, an easy day's journey. Happily, the halfway point, for those who like to linger, is the Quilchena Hotel. ❧

10 LILLOOET ADVENTURE ROAD

The scenery around Lillooet has a decidedly vertical thrust. Surrounded by mountains deeply incised by tributary rivers that hurtle down to meet the Fraser in its own steep and twisting canyon, this is a visualizing stunning landscape, and an interesting one because the geology is divided: west of the river lie the peaks of the Coast Mountains and to the east the gentler uplands of the Fraser Plateau. An adventurous circle drive from Lillooet starts north up the Fraser, then follows the Bridge River to Carpenter Lake, crosses the divide to Seton and Anderson lakes and joins Highway 99 at Mount Currie for the return journey. It's scenic, wild and historic, a perfect combination.

Lillooet is strung out on a series of high glacial terraces above the Fraser River beside its confluence with Cayoosh Creek. It is one of the oldest towns in British Columbia, dating from the gold-rush days of the 1860s, but 150 years of history is nothing compared to the Native presence here. At Keatley Creek, just 20 kilometres north, archaeologists from Simon Fraser University found a fishing village of 115 pit houses that had been lived in continuously for 1,500 years, its occupation disrupted only once when a major landslide blocked the fish runs on the Fraser. Underneath the village remains were signs of occupation dating back 7,000 years.

The confluence of the Bridge and the Fraser rivers has always been a culturally important place to people of the St'at'imc Nation. They knew it as Xwisten, or "smiling place," because here the fish were always in abundance and living was easy on the wide river terraces, despite torrid summers and icy winters. The people lived on the riches of the river, catching salmon in the rapids, and curing them on racks hung in the hot winds that still blow along the canyons. This air-dried salmon, known as *tswan*, provided food for the winter and was produced in such quantities that surplus was available for trade. Steelhead swam up the river in spring, spring salmon

The confluence of the blue Bridge River and the muddy Fraser, a traditional Native fishing area.

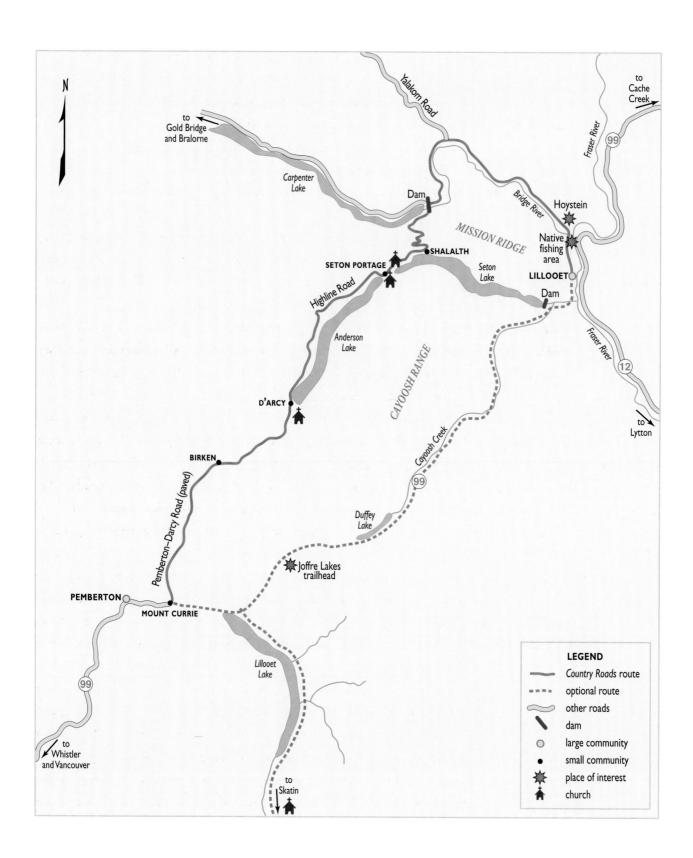

N

to
Gold Bridge
and Bralorne

*Carpenter
Lake*

Dam

Yalakom Road

Bridge River

Fraser River

99

to Cache
Creek

Hoystein

MISSION RIDGE

Native
fishing
area

SHALALTH

SETON PORTAGE

*Seton
Lake*

LILLOOET

Dam

Highline Road

*Anderson
Lake*

CAYOOSH RANGE

Fraser River

12

D'ARCY

to
Lytton

BIRKEN

Cayoosh Creek

99

Pemberton–Darcy Road (paved)

*Duffey
Lake*

Joffre Lakes
trailhead

PEMBERTON

MOUNT CURRIE

*Lillooet
Lake*

to
Whistler
and Vancouver

99

to
Skatin

LEGEND

━━━ *Country Roads* route

- - - optional route

〜〜 other roads

▬ dam

◯ large community

● small community

✶ place of interest

⛪ church

in July, and sockeye — part of the famous Adams River run — in August and September.

The first Europeans to infiltrate this self-sufficient salmon society came with Simon Fraser, who staggered through in 1808, asking for help to bring their canoes through the Fraser rapids and for advice on how to reach the Pacific. According to Fraser's reports, he was met near Lillooet by a contingent of 1,000, treated kindly, given provisions and sent on his way. Fraser and his voyageurs were the first White people the Natives had seen, and the historic encounter lives on in old stories. Nothing changed in the lives of the St'at'imc peoples here until the Fraser River and Cariboo gold rushes, some 75 years later.

The very first miners' trail from the coast went from Harrison Lake to the upper Fraser, by way of Anderson and Seton lakes, a route that combined land and water travel. The mule trail connecting the lakes was hacked out under a make-work project Governor James Douglas devised for miners who were spending the winter of 1858 bickering in Victoria. He advertised for workers: each man would labour without pay and had to put up a $25 deposit, money that would be refunded in goods and supplies at trail's end, but only if their work and conduct had been exemplary. Amazingly, more than 500 miners signed up for the work. Their reward, more than the free food and equipment, was transportation upcountry closer to the alluring goldfields of the Cariboo. The route was finished in October, and Douglas was satisfied that his $14,000 expenditure had been worthwhile. Later, parts of the narrow trail were upgraded to wagon road, but the route was never really satisfactory, mainly because of the cost and inconvenience of portaging goods from wagons to boats and back again. When work began on the Cariboo Wagon Road up the Fraser from Yale to Lillooet four years later, in 1862, the old lake route faded into obscurity.

The 500-plus miners who had built the trail in 1858 were the first to establish a camp beside the Native settlement on the river terrace where Cayoosh Creek entered the Fraser. And on this strategic spot, the supply town first known as Cayoosh, and later as Lillooet, sprang up. It was a lusty little town that commandeered the river bench, pushing aside the Native settlement as it spread out. Houses, stores, saloons and churches jostled for space along the main street; the same street is there today, marked by a stone cairn commemorating Mile 0 of the Cariboo Wagon Road.

There is so much history in and around Lillooet that you could very well stay a while before heading out on this circular journey. At the very least, take a walking tour of the town and spend some time beside the old suspension bridge that crosses the Fraser at the foot of Main Street. This bridge, now a provincial heritage site, was built in 1913 to replace a winch ferry that had been in use since 1860. Restored for foot traffic only, it provides a good view of the river — and a great home for the local bats. The Lillooet Naturalist Society has installed several bat boxes under the bridge; come at dusk to watch the bats fly.

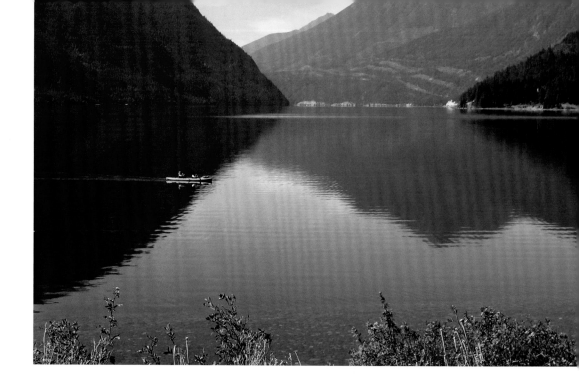

Looking south down Anderson Lake at the start of the gold-rush "short portage" to Seton Lake.

Our journey heads north along the east bank of the Fraser, past a few old farms and orchards on the river terrace. The river itself is far below, twisting a sinuous course through a deep canyon full of rapids. At about six kilometres from Lillooet, the Bridge River flows in from the east through a narrow rock canyon, its waters a clear, deep blue-green, an astonishing contrast to the muddy brown Fraser into which it flows. There is space for parking on the river side of the road just before the bridge, but be considerate: this is Native territory and their prime fishing spots are nearby. If you venture out along some of the short trails leading to the river's edge, you might see, if the season is right, racks of salmon drying in the wind under tarps, or people fishing. In the Native language, the 30-metre-wide canyon just above where the rivers join is Sxetl, or the "drop-off," and you will see that it was aptly named. Archival photos show Natives fishing here with dip nets and spears, hunkered down on frail-looking planks suspended high over the river, or standing precariously on water-splashed rocks. There is still a strong fishery here. From mid-June to mid-September, the St'at'imc Nation offers half-day tours to local fishing grounds and archaeological sites, culminating in a salmon barbecue. (For information, phone 250-256-0673 or inquire at the Band Office.)

Cross the bridge over the Bridge River, which took its name from a toll footbridge built by Natives for gold-rush travellers. The river drains glaciers and high snowfields in the Coast Mountains and owes its clarity and colour to the dams that trap its sediment in Carpenter Lake. Once across the bridge, turn right up the steep West Pavilion Forest Road to the site of an abandoned Native village named Hoystein. Several deserted log cabins remain here, but the church was destroyed by fire, like many others in the dry belt. The cemetery is impressive: rows of white

crosses and an amazing view south down the Fraser River to the mountains beyond. Return to the Bridge River road and head east through the dry pines of the valley. This is a variable road, sometimes wide and easy, sometimes narrow, twisting and very close to the canyon edge, and it's a forestry road, so keep an eye out for trucks.

Just past the intersection with Joseph Road, which leads down to the new houses of Xwisten village, a huge array of circular depressions, like giant dimples, on a sagebrush bench above the river is all that remains of an ancient pit house village. Do not trespass on the meadow here, but you can stop and look. The road continues through forested benches high above the river canyon, past a few old log homesteads and barns, then circles around a gigantic S-bend carved through towering cliffs of sand and clay, an example of the destructive force of a previous hydraulic mining operation. About 30 kilometres from Lillooet, the Yalakom Road leads north to the community of Moha and beyond. With a four-wheel-drive vehicle you could make it from here all the way to the Big Bar ferry across the Fraser and connect with the Cariboo Road (see Chapter 1). Past the junction, after a series of plunging hairpin bends, the road curves beside a small oasis-like ranch with a tiny vineyard, continues down to cross the mouth of the Yalakom River and enters the Bridge River canyon. After the exposure of the high road, the shady cool of the canyon, overhung with waterfalls and steep talus slopes, is a pleasant contrast.

At the head of the canyon, about 48 kilometres from Lillooet, the Mission Dam recreation site beside the river is a good place for a picnic, under the spillway of the huge earth-filled Terzaghi Dam (Mission is its colloquial name). This backs up the Bridge River to form a long skinny reservoir known as Carpenter Lake, which stretches for 55 kilometres northeast all the way to Gold Bridge. The former gold-mining town of Minto, which once housed 2,500 people at the mouth of Gun Creek, was drowned by the rising lake, but its ghostly foundations can still be seen during periods of low water. A road follows Carpenter Lake along its eastern shore, but we turn left at the next intersection, signposted for Seton Portage. This road was built right across the top of the dam (single-lane traffic), then tunnels through the ridge of Mission Mountain to emerge on the west side of Carpenter Lake.

The topography of this dramatic mountain area proved perfect for hydroelectric projects. The upper Bridge River valley is nearly 550 metres above Seton Lake, which lies almost directly below it on the other side of Mission Mountain Ridge. This huge difference in elevation was put to good use when engineers dammed the Bridge River and sent water from the impoundment into a diversion tunnel through the mountain and down the other side to powerhouses on Seton Lake. Other hydroelectric dams on the upper river and also on Seton Lake followed soon afterwards. All this dam construction, which produces today only about 8 percent of the province's electricity, resulted in Bridge River water being used three times for the production of electricity

before being discharged back into the Fraser River. There are costs, of course: the loss of Bridge River fisheries; the flooding of a productive river valley and its Native and pioneer settlements; and the degradation of once-pristine Seton Lake, a freshwater fiord once noted for its clear sky-blue waters—all things to think about as you start the climb up Mission Mountain, ready for the plunge to Seton Lake. You can stop at the summit to enjoy the view and the wildflowers.

The journey from Carpenter Lake to Seton Lake is only 20 kilometres, but this drive will take some time. An aerial view of the road shows a faint skinny line looping in sharp, precipitous zigzags down through steep forests to the lakeshore. It is hard to believe that this frail link was once the only access route to the gold mines of the Upper Bridge River. Along its 14 percent grades came all the goods, supplies, machinery and workers needed in the townsites of Bralorne, Pioneer, Gold Bridge and Minto. When the hydroelectric projects began, convoys of trucks travelled the same road, hauling heavy machinery up almost 1,200 metres to the ridge summit and then steeply down to the dam site.

Today's descent down this road to Seton Lake is an experience not advised for those pulling long trailers or not used to mountain driving. The grades are steep, the curves very sharp—there are at least eight hairpin bends—and the road in places is not only narrow but perched on the edge of the steep mountainside. It's comparable to the dreaded "Big Hill" on the road to Bella Coola but, thankfully, not nearly as long—only about 12 kilometres of steep switchbacks—and the views more than compensate for any driving stress. Framed in overlapping ridges of blue mountains, the lakes are jewels of a different colour: Seton Lake is bright turquoise, milky with water from glacial Bridge River, while Anderson Lake is a deep, dark sapphire blue. This challenging road is the only one linking Seton Lake and Lillooet, and locals think nothing of driving up and back for groceries or doctor's visits, even in winter.

At the end of the descent, about 75 kilometres from Lillooet, the road splits: left leads to South Shalalth, right to the settlements of Shalalth and Seton Portage, known until 1959 as Short Portage (to differentiate it from the Cariboo Trail's Long Portage, between Anderson and Lillooet lakes). The short portage connects Anderson and Seton lakes, which were once a single freshwater fiord almost 50 kilometres long, curving between the Bendor and Cayoosh ranges of the Coast Mountains. About 10,000 years ago, tectonic movement along a nearby fault line triggered a giant landslide that blocked the valley, dividing the lake into two sections. In 1861, along the five-kilometre isthmus between the lakes, Karl Dozier built British Columbia's first railway, a crude affair that used mules as the engine to pull wagons on wooden rails.

The road to South Shalalth follows the railway tracks along the lakeshore. And while the Canadian National trains don't stop at any of the stations here, there is a daily shuttle train that carries passengers between Seton and Lillooet. At the Seton Lake Coffee Shop above tiny South

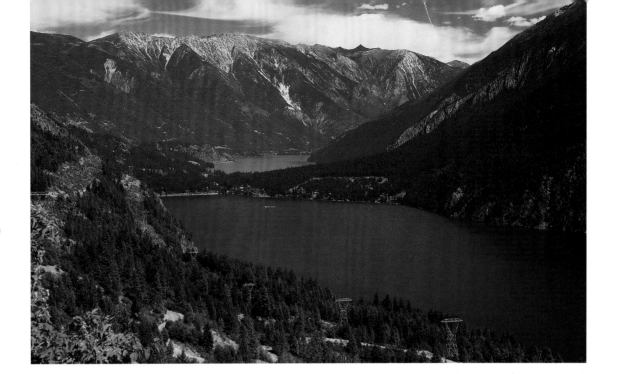

From Highline Road, you can see the different colours of the two lakes: Anderson is blue, Seton is green.

Shalalth station, you can get the train schedule and buy tickets for the one-hour, once-a-day (three times on Fridays) return trip. This shuttle service, run by the Seton Lake Native band, is understandably popular. Its two-passenger cars are usually full and space must be reserved. The run permits a three-hour stopover in Lillooet before returning. On Fridays, it's possible to make a return day excursion from Lillooet. And by advance reservation only, the shuttle will run all the way down Anderson Lake from Seton to D'Arcy and back. (For information, phone 250-259-8227.)

The train station at Shalalth is decorated with Native motifs and is near the Sq'ulht (Muddy Clay) picnic area beside the lake. Turn off at the Bridge River Townsite Road to see the neat, still-occupied houses, all of them in green and flowery gardens, with rock retaining walls and shade trees. The town was built to house construction workers during the long period of dam construction.

From Shalalth, the road to Seton Portage climbs up to avoid the steep, rocky shoreline, then down again, under the thick black pipes bringing water down the mountain to the power plant. Cross the railway tracks at the head of Seton Lake and detour left at a sharp bend where Portage Road leads down to the lake head. Near the water is one of B.C.'s oldest churches, today so frail it is only the ghost of a church. St. Mary's in the Native settlement of Nkiat is a small building of hand-hewn logs covered with cove siding at the porch end and with a delicate shingled belfry. Condemned as unsafe years ago, this old church was scheduled to be razed, but the older people of the community wanted it left alone, to disintegrate on its own. Open to the elements, its timbers darkened with age, the church still stands, though perhaps not for long. Oblate

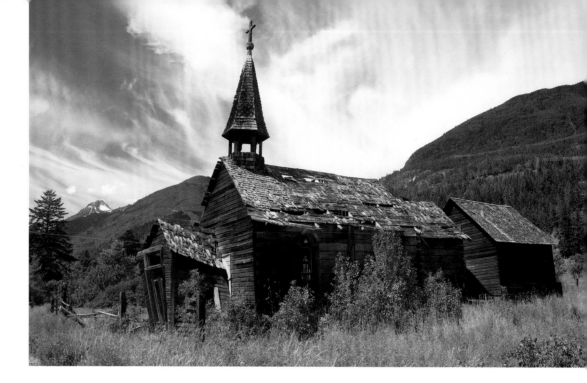

St. Mary's Church on Seton Lake, which dates from the 1880s, is now in ruins.

missionaries built a church here in the 1860s, and for a while the settlement was known simply as The Mission, after which Mission Creek and later Mission Mountain (and even Mission Dam) took their names. The original church burned down, and this one was built in the 1880s.

The isthmus connecting Seton and Anderson lakes, sheltered by high mountains and warmed by the lakes, enjoys a microclimate surprisingly akin to that of the Mediterranean. Snowfall is meagre and the alluvial soil fertile. Gardens thrive here, and at one time the area was known for its fine orchards, some of which still survive. Locals think of it as a Shangri-La, almost cut off from the rest of the world.

The community of Seton Portage is loosely spread out beside the original portage trail of 1858, now the only main road through the isthmus. Travellers can find most facilities here, including a motel, a general store and the Highline Pub and Restaurant. In a small park commemorating B.C.'s first railway, there's a restored caboose along with picnic tables. At the north end of town, the main road crosses the creek that connects the two lakes and comes out on the shores of Anderson Lake. But if you are interested in old churches, drive straight through instead of turning to cross the creek and make your way up to the Native settlement, where a small Catholic church, built in 1895, is still in good condition. Its exterior is simple white siding, and it has a small shingled bell tower. The interior of the church is remarkable for the amount of elaborate fretwork, wood carved to look like lace in traditional folk designs.

Anderson Lake gleams a dark and vivid blue, reflecting the receding ridges of the high mountains that surround it. The road comes down to the lake beside a narrow shingle beach and crosses White Cap Creek. Follow the power lines up the hill to Highline Road, another narrow,

unpaved challenging road that climbs high (500 metres) above Anderson Lake and stays high for its 28-kilometre run to D'Arcy. Check conditions before you start—the road is subject to wash-out—and be prepared for a slow, rough drive with few places to stop or park. Allow about 45 minutes. Some single-lane log bridges cross foaming creeks so steep they could be considered waterfalls. This high and daring route is not a public road, but it is the quickest way from Seton to the coast, and it is patrolled and maintained by the people of Seton. There's an information board at the start of the road. Again, drive slowly and enjoy the view. Except on weekends, there won't be many other vehicles on the road and there's always a good chance of seeing deer or bear.

Highline Road winds down into the little settlement of D'Arcy. Cross the railway tracks and head into town. The small, plain white church here with the squashed-down spire is Holy Rosary Church, built in 1909. Heritage Park, at the south end of Anderson Lake, marks the finish of the Long Portage and the beginning of steamer travel along the lake to Seton, in gold rush and pre-railway days. It's a good place to unwind after your drive. The rest of the journey is easy—40 kilometres of paved highway all the way to Mount Currie on Highway 99, through coastal greenery, lush with salal and cedar.

At Mount Currie, you can head south to Vancouver by way of Whistler and Squamish and a beautiful drive along Howe Sound. But if you like circle tours, turn left at the village and head north back to Lillooet along the Duffey Lake Road. This, too, is a scenic road. Joffre Lake is worth a stop, if only for the reflections of the glacier in its green waters. And above Lillooet, there's a great picnic site and viewpoint high above the dammed western end of Seton Lake. A road down to the shore here leads to a small provincial park, where ancient acacia trees, planted as memorials to the men of the First World War, provide welcome shade. At Lillooet, where the new Bridge of the 23 Camels takes the highway across the Fraser en route to the Cariboo, the circle trip is over. What will you remember best? The daring zigzags of Mission Mountain or the hypnotic blue of the lakes and mountains?

PILGRIMAGE

If you are headed to Lillooet and have time to spare, make this 50-kilometre pilgrimage to one of the most beautiful rural churches in B.C. at the Native village of Skatin. Follow Highway 99 east for nine kilometres. Where the highway turns up Joffre Creek, turn right (south) onto Lillooet Lake Road and follow along the lakeshore and then beside the Lillooet River, the route of the first leg of the Harrison gold-rush trail. Watch out for logging trucks—it's an active forestry road (kilometre signs mark the distances from Mount Currie). There are several attractive

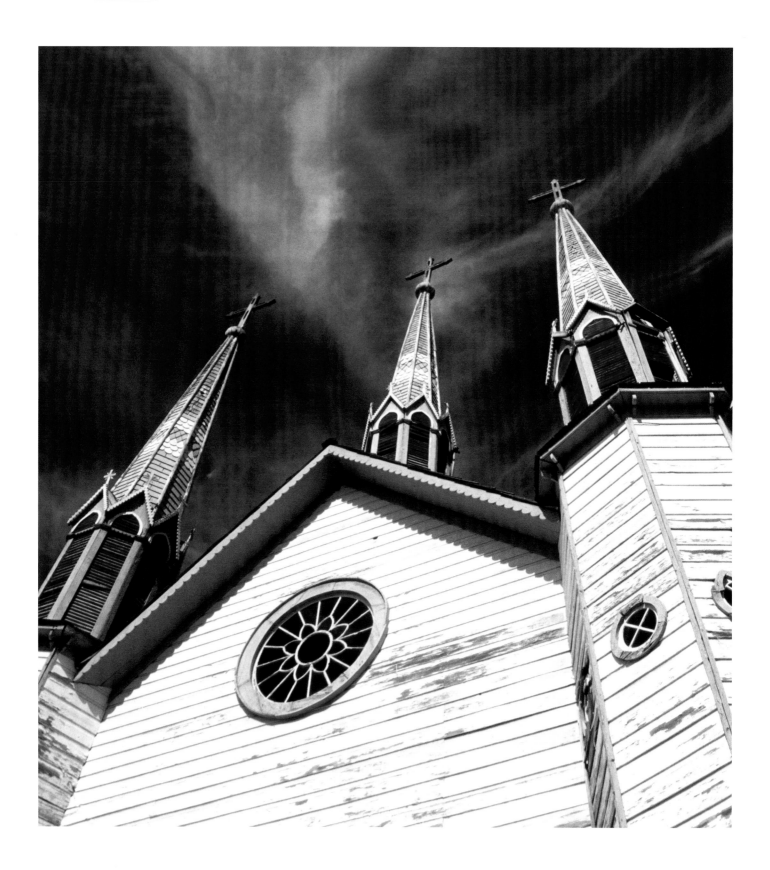

forestry recreation sites near Twin and Lizzie creeks and a couple of small Native reserves along the route. Near marker 38 there is a small fenced graveyard and another one, with an ornate Gothic-inspired gateway, at Sweeten, a few kilometres farther.

If it's a hot summer weekend, you might wonder at the number of family cars and pickups driving along this road. They are most likely headed for St. Agnes' Well hot springs, about 46 kilometres along. This natural hot springs (privately owned but only lightly developed, with a shady campsite beside the river) was a popular stopping place on the miners' trail. It was named by Judge Begbie, who made a trip along the trail from Lillooet to Harrison in 1859. This trail through the coastal jungle was later widened to a wagon road, perhaps the very same track that today's road now follows.

Instead of turning in to the hot springs (or afterwards), keep on the main road that climbs above the campsite and continue south for another four kilometres to the village of Skatin (shown on most maps as Skookumchuk). The first view of the beautiful church, a veritable cathedral in the wilderness, is from high on the road: three elaborate red spires soaring to heaven above an extensive graveyard, almost smothered in the dense green of the coastal forest. Take the road beside the graveyard down to the small village on a narrow bench above the river. The huge white Church of the Holy Cross towers over the dusty village street, a miracle of survival: it has been standing here since it was completed in 1905. There are other B.C. churches older and as elegant as this one, but none in such an isolated place. It is a marvel of Carpenter Gothic architecture, its facade flanked by two hexagonal towers, each topped by a slim and richly decorated spire, with a third spire above the centre roofline. A half-circle fan light above the door echoes the flower design of a rose window above. And all the Gothic windows are filled with stained glass imported from Europe. Inside, everything is ornately beautiful, with much hand-carving and ornamentation, particularly on and around the white and gold altar. And when the sun shines through the windows, casting pools of colour onto the painted pews and wooden floor, it is heavenly indeed. Arriving here at the end of a very long and dusty (or muddy) road really does seem like the completion of a pilgrimage. The place is difficult to leave. The village is quiet, the roar of the river very loud.

This historic church, on a historic route, has been designated a national heritage site. A Catholic mission was established here in 1861, and there were at least two previous churches in the village, which once must have been far larger than today. Still in use for special occasions (the bell is the local alarm for fire or other disasters), the church is in need of repairs and restoration. (Donations can be sent to The Ama Liisaos Heritage Trust Society, Box 95, Mount Currie, B.C., V0N 2K0. Email: amaliisaos@canada.com.) ❖

Three spires of the Church of the Holy Cross thrust heavenward in the Native village of Skatin, south of Mount Currie.

GHOST TOWNS, GHOST TRAILS

Princeton is a small town at the eastern foot of the Cascade Mountains at the confluence of two lovely rivers, with even lovelier names: Similkameen and Tulameen. If you say these words slowly, like a mantra, you can't help feeling peaceful, contemplative. And that's the right attitude when driving the old stagecoach road north to Aspen Grove, for it's a slow and winding route that leads through the thick of B.C. history, a history that was founded on the rich resources of the area.

Like all of British Columbia, the area was first Native land. Cliffs along the Tulameen were a source of red ochre, a precious commodity used for paint, which brought First Nations traders from as far away as the prairie grasslands. The first Europeans to enter the valley were also traders: the fur brigades tramping from Hope to Kamloops via Nicola camped at Otter Lake. They were followed in turn by prospectors who worked the creeks for gold. Later on, coal was discovered and ephemeral boom towns were born, strung together by a road and, later, a railway. But the industrial heyday faded. Today, the old settlements are merely skeletons, some of them ghost towns if you wish to call them so, others adopted for summer recreation use. But the wagon road remains, just about where the first builders put it.

For most of the way north from Princeton, the old road follows the abandoned ghost track of the Vancouver, Victoria and Eastern Railway (VV&E), which raced along here vying with the better known Kettle Valley Railway (KVR) to reach the coast first, scooping up ore-hauling contracts along the way. The VV&E railway grade is now part of the Trans-Canada Trail, visible along the way for 65 kilometres.

A short walk along the trail north of Princeton will take you through a long VV&E tunnel and across an old railway bridge to the site of the ochre cliffs. The tunnel goes underneath

The abandoned VV&E railway track (now the Trans-Canada Trail) winds beside the Tulameen River.

118

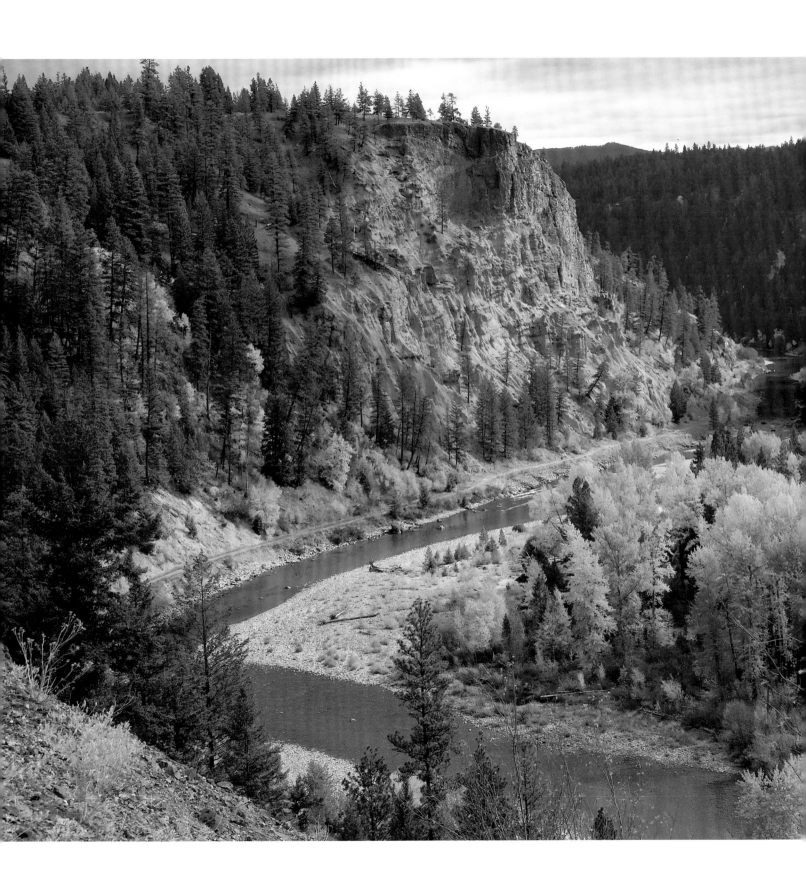

LEGEND

Country Roads route
optional route
other roads
bridge
tunnel
large community
small community
place of interest

to
Merritt

to
Aspen Grove,
Merritt
and Nicola

5

Coley Creek Road

BROOKMERE

Spearing Creek

N

Old station
site, Thalia

5A

Otter Creek

Thynne Lake

Thynne Ranch

Frembd Lake

Otter Lake

Tulameen River

TULAMEEN

COALMONT

to
site of
Blakeburn

Granite
Creek
(ghost town)

VV&E
rail tunnel

Vermilion
cliffs

Old Hedley Road

Similkameen River

PRINCETON

3

Tulameen River

3

Similkameen River

Similkameen River

Trans-Canada Trail

to Coalmont

PRINCETON

Tulameen River

Tunnel

3

Similkameen Ave

Similkameen River

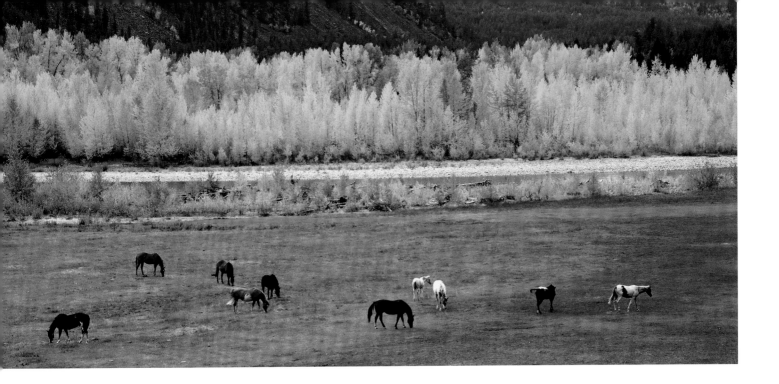

Young poplars in fall colours create a vivid backdrop for horses grazing beside the Similkameen River.

Highway 3, piercing the ridge that separates the two river valleys. Some lighting has been installed for safety, but the tunnel is still a dark and spooky place, so bring a flashlight. Once through the tunnel, a pleasant 15-minute riverside stroll brings you to the striped red ochre cliffs. To the first inhabitants, this vermilion earth was *tulameen*. The high and crumbling rock outcrop is mostly red, but among the many different layers you can see shades of yellow and orange and bands of dark chocolate. In fall, with the cottonwoods and aspens in brilliant shimmering gold beside the river, this is a walk to be remembered. Ask at the tourist office (just east of town on Highway 3) for specific directions to the tunnel, or just drive west along residential streets south of the highway.

The Native settlement at Princeton, once situated on the flats near today's RCMP station, was known as Yak Tulameen, "the place where red earth was traded." The first Europeans changed the name to Vermilion Forks, and in 1860, when the townsite on the newly built Dewdney Trail was surveyed, Governor James Douglas changed it again, to "Princetown," to commemorate the visit to eastern Canada that year of the Prince of Wales.

Once through the tunnel, our route begins at the north end of Princeton's Bridge Street, where the original stagecoach road crossed the Tulameen River. The bridge is narrow and wooden, wide enough for only one lane of traffic. Turn left across the bridge and follow the old route up through pine benchlands, passing side roads to Snowpatch and China Ridge ski areas. The road negotiates through steep cliffs high above the river, then narrows as it cuts through even steeper terrain. If you can stop safely and look down, you will see the river, the red bluffs and the railway grade far below.

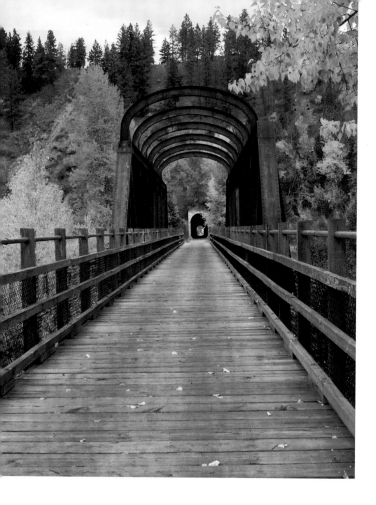

The old rail bridge of the VV&E and the tunnel beyond provide access along the Tulameen River to the red ochre, or vermilion, cliffs.

Once past the red earth, the road descends quietly into the valley and the town of Coalmont (about 18 kilometres from Princeton), where an immense three-storey hotel, built in 1911 and painted the colour of a boiled lobster, is still very much in business, though it wears the ramshackle look of a long and lusty life. Little else remains of the town: a few deserted false-front buildings, including a meat market and a general store, and several cabins under the cottonwoods. Coalmont was founded around the turn of the century by the Columbia Coal and Coke Company to house workers for its huge lignite mine in the nearby "mountain of coal." The VV&E railway first chugged into the valley in 1912 and immediately contracted to buy some 500 tonnes of this coal a day to feed its steam locomotives. Rail spurs were built to carry coal from five of the surrounding mines, but Blakeburn, the largest and longest lived of the coal mines, shipped its ores to rail by means of a 600-metre aerial tramway.

With the town connected to the rest of the world by rail, Coalmont's prosperity seemed assured. The *Coalmont Courier* painted an optimistic picture of the town's future, expecting a population of 10,000 to rush into what it called "the City of Destiny, the coal-mining metropolis of southern B.C." But this was false optimism. The easily extracted surface coal was soon exhausted, and deeper seams were thin and unprofitable. Many of the mines closed, but Blakeburn kept going full steam right up until 1930, when a terrible catastrophe sealed its fate. On "Black Wednesday," August 13, a huge explosion at the Number 4 Mine sealed the tunnel opening, entombing 45 men working underground. Rescue attempts proved futile, a blow from which the community never recovered. The mine did re-open in a small way and continued to produce coal for several years, but in 1940 it closed for good.

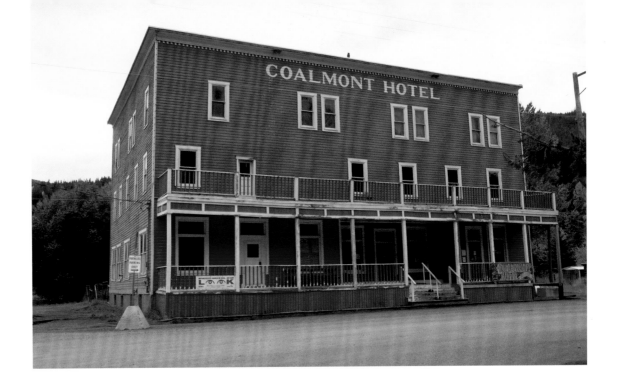

The Coalmont Hotel, the heart of the town, has been going strong since 1911.

Coal mining in the valley is relatively recent. Before coal there was gold. A short distance from Coalmont (though a good 60 years older) lies the ghost town of Granite Creek. In 1885, news of a large gold nugget, picked up in the stream by a passing cowboy named Johnny Chance, started a stampede. A prospectors' camp at the mouth of Granite Creek soon exploded into a town of more than 2,000—some called it Granite City—and at one time it had more than 200 buildings, including 13 saloons. After only two years it became the third largest town in B.C. Placer gold from the creek and its tributaries was taken out in vast quantities: government reports record shipments worth $90,000 in only four months.

To visit the site, turn beside the Coalmont Hotel, cross the Tulameen bridge and drive along the river to an intersection marked "Brigade Trail" and "Blakeburn." Straight ahead down a grassy track lies all that is left of the town of Granite Creek, beside the creek of the same name. Park here and walk out onto the flats. Where did it all go? Little is left of the gold-rush boom town: traces of old streets, a couple of leaning ruins, some piles of old lumber and ground hillocky with old cellars and the diggings of ghost-town relic hunters. The good times on the Granite lasted a scant three years, and the motherlode, if it exists, was never found. Miners left, the town was deserted and fire and vandalism took their toll. It's a sad place, but a beautiful one. Every spring the flat is golden with sagebrush buttercups, and gold returns to the creek every fall when the cottonwoods blaze. Now a forest service campsite, this is an interesting place to walk around at any time of year, and in the tidy little cemetery above the townsite you can read the inscriptions on the tombstones (one records the death of storekeeper Foxcrowle Percival Cooke, a magnificent name) and listen to the stories of the real Granite Creek ghosts.

One of these might very well tell of the white mineral that miners found intermixed with the gold in their pans, very difficult to separate out. Bucket-loads of the stuff were simply dumped back into the river. This mineral was platinum, worth far more than gold, if the miners had only known. (The Tulameen River system and Russia's Amur River are the only places in the world where free platinum is found). One miner, a Swede by the name of Johanssen, didn't throw away his bucket of white stuff, but buried it beside his cabin door, all 10 kilograms of it—or so the whispers go. The cabin burned down in one of the great fires, but the bucket is still there, somewhere on the river flats—if you listen to ghost-town talk.

If you want to touch something more substantial from the old days, the original bar from the Granite Creek Hotel is to be found at the museum in Princeton, along with much other gold-rush memorabilia, including one of the Welby stagecoaches that used to come this way.

The road from Granite Creek continues up the hill to the old townsite of Blakeburn (now obliterated by an open pit mine) and to an access point for Lodestone Lake on the Brigade Trail, a wilderness route still travelled on occasion by hikers and horseback riders. To continue on the route north, retrace your steps to Coalmont and follow the river for eight kilometres to the settlement of Tulameen, at the foot of tranquil Otter Lake. A far older settlement than either Granite Creek or Coalmont, Tulameen was once the site of a large Native encampment, a place where women and children traditionally stayed while men of the tribe went into the mountains to hunt. It was already established when the fur traders came this way and they called it "Campement des Femmes." It became a popular rest stop for the fur brigades after their gruelling five-day passage over the mountains from Fort Hope. Later, a tent city of several thousand bloomed here during the gold-rush frenzy, and a townsite was surveyed in 1901. The gold never amounted to much, and when the railway came through, the townspeople found another commodity to sell. Otter Lake freezes solidly every winter. Cut into blocks in January, the lake ice was shipped south by rail to keep iceboxes cold throughout the American west.

Today, tiny Tulameen enjoys a laid-back recreational atmosphere: the lake provides excellent boating, fishing and water skiing. The old HBC Trail of 1859 and the later stagecoach road follow the western shore (the railway track and the Trans-Canada Trail thread east) past summer cabins and a popular provincial campsite. North of the lake, the valley narrows, filled with a string of smaller marshy lakes and crowded in by steep mountain slopes. Between the lakes, stretches of meadowland provide attractive settings for old ranches and tumbledown barns, herds of cattle and sheep.

About 40 kilometres from Princeton is the Thynne Ranch, one of the area's most historic places, an overnight rest stop on the stagecoach run between Nicola (north of Merritt) and Princeton in the days when the jolting journey took a good day and a half. Coaches left Nicola at

Historic Thynne Ranch, shown here dwarfed by giant cottonwoods, was once an overnight stop on the stagecoach road in the Otter Valley. It is now a private ranch.

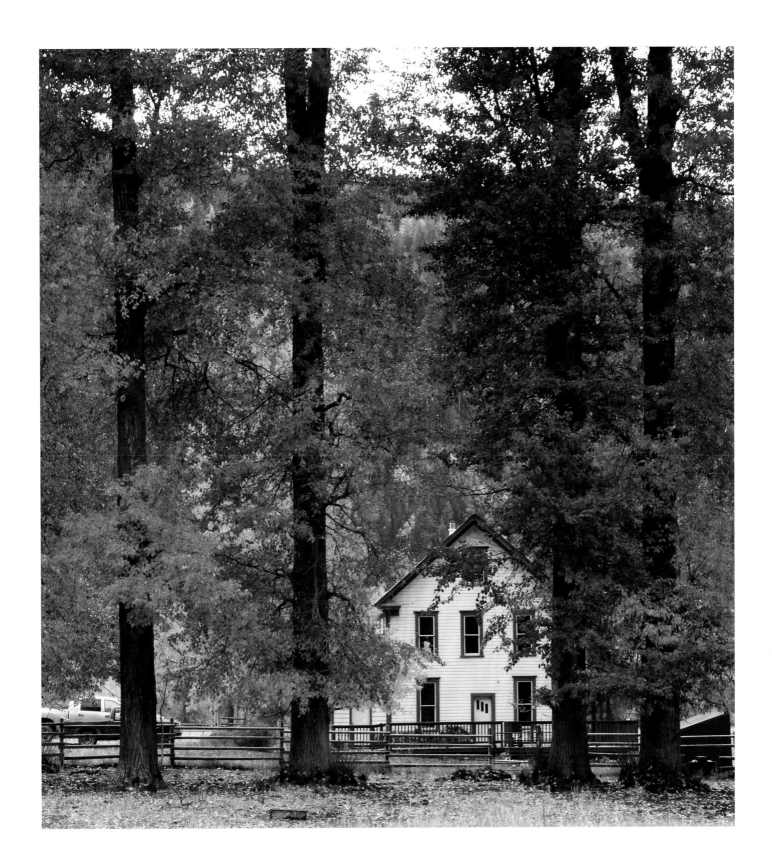

6 a.m. and arrived at Jack Thynne's house by way of Aspen Grove at 7 p.m. The horses would be stabled and fed and passengers put up for the night. At 6 the following morning, the stagecoach left again, arriving at Granite Creek by 10 a.m. and Vermilion Forks (Princeton) in time for lunch. Today, the trim three-storey ranch house stands in a shady grove of old cottonwoods surrounded by fences and barns and mountains of round hay bales. There is no sign to mark its history and the house, now known as the Mullin Ranch, is privately owned.

Beyond the Thynne Lake meadows the road runs across talus slopes with Otter Creek below in a maze of willows and red osiers. Spearing Creek cuts in from the west and here the VV&E railway once crossed the road on a high wooden bridge at the station of Thalia. The bridge has disappeared, along with the rail tracks, but the Trans-Canada Trail follows the rail line faithfully: there's an old bicycle propped up here with a sign indicating hot showers down the track. The route is popular with cyclists.

The road veers northwest from Thalia, through tight Otter Creek Canyon and out into a broad valley laced with aspens—good rangeland for cattle. A few kilometres farther, at the Brookmere Road intersection, you have to choose between the stagecoach-HBC route north to Aspen Grove, or west along Coley Creek Forestry Road, which meets up with the railway and follows it to Brookmere. If you're a purist intent on following the threads of history you'll want to take the first option, an easy 14 kilometres through meadow and forest to Aspen Grove on Highway 5A and then, if you choose, down to Merritt and (still on Highway 5A) the town of Nicola, the oldest settlement in the area. Bypassed by the railways and eventually outshone by the upstart town of Merritt, Nicola retains many traces of its pioneer pretensions. There are a few Victorian houses, a grand old courthouse and one of the oldest and prettiest churches in B.C. It's an interesting and appropriate place to end the journey.

If you're a railway buff and choose the Brookmere route, be prepared for a slightly rougher drive along some 10 kilometres of logging road to the Spearing Creek Valley, where the route follows the old railway line to the junction town of Brookmere. This was a two-railway town, for it serviced both the VV&E, which came north from Princeton, and the KVR, which came west from Merritt. Because Brookmere was a divisional point for both railways, there had to be two of everything: roundhouses, turntables, coal chutes, sheds and stations. The only service the two railways agreed to share was a water tower: it was built with two spouts, north and south, one for each of them. Today, this red landmark is one of the few physical remains of railroad days, a reminder of the town's past. The sole remaining station is now a private home. The tracks have been pulled up, and yet this tiny town still holds together, basking in its railway history. From here, it's an easy dozen kilometres along a wide, straight road to the Coldwater River for access to the Coquihalla Highway and the town of Merritt. ❖

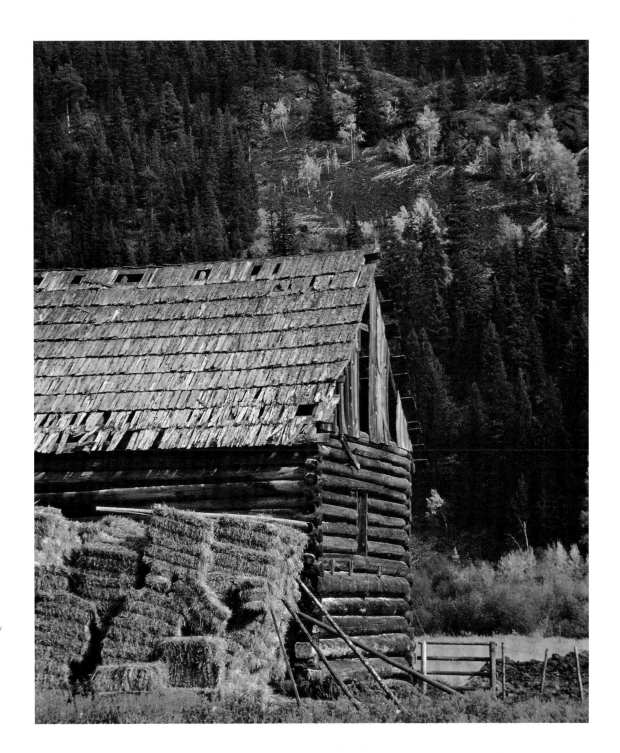

The Otter Valley is narrow and damp, good country for haying.

LAVA ROAD TO THE NASS

Many years ago, when the humpback salmon were spawning, two young boys playing beside the Nass River caught some fish, slit their backs and inserted thin slivers of slate that resembled the fins of a killer whale. When they put the fish back into the river, the boys laughed to see them trying to swim. Suddenly, disaster struck. The mountains roared—they had been rumbling off and on for months—and a great pillar of smoke appeared on one of the peaks. The people of the Nass watched in awe as a river of burning molten rock moved slowly, inexorably down the valley. Before the fiery punishment reached the villages, people who ran out of their houses to look at the spectacle were smothered by deadly fumes. Other villagers fled as best they could, or buried themselves in earth cellars. When the violent episode was over, two settlements had been entirely engulfed by the lava and 2,000 people were dead. The salmon spirits had exacted a terrible revenge.

This is the Nisga'a oral history account, retold many times, of British Columbia's most recent volcanic eruption, which occurred in the Nass Valley about 225 years ago, a geological catastrophe that changed the face of the Nisga'as' world. A written report of the event has also survived. In 1775, sailors on the Spanish ship *Sonora,* under the command of explorer Juan Francisco de la Bodega y Quadra, apparently witnessed the eruption from the mouth of the Nass River. The expedition chronicler described a landscape in upheaval: great heat and flames shooting up from four or five mouths of a volcano and flames so high they lit up the night.

Scientific radiometric dating confirms two eruptions in the Nass Valley, at approximately 650 and 225 years ago, as well as evidence of other older flows. The culprit volcano, pinpointed today by a sharp cinder cone along a tributary of the Tseax River, erupted violently, spewing lava downhill for five kilometres, where it piled up, damming the river to form Lava Lake. Lava

Fields of lava from B.C.'s most recent volcano cover a huge area of the Nass Valley. Early-morning mist rises like smoke.

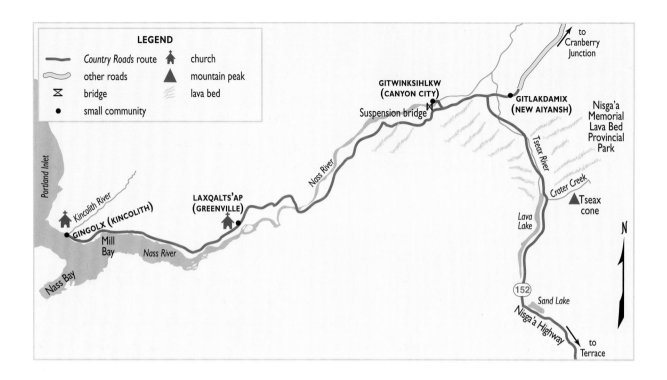

continued to flow for another 22 kilometres down the Tseax, where it fanned out into a great molten sea, pushing aside the Nass River and burning and burying everything in its path. Eventually, 38 square kilometres of fertile coastal forest was gone and in its place lay a wasteland of solidified lava, 12 metres deep.

This journey from the Skeena River near Terrace to the mouth of the Nass leads through the eerie landscape of the lava fields, where tumbled sheets of glassy rock are softened by bumpy bandages of grey moss and lichens. In two hundred years, only a few sprigs of fireweed and some brave willows have established a foothold in this raw moonscape. But there is much of geologic interest: there are two types of lava, smooth and wrinkled; lava tubes, like huge drainpipes; tree casts bearing the imprints of long-lost forests; and the cinder cone itself, today all innocent, its volcanic fury long spent. There is also a kind of haunting beauty. For above this great sea of destruction, snow-covered mountains rise high and virginal, their forests a deep and luscious green, and morning mists hover above the lava fields like smoke.

To reach the volcano lands of the Nass, begin the journey just west of the town of Terrace and follow Highway 152 (the Nisga'a Highway) north to the heart of Nisga'a territory, where the Nass River is known as Lisims. In spring, when the river is silty with glacial flour, it is known as Ayns Lisims, or the River of Milk, and in Nisga'a tradition it is said to achieve its milky white froth from mixing with the milt from eulachons, the tiny oily fish that play a large

part in Native culture. The "grease trails," which laced together the different peoples of the north, were trade routes established primarily to transport eulachon oil to the Interior, and to bring trade goods back. Spawning as early as March in the river mouth, the eulachons were a welcome spring tonic.

The highway follows the Kitsumkalum River, a Skeena tributary, which flows clear and blue into long Kitsumkalum Lake. The road hugs the shore, with only a few places to pull off and admire the view. Rosswood general store near the lakehead provides gas and snacks and a chance to fill up the canteen with some pure cold water—from a spigot set into a tree (about a kilometre south of the store.) Cedar River flows into the Kitsumkalum just north of the lake, and when you cross the Big Cedar Creek bridge you are on a divide: north the drainage is into the Nass by way of Sand Lake and the Tseax River.

The first sign of the lava is at Lava Lake, a narrow 10-kilometre-long finger that fills the valley floor, leaving barely enough room for the road along its eastern edge. Formed when lava from the volcano dammed the Tseax River, the lake and its surrounds are now part of Nisga'a Memorial Lava Bed Provincial Park, which extends all the way to the Nass. The lake has an otherworldly aspect: rimmed by sheets of broken, grey, moss-covered lava, its colour is a startling milky green, the reflections very clear. Its Native name is Sii T'axl, or "new lake." A picnic site at its northern end has a canoe-launching ramp.

From here, with the help of the park's *Auto Tour Guide* (available at the visitor centre at the entrance to the park campground), you can follow the road along the Tseax River, investigating places of interest along the way and stopping for short walks. The river is intriguing, sometimes disappearing beneath the honeycombed lava, then emerging to form deep green pools. Several pretty waterfalls tumble into it. Crater Creek, now covered by lava flow (its Native name, Lax Mihl, means "on top of fire"), is a good place for a short walk. Go carefully: the lava is sharp and uncomfortable, especially through sandals. On the plateau above is the Tseax Cone, out of bounds unless you're on one of the guided hikes that leave from the visitor centre and go right up to the crater rim. The centre itself is built in the style of a Native longhouse, its facade painted with totemic emblems.

Where the park road approaches the Nass River, the lava spreads out, engulfing nearly the whole valley. It's a most impressive sight, particularly when the mountains above are covered with snow, a cool contrast to the once-fiery fields of destruction. Park signs describe the interesting features and short trails lead to some of them.

At almost 100 kilometres from Highway 16, the Nisga'a Highway meets the Nass River. At a T-junction, the road to the right leads to the surprisingly large and modern village shown on most maps as New Aiyansh. It's now Gitlakdamix, the name of the previous (but post-apocalypse)

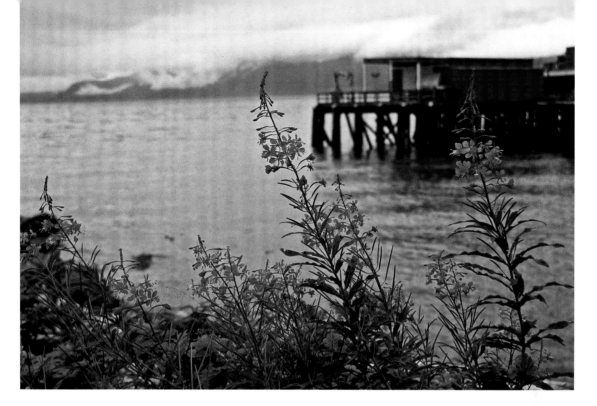

settlement that was located on the west side of the river and subject to regular floods. The new village was established on higher ground in 1961, and everything seems spanking new, including the architecturally stunning band office and the community hall, its front painted with Nisga'a designs. The village provides basic tourist facilities, and the general store sells gasoline as well as snacks. Beyond, forestry roads lead northwest, all the way to Alice Arm at the head of the long fiord of Observatory Inlet, and northeast almost 50 kilometres through the bush to Cranberry Junction on Highway 37. The latter route connects with the country road described in Chapter 5, but it's a logging road and its surface can be rough and potholed.

To continue this journey to the sea, return from Gitlakdamix to the T-junction and drive straight south through the stark lava plain along the Nass Valley, pausing at the memorial plaque to remember the lost villages, then turning right (west) on the road to Canyon City (now Gitwinksihlkw, or "People of the Place of Lizards") on the far side of the Nass. The road bridge was built in 1995. Before that, a skinny footbridge suspended high above the river provided the only land access to the village, and even this wasn't built until 1969. In the years before, the river provided the only transportation, and villagers boated down to the river mouth at Kincolith for supplies brought in by steamer from Prince Rupert.

Park just before the new road bridge and walk down to see the fish wheels, set up to count salmon coming up the Nass en route to their spawning grounds. The bridge entrances are flanked by totem poles depicting the four Nisga'a clans, Wolf, Eagle, Raven and Killer Whale. Drive into the village to walk across the old suspension bridge. You'll pay a small fee for the privilege

Old carving near Gitwinksihlkw suspension bridge.

132

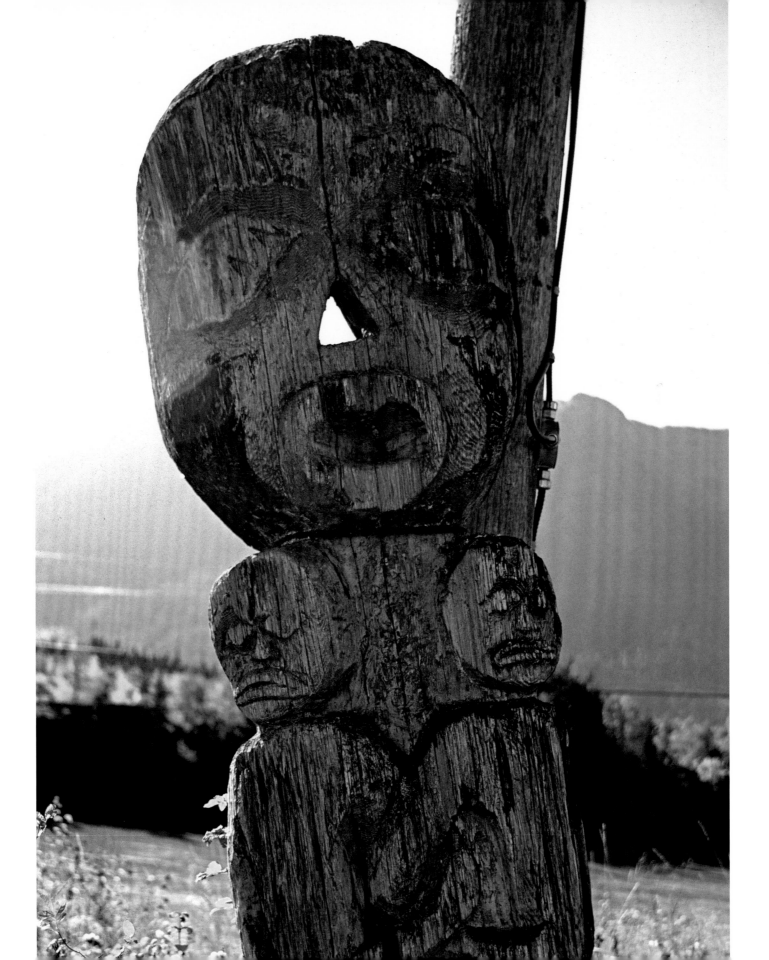

of crossing the river this way, but it is an experience to remember. High on the swaying planks above the Nass, you can see and feel the raw power of the churning water and look across a sea of lava to the sparkling mountains. There's a coffee shop beside the suspension bridge and old grave markers in the long grass nearby. Also well worth a look is the very tall pole at the community centre; raised in 1992, it was the first carved here in more than a century.

Return across the river to the main road and continue southwest along the Nass, at first through lava fields, then through tall forests of cedar and cottonwood, crossing several rushing tributary creeks. Views of the river are scarce, but about 20 kilometres from Gitwinksihlkw, where the road forks, a bridge leads the main road across the river, now very much wider as it approaches its estuary. Gulls wheel and call over the water. Notice the air: if you stop and sniff, surely there's the tang of the sea?

The village of Greenville, about 10 kilometres west of the bridge, was named for Methodist missionary Alfred Green, who arrived here in 1877 and had a tough job persuading the villagers to abandon their old beliefs. Today the community is known as Laxqalts'ap, one of four Nisga'a villages on the Nass and the centre of the historic eulachon fishery. Situated near the tidal waters of Fishery Bay where the Ishkheenickh River flows into the Nass, this place has always been a multicultural fishing ground. The Haida, Tsimshian and Gitxsan were welcome to fish here, side by side with the Nisga'a. Accessible by road only since 1984, this part of B.C. is wilderness indeed: the Ishkheenickh River and its tributaries reach far into trackless mountains, south to the very edge of the Khutzeymateen Grizzly Bear Sanctuary.

Ravens watch over the beach at Gingolx.

Laxqalts'ap provides a few tourist amenities (check at the administration office, the largest building in town). There's a totem-carving shed (visitors welcome) alongside the wharf and fishboats are tied up nearby. The big red church is fairly new. The first one here burned down in 1922 while all the people in the village were away fishing for eulachon. Eulachon still come into the river to spawn in huge numbers in March and April, and they are caught, dried and traded, just as they have always been. An added attraction for today's travellers are the predators—gulls, eagles, seals and even killer whales—that come into the river in huge numbers to feast on the little fish.

Beyond the village, around Black Point, the road runs along the edge of the Nass River estuary, which stretches wide: the opposite shore seems very far away. Suddenly it's a maritime landscape, waves washing onto sand flats and pebble beaches heaped with seaweed and driftwood, with eagles and great flocks of gulls feeding in the eelgrass and wheeling overhead. In dramatic contrast to the strange, barren land of lava, this is a totally different country, with its fiords and forests. From Laxqalts'ap, the beautiful 28-kilometre drive is fringed by cliffs and open to the western sky. It winds past Mill Bay and Fort Point to the protected shores of Portland Inlet and the end of the road: the village of Kincolith, now Gingolx, "place of skulls."

The name refers to the ancient practice of posting skulls on sticks at the river mouth to scare strangers away from the rich fishing grounds. Today, visitors are welcome here. The small fishing port (population 500) is becoming known for its Crabfest, a two-day musical event in July that draws performers and visitors from afar, to feast not on musical offerings alone, but also on local crab, salmon and halibut. Until the road was put through from Laxqalts'ap in 2003, people and supplies came in by boat or float plane.

Originally settled in 1867 as a Protestant mission, Gingolx still has an impressive church. It's a huge white building with two towers, a steeple and flying buttresses, built in 1900 and refurbished in 1961. Today, the Native heritage of the village is most apparent. It is home to a famous troupe of Nisga'a ceremonial dancers, and the Native carvers here are producing work of world renown. There are new totems at several locations: by the school, the playground and flanking the handsomely painted longhouse that doubles as a gift shop. A paved walkway leads around the bay to Gossip Dock, where a traditional roofed area seats old-timers swapping yarns. And across from the long breakwater and wharf, a big old landmark hotel sits sturdy and comfortable. A totem pole here provides a perch for fishing eagles. Drive west through town as far as you can, across the long bridge over the Kincolith River mouth, and follow the sign to the marina to look at the fishboats and enjoy the fresh sea winds—a restful place to end the journey.

If you plan to stay the night in the Land of the Nisga'a, reserve early. There are only two B&Bs in Gingolx, a few more in and around Gitlakdamix. ❧

SAGEBRUSH SOLITUDES

Canada has only a few pockets of dry country that can rightly be called desert, and one of the loveliest lies in the south Okanagan, where a northern leg of the great Sonoran desert sidles up through western North America, beginning in Mexico. Here, areas of dry, sandy scrubland, bony with cliffs and boulders and peppered with sprawling antelope brush, sage and cactus, are home to a variety of desert denizens such as rattlesnakes, scorpions and spade-foot toads. It is vanishing fast. Every year, more desert succumbs to irrigation, as juicy orchards and vineyards, relying on water from the Okanagan River, replace the sagebrush with a livelier green. Fortunately, parts of this desert, technically a southern grassland/sagebrush ecosystem, are being saved.

Why is there desert here? The whole of the Okanagan lies in the rain shadow of the Cascade Mountains, and Osoyoos, at the southern end of the valley (the Canadian end, at least) receives an average yearly rainfall of less than 20 centimetres. In the face of global warming, it may in future receive even less.

Cut through with ranch and vineyard roads, the remnant desert lands in the South Okanagan are easily visited. While this easy access might not always be desirable, given the fragility of the terrain, it allows observation—and appreciation—of the desert's many moods. This route starts at Osoyoos, a desert hotspot known for its warm lake and sandy beaches, travels north through the Native Nk'Mip lands, then crosses the Okanagan Valley to explore the high sagebrush bowl cradling White Lake.

In spring, the desert comes alive with thick clumps of pink phlox.

Traditionally, the east side of Osoyoos Lake at the narrows (where Highway 3 crosses) was a gathering place for the Okanagan people. Families came from afar to fish for trout and salmon, to gather berries, trade for vermilion and obsidian, and engage in intertribal festivities. The remains of their kekulis, or semi-underground winter homes, can still be found along Nk'Mip

N

LEGEND

Country Roads route
optional route
other roads
○ large community
● small community
✹ place of interest
⛪ church
▲ mountain peak
border crossing

to Penticton
97

Skaha Lake

OKANAGAN FALLS

Observatory ✹

Twin Lakes
TWIN LAKES

White Lake

Green Lake

97

Mahoney Lake

Vaseux Lake

McIntyre Bluff ▲

3A

to Princeton

KEREMEOS

CAWSTON

Okanagan River

Site of Fairview ✹

OLIVER

Similkameen River

3

Mount Kobau ▲

Black Sage Road

⛪ Nk'Mip Village

Haynes Ranch ✹

22

Spotted Lake

3

Osoyoos Lake

Anarchist Mountain ▲

Nk'Mip Cultural Centre ✹

to Rock Creek

OSOYOOS

CHOPAKA

NIGHTHAWK

BRITISH COLUMBIA
WASHINGTON

97

Osoyoos Lake

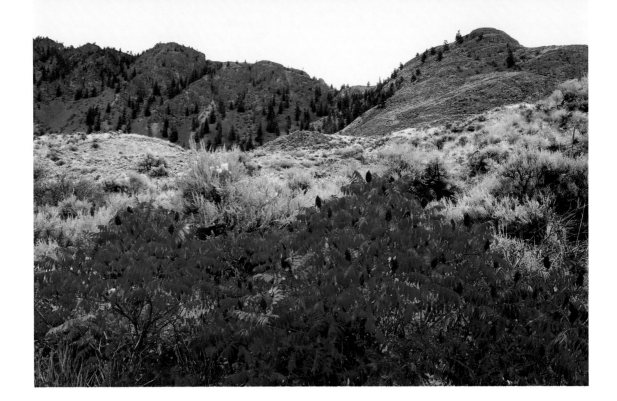

Creek, and there are ancient pictographs in the hills above. The reserve lands are private and can only be explored with an Nk'Mip guide, but the road through the desert is public domain. Drive it slowly, look and listen, but do not trespass.

It is fortunate for desert lovers that the Nk'Mip reserve lands on the east side of the Okanagan River were not irrigated until recently, and that a large expanse of the 12,000-hectare Native territory—most of it desert—remains pristine, despite the Okanagan Band's investment in viticulture and tourism. Part of the desert here has surrendered to vineyards, a successful winery, a resort, campground and even a golf course. But the Nk'Mip people take seriously the custodianship of the remaining desert lands. Near the winery, a cultural centre focuses on Native traditions and the ecology of the land. Primarily an educational centre, it is surrounded by four kilometres of interpretive trails that wind through 25 hectares of different desert ecosystems. A visit here will provide much background information for the trip ahead.

Since early days, Osoyoos has been a natural crossroads, first for Native trails, then for those of the fur traders, and later, for gold-rush prospectors. The Hudson's Bay Company fur brigades en route from Fort Okanogan on the Columbia River to Thompson's Post at Kamloops camped in the meadows at the head of Osoyoos Lake. Gold rushes at Rock Creek (along Highway 3 to the east), and later in the Okanagan and Cariboo, saw this north–south route pressed into service again, as miners and cattle drovers passed along the lake, heading for the gold camps.

The Dewdney Trail built from Fort Hope to the Kootenays became the route of today's Highway 3, which intersects at Osoyoos with Highway 97. From this highway junction, drive

north on Highway 97 for about four kilometres and follow a sign (right) to the cemetery, where a cairn commemorates the first customs house in the Okanagan, built here in 1861 just after the first gold strike at Rock Creek. The post was manned by John Haynes, who was also the gold commissioner and later became a judge and the area's largest rancher.

Return to the highway and continue north to No. 22 Road, which heads east through valley meadows to cross the Okanagan River, here confined into a channel for the purposes of irrigation and flood control. The dikes along the channel provide good access for hikers, bikers and anglers—there are good-sized rainbows here—and the meadows themselves provide cover for snipe, meadowlarks and short-eared owls. Across the bridge, the road twists beside a marshy area of former riverbed and then climbs to a T-junction on a sandy bench. The barn on the left and the two tumbledown wooden buildings on the right are all that remain of Judge Haynes' ranch, built in 1882 of lumber barged down the river and through the lakes from Okanagan Mission near Kelowna. There are two homes here: the smaller one, to the south, was the original homestead. This became a bunkhouse for cowhands when the larger house was built beside it. These heritage ranch buildings, stark against the desert slopes, are being restored: they comprise one of the earliest historic sites in this part of B.C. Nearby, a section of the old ranch property is now the Haynes Lease Ecological Reserve, desert set aside principally for the re-introduction of the endangered burrowing owl.

Turn right at the road junction by the old ranch and head downriver toward the Osoyoos Oxbows, another reserve that protects critical habitat. This cut-off part of the original river is considered one of the best birding places in the Okanagan. There are prominent osprey nests, and in summer long-billed curlews, black-throated swifts, lazuli bunting, canyon wrens, bobolinks, hummingbirds and many other species can be seen. Stiles provide foot access through the desert down to the river where, in October, you can watch Kokanee spawning in the shallows.

At first glance this desert seems empty of life, for most of its inhabitants are nocturnal or seek the shade. Larger mammals such as deer, coyotes and bighorn sheep live here, but it's the smaller species that are of most interest, several being rare or endangered. Here are five-toed kangaroo rats, pocket mice, horned and spadefoot toads, rattlesnakes, scorpions and black widow spiders. Shrubs and flowers bloom in the desert for most of the year, from the first shiny sagebrush buttercups and pink phlox to golden cactus flowers and sharp yellow blossoms of the antelope brush. In hot July, when you think nothing at all could survive in such baked earth, mariposa lilies unfold their elegant three-petalled flowers in a fragile shade of mauve. September brings the gold of rabbitbrush, and the first frost turns sumac bushes to flame. The Okanagan desert is truly an endless source of natural delight.

Historic Haynes Ranch, built in 1882 at the edge of the Okanagan desert near Osoyoos, awaits restoration.

East of the Okanagan River, our road runs through Native reserve lands above the valley, at first through desert, then through vineyards at the foot of craggy Throne Mountain. It cuts across to the shady cottonwoods around Inkaneep Creek (the old spelling of Nk'Mip), crosses the creek bridge (about 4.5 kilometres from the highway), turns left up a rocky draw and heads north through uncultivated, stony desert, on the east side of the Throne. Watch for circling turkey vultures and eagles and, as you near the creek again, for California quail. Nk'Mip village itself is scattered. The schoolhouse appears first, then a cluster of old houses and then, at nine kilometres, on the north side of the creek, the tidy white and blue frame Church of St. Gregory appears on top of a rise. It is an old church (1885), but a little beyond is an even older one, of hand-hewn logs. In 1964, investigations by the Okanagan Historical Society revealed that this had been built around an even older and smaller church. Windowless and with a sod roof, this first building was dated to before 1860. The church that was constructed around this older core is of logs, once sheathed with pine planks. Today in ruins and open to the elements—only swallows congregate here now—its stark simplicity is somehow more redolant of past faith than the "new" church opposite. The Catholic church at Inkaneep was known in pioneer days as the Division Church because it marked the boundary between the administration of the Oblate missionaries, headquartered at Mission in the Fraser Valley, and that of the Jesuits, working out of Colville, Washington.

Beyond the church, the valley widens to encompass fields, open pine woods and small lakes, overlooked on the west by high rocky bluffs that separate it from the Okanagan Valley. Much of the land for the next six kilometres is, luckily, still desert. Inkaneep Road intersects Black Sage Road on a shoulder above the Okanagan Valley. A left turn here will enable you to circle back to Osoyoos through an interesting contrast of scenery: dry desert on one side and irrigated orchards

Vines march in rows across the desert.

and vineyards on the other. To continue your desert journey to White Lake turn right (north) on Black Sage Road to Oliver, turn left, cross the Okanagan River bridge and Highway 97 and head west along Fairview Road into perhaps the most extensive desert lands in the Okanagan.

It is extraordinary that the huge area of grassland/sagebrush in which White Lake sits like milk in a teacup is still intact, a wonderful undulating sweep of country devoid of development, except for the observatory on its northeastern edge. Close to the well-populated Okanagan Valley and its communities of Oliver, Okanagan Falls and Twin Lakes, and intersected by a network of country roads, this area still seems splendidly wild, one of the unique places in southern B.C. The Dominion Radio Astrophysical Observatory, the largest in Canada, built its first radio telescope here in 1960 to map the sources of our galaxy by means of radio waves. To do this, it needed to reserve a large expanse of "radio quiet," and the White Lake area fit the bill. Much of this sagebrush bowl has been protected from development ever since, an almost 50-year hiatus from the pressures of urbanization. Now it is under the protection of the Okanagan Grasslands Reserve, a patchwork conglomerate of land (and the nucleus of a proposed national park) that extends south to the borderlands around Snowy Mountain and Kilpoola Lake, and east almost to Keremeos. You can visit this protected preserve from several directions, and each of the roads leading in to the observatory is worthy of your time. From Oliver, Fairview Road leads through town and orchards, then higher, onto a sagebrush flat. Here there's a place to park and picnic beside a signboard describing the site of Fairview, one of the early gold-rush towns in the Interior—of which nothing remains. Walking trails, park benches and a few old lilacs in former gardens are all that is to be seen.

Delicate blooms of pink Lewisia, a desert specialty.

It was high-grade lode gold in the hills behind Fairview that birthed the town in 1887, when the famous Stemwinder deposits were staked, to be followed in short order by Morning Star, Tin Horn, Wildhorse, Smuggler, Brown Bear and Rattler, mines strung out in the gulch of Reed Creek. Fairview very soon became the largest town in the Okanagan, with everything necessary for urban life: stores and livery stables, doctor's office, school, government buildings, two churches, a Chinese laundry and a jail. Its six hotels included the Fairview, a three-storey palace with an elegant Gothic tower that prompted its nickname of "The Big Teepee." The town supported 200 families for almost 20 years, survived a typhoid epidemic and a disastrous fire that levelled the Fairview Hotel in 1902—but it could not survive the death of the mines. By 1910 Fairview was finished and the townspeople moved away. A few of the buildings were dismantled for lumber or were moved, but most of the old town was abandoned and eventually burned. For many years, the sole remnant of this "ghost" town was the one-room jailhouse, complete with iron bars, but this has since been moved to the Oliver Museum.

But there was treasure of a different kind at Fairview. In the 1960s, souvenir hunters excavating the site of the Fairview Hotel hit pay dirt. Out of the rubble of the burned hotel came an impressive array of gold and silver coins, watch chains and diamond rings, items abandoned when guests fled for their lives, leaving their valuables behind. A bonanza indeed!

At the north end of the townsite, the road forks. Straight ahead, it leads along the valley of Reed Creek where a few traces of the old mines still survive, climbs around the shoulders of Orofino Mountain, then angles southwest to swoop down Blind Creek to the Similkameen Valley near Cawston. This is an interesting drive, though the road is closed in winter. The

righthand fork heads north to White Lake, through a narrow valley beaded with ponds and fringed with pines, past the UBC Geology Field Station. A few kilometres along, Sawmill Road turns left to Burnell Lake Recreation Site, and farther north, Secrest Road leads back to the main valley. Historians believe that the fur-brigade route north to Fort Kamloops left the Okanagan Valley in search of better grazing for their horses, and came up the draw at Secrest Road to extensive meadows on Meyer's Flat, where they regularly camped. From here on, our route follows the general direction of this historic brigade trail.

Meyer's Flat, watered by a tiny stream called Park Rill and now occupied in part by the suburban settlement of Willowbrook, is a good place to see poor-wills, night-flying birds that pick up insects on the hot pavement on summer evenings, then crouch, perfectly still. Drive slowly, and in the semi-dark your headlights will pick out their eyes, like twin rubies. The birds will often allow you to approach quite close before fluttering off, like great grey moths. At the top end of the flats, the road forks again. The right branch, signposted to Green Lake, leads to Hawthorn Mountain Winery by way of Mahoney and Green lakes (both good birding spots) and out to Okanagan Falls. The fur-trade route (and ours) follows Park Rill left through a narrow cultivated valley edged with sumac and wild clematis. Watch for scurrying families of California quail and keep an eye out for the rare white-headed woodpecker sometimes seen here. The road climbs beside steep volcanic cliffs and rounds a corner by Dry Lake, true to its name in summer: it's merely an alkaline depression. The cliffs are worth a study, both for their craggy castle formations and for possible sightings of rock wrens and black-throated swifts. Rattle-snakes also have their dens here.

This is the southeastern lip of the White Lake Basin and soon the lake itself comes into view, cradled in an immense sweep of sagebrush. You can park by a gate here and follow a track down to the lake's edge and beyond, but stay on the trail. This is all fragile land, much of it in the White Lake Grasslands Protected Area, though the lower parts of the basin and the lake itself (a total of 1,100 hectares) come under the jurisdiction of B.C.'s Nature Trust, which has bought several ranches here and is running them as experimental "biodiversity ranches." It will be interesting to see if a working cattle ranch can be sustained in rangeland conserved and improved as natural habitat for wild things.

White Lake itself is alkaline — usually thickly rimmed with white salts in summer — and known as a birder's hot spot. In spring migration, flocks of sandhill cranes congregate here, along with many species of water birds, including northern pintails and Wilson's phalarope. There are also shrikes, Brewer's and grasshopper sparrows, long-billed curlews, meadowlarks and perhaps even the rare sage thrasher. And it is also home to the endangered tiger salamander, which lives both in and out of water, burrowing under the earth to keep cool in summer. It is worth stopping

White Lake, rimmed with alkali, sits like milk in the teacup of the sage-covered basin. In the background is the astrophysical observatory.

often along the road here—there is little traffic—just to look about, listen to the meadowlarks and enjoy the pungent smell of sage.

Past the lake, the road divides yet again. While our route turns left here, take the right-hand road (which leads out to Highway 3A near Kaleden) for a visit to the White Lake Radio Astrophysical Observatory. You can see eight radio telescopes like giant TV satellites: a large one built in 1960, and seven other smaller ones, arranged in a row. Harder to visualize is the largest telescope of all: the T-shaped grid of 1,700 cedar posts strung with wires that stretches for more than a kilometre. Unlike at other observatories, the telescopes here do not view the stars and planets but monitor the skies for radio waves: in lay terms, they listen for messages from outer space. Now under the auspices of the National Research Council, the observatory's main mandate has been to map radio signals from the Milky Way as part of the Canadian Galactic Plane Survey. On summer weekends and holidays, observatory staff provide tours of the facilities and at other times you can walk in (park your car at the gate) for a self-guided visit.

Afterwards, return to the observatory gates, turn left and keep straight on, following the fur-brigade trail northwest around the curve of the sagebrush bowl. In spring, white lupines mingle with arrow-leaf balsamroot for a most pleasing view south to the lake. Past the White Lake Biodiversity Ranch, the road continues on to Horn Lake, one of the Twin Lakes that make up this settlement of mostly vacation homes. Turn right at a prominent intersection and sidle past Twin Lakes Golf Course to Highway 3A, a useful connector road. It leads south to Highway 3 at Keremeos, north to Highway 97 near Kaleden. Either route will allow you to complete a return circle drive to Osoyoos. ❧

14 KOOTENAY GOLD RUSH TRAIL

Think of them as field trips through history. Both Barkerville, at the end of the Cariboo Road, and Fort Steele, in the East Kootenays, are educational destinations. Once almost ghost towns, they have both morphed into historical theme parks, faithfully restored and provisioned, peopled not by ghosts but by flesh-and-blood actors bringing history to life. You can walk down wooden boardwalks alongside refurbished stores, churches, barbershops, hotels, schools—and into a different era. No automobiles here, just wagons and stagecoaches. It's a kind of time travel, the perfect field trip.

Barkerville was a gold-rush town—the biggest and bawdiest–and it has been recreated as such. But Fort Steele has a different history. The boom times of placer mining on nearby Wild Horse River were over by the time the little settlement of Galbraith's Ferry beside the Kootenay River grew to town stature. And when the first police fort in the west was established here, it grew even larger,. It became a ghost town, not because the gold ran out, but because the railway failed to run in—it bypassed the town in favour of Cranbrook. Fort Steele today is not a mining camp but a restored pioneer town of the 1890s, respectable and prosperous.

This journey takes a look at the earlier history of the Fort Steele area (for more on Barkerville see Chapter 2), searching out the final stretches of the Dewdney Trail and the ghost streets of Fisherville and Wild Horse gold camps. Then it makes its way through the countryside to the St. Eugene Mission where an elegant church was built with the proceeds of a silver-lead mine in the Moyie hills.

The Kootenay River flows through the southern Rocky Mountain Trench, an immense geological fault line that cleaves British Columbia north to south for more than 1,000 kilometres, so huge and distinct that it can be seen from the moon. A seam between two different geological

Pioneer garden in the refurbished town of Fort Steele. Mount Fisher dominates the skyline.

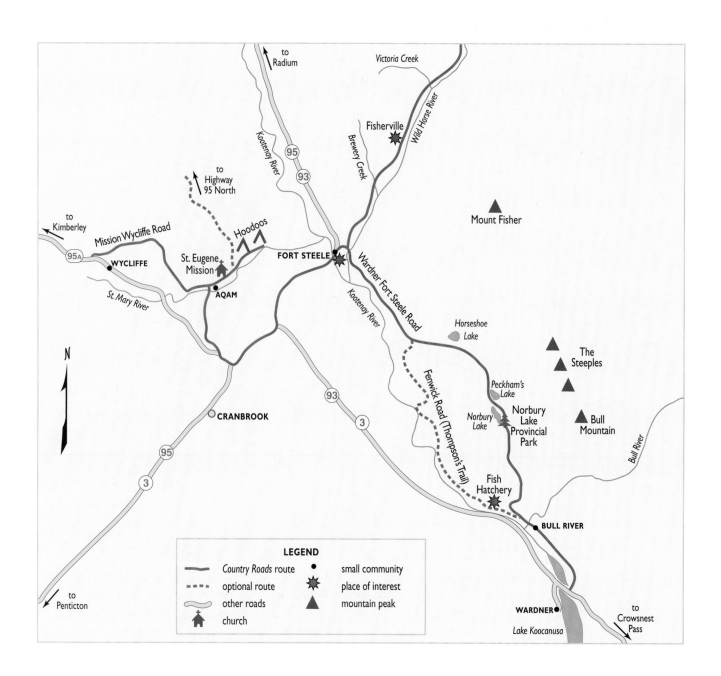

to
Radium

Victoria Creek

Wild Horse River

Fisherville

Brewery Creek

Mount Fisher

Kootenay River

95
93

to
Highway
95 North

to
Kimberley

Mission Wycliffe Road

Hoodoos

St. Eugene
Mission

FORT STEELE

Wardner Fort Steele Road

95A

WYCLIFFE

AQAM

St. Mary River

Kootenay River

Horseshoe
Lake

The
Steeples

*Peckham's
Lake*

Fenwick Road (Thompson's Trail)

*Norbury
Lake*

Norbury Lake
Provincial
Park

Bull
Mountain

N

93
3

CRANBROOK

Bull River

Fish
Hatchery

95
3

BULL RIVER

to
Penticton

LEGEND

——— *Country Roads* route ● small community

- - - optional route ✷ place of interest

〰 other roads ▲ mountain peak

⛪ church

WARDNER

to
Crowsnest
Pass

Lake Koocanusa

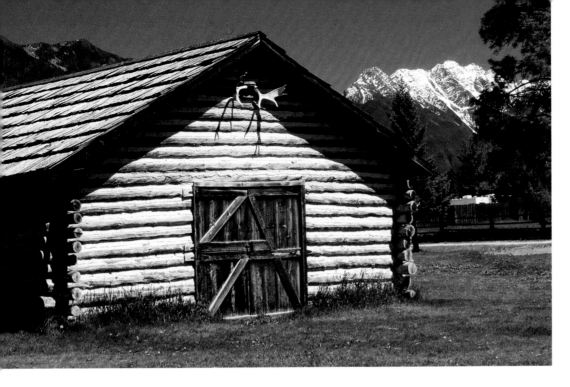

terranes, it divides the Rockies in the east from the Purcell Mountains in the west. The river flows south down the Trench into the United States, where it carves a huge U-bend and returns into Canada near Creston. In gold-rush and early-settlement days, steamboats up the river provided the easiest form of transportation to the Kootenays. Now Libby Dam in Montana impounds the river to form Lake Koocanusa, a huge, elongated international reservoir. (For those interested in names, this one is an amalgam: Koo(tenay), Can(ada) and USA.) Highway 3 crosses the north end of this reservoir about 40 kilometres east of Cranbrook, and this is where our journey begins.

Immediately east of the river bridge, turn north along the road signposted to Wardner-Fort Steele. If you are driving from the east, this is a shortcut, at least in distance. But it's slower, more scenic and less travelled, a road that will put you in the right frame of mind for old roads and ghost mines. It also has a very scenic start: the road rides high above the valley, and when Lake Koocanusa levels are down, the old Kootenay River channels create a watery labyrinth. Beside the road are clumps of sagebrush and antelope brush, for this area includes a sliver of desert very similar to the south Okanagan's. At one point, the road cuts under a high cliff of yellow sand, pitted with the nesting holes of bank swallows. Park nearby and watch the activity.

Just over five kilometres along, the road crosses the Bull River above its confluence with the Kootenay. Named not for the animal but for a lucky prospector who worked the river for placer gold in the 1860s, the river was fleetingly the focus of a gold rush, one of the many that didn't pan out. The miners' camp at the Bull River mouth lived on as a forestry community, though little is left except for the ebullient Bull River Hotel, a local landmark.

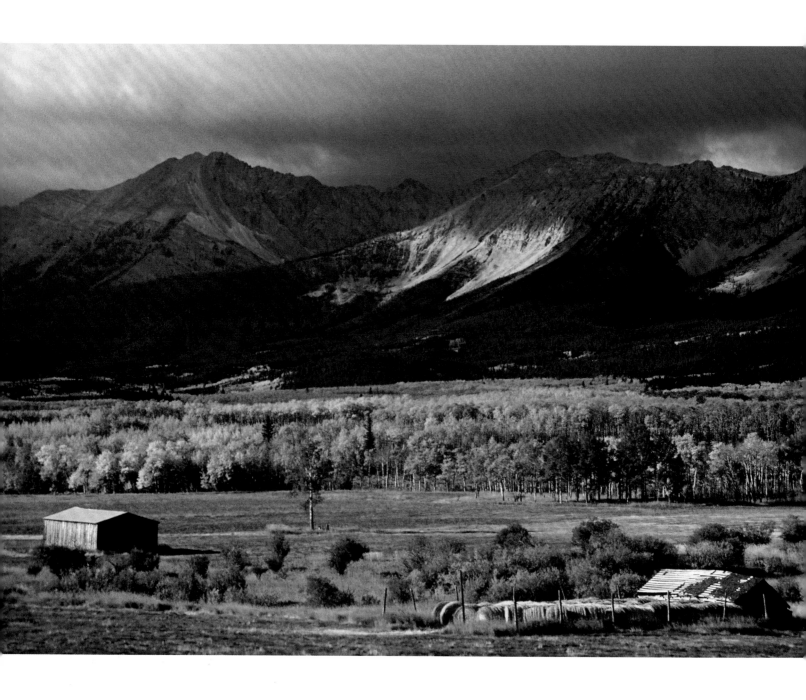

*Autumn storm over the
Hughes Range above the
Bull River Valley.*

Just beyond the bridge, the road divides: unpaved Fenwick Road (left) leads to the Kootenay Trout Hatchery, set in impeccably groomed gardens complete with turtle ponds and a kids' fishing pool. Originally set up to hatch trout and char (it releases 2.5 million trout fingerlings every year into B.C. lakes), the facility was recently expanded to handle white sturgeon, the largest freshwater fish in North America (as large as 700 kilograms and more than 6 metres long). Kootenay River sturgeon are in serious decline, and in an international effort to increase stocks, eggs are sent from a fisheries station at Bonners Ferry, Idaho, to the Kootenay hatchery, where the young fish are reared and released. Fenwick Road continues along the riverside and rejoins the Fort Steele Road about 15 kilometres north. It's a historic route, followed by David Thompson in 1808 when he was on his way home to Kootenae House in the Columbia Valley, near Invermere. In his journals he called it the Peigan War Trail, because the Peigans (now the Piikani) from southern Alberta came this way en route from the Crowsnest Pass to the Kootenays. The landscape along the riverbank must look pretty much as it did then, apart from a few contemporary ranches.

Our route turns right at the Bull River bridge and travels through Horseshoe Creek valley, where fields stretch east toward The Steeples, a line of spectacularly sharp-pinnacled peaks, part of the Hughes Range of the Rockies. Norbury Lake Provincial Park, about 10 kilometres beyond the junction, is split into two sections. West of the road, Norbury Lake houses a campsite in a sheltering grove of evergreens and a little farther, on the east side, Peckham's Lake provides the perfect setting for picnics. The small blue lake is rimmed by open pine forests and grasslands, with stands of trembling aspen trickling east to mingle with the talus slopes of the Steeples, which cast their rocky reflections into the deep blue water. The lake is warm enough for swimming, and it's stocked with rainbow trout. In fall, surrounded by golden leaves and with fresh snow on the mountains, this is a particularly beautiful place. Deer, elk and bighorn sheep frequent the area year-round, and there are many different birds and wildflowers. A short distance farther north, a campsite on spring-fed Horseshoe Lake is locally popular for fishing.

Beyond the lakes, the highway comes close to the Kootenay River and rounds a horseshoe bend to cross a bridge over the Wild Horse, one of the few gold-bearing streams to flow west from the Rockies. The Kootenay here is wild and stony, braided among heaps of debris from upriver placer mining. Beyond the bridge, there's a picnic area with a historic site sign—and an active osprey nest on a pole. The sawtooth peak to the east, framed in the cottonwoods, is Mount Fisher, at 2,846 metres, the highest summit in the Hughes Range. Both the mountain and the gold camp upstream were named for Jack Fisher, one of the first miners to stake a claim on the river in 1864. The gold was easy to pan—the flakes were big and there were large nuggets to be found. The Wild Horse gold rush had begun.

To reach the old camps along the river, turn right (northeast) along the unpaved forestry road that parallels the Wild Horse River. The road is narrow and there are few places to stop and look down over the steep river canyon. Placer gold in the gravels of the river was plentiful—one lucky miner picked up a nugget weighing 37 ounces. Soon there were so many people on the river that Fisherville Camp included six stores, four saloons, a brewery and a motley collection of miner's shacks and tents. Many of the miners were Americans who came up the Kootenay River from Montana, bringing with them all the lawlessness of the American Wild West. For several months, the camp was subject to lynch law; there were murders, claim disputes, fights, riots and general mayhem. But in August 1864, British Columbia's gold commissioner, John Haynes, rode in from the Okanagan with a lone constable to establish British law and order, register mining claims, issue licences and collect taxes. To the Americans, these colonial taxes were usurious: each miner was charged $5 for a three-month licence, plus a head tax—and customs duty on all goods shipped in from the United States (which was just about everything). Any miner lucky enough to find gold was charged an export duty of two shillings an ounce to take it out of Canada. The miners grumbled, but within a month Haynes had collected $20,000 for the colonial treasury.

It was small wonder that most of the Wild Horse miners came from the south: the Kootenay Valley was a natural north–south transportation route, and most of the men and supplies came upriver by steamboat from the United States. Most of the gold left by the same route. To staunch this outflow of business and resources, the government in Victoria hurriedly decided to extend their all-Canadian Dewdney Trail, which at that time ended at Rock Creek (where there had been a flash-in-the-pan gold strike in 1859). East of Rock Creek was wilderness entangled with great rivers and towering mountain ranges. Nevertheless, the trail—by any standards a monumental achievement for so small a colony—slogged through, preparing the way for settlement and establishing the first major transportation route, now Highway 3, across the southern province. A few sections of the original Dewdney Trail to Fisherville, the first town in the East Kootenays, still remain along the Wild Horse River. The East Kootenay Historical Association, which searched them out, has put up signs so that you can easily find them, still only footpaths in the forest.

Ironically, by the time the trail blazed through to the mines in the fall of 1866, the glut of easy gold was running out and the miners were looking elsewhere. There was still gold on the Wild Horse, but it needed big money and clever engineering to get it out. Toward the end, there were two gold towns along the river. In the last gasps of the gold rush, miners realized that the gravel bench on which Fisherville was built could be rich in gold. They didn't waste a minute. They moved their shacks higher up the hill to a new place they called Wild Horse, razed the old town and went to work.

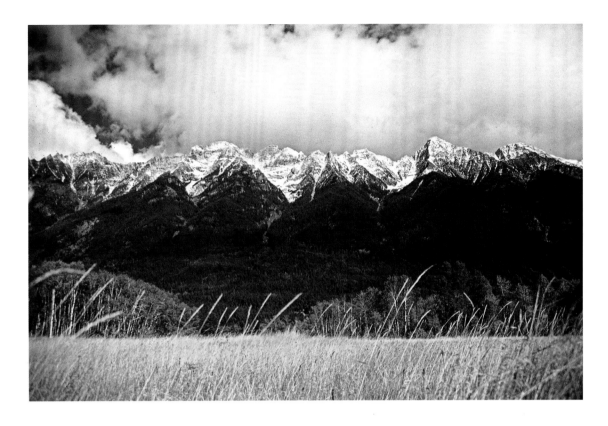

Snow-covered
mountains known
as The Steeples,
above the
Kootenay Valley.

White crosses
and picket fences
under the trees in
Fisherville cemetery.

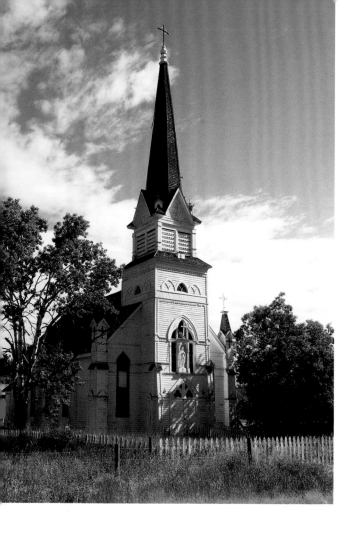

St. Eugene Mission Church, one of B.C.'s loveliest, was built with the proceeds of a silver-lead mine near Moyie.

As it nears the old historic sites, the road up the Wild Horse makes an S-bend across Brewery Creek, where a sign directs you to a small parking lot. From here, trails lead to the few last remnants of the Kootenay gold rush. The first site is the Fisherville graveyard, under tall trees, its nameless graves marked by small white crosses and edged with picket fences. In July, white mariposa lilies bloom here. Farther along the trail, among heaps of river stones from hydraulic mining, the only other tangible relics are the grave of Thomas Walker, killed in a gunfight in 1864, and a few trees in the first Kootenay orchard, planted in 1872.

Until the excellent work done at this site by the local historical association, it was difficult to make much sense of the heaps of rocks, the odd foundations, fireplaces, ditches and flumes scattered on the bench above the river. But today, if you follow the suggested trails from the cemetery, there are descriptive signs that will explain it all. The map in the East Kootenay Historical Association's guide to Fisherville and the Dewdney Trail shows the locations of the Victoria Ditch, which provided water for giant sluices; the Chinese burial ground; the first store and post office (known simply as Kootenay); and the site of Wild Horse town, above the original camp. (The map can be downloaded at http://fortsteele.ca/groups/edu/Fisherville%20brochure.pdf or obtained from the Fort Steele Museum.)

While the first, flamboyant gold rush was short-lived, there was still much gold in the canyon, though it was difficult to reach. Construction of the Victoria Ditch at the cost of $25,000 had brought water higher up the river bench, allowing 100 new claims to be worked, but even this was not enough. The glory had gone. Hard winters, disastrous floods and the crippling gold tax soon put an end to any get-rich-quick ideas, and Wild Horse, the second town on the river, was

gradually abandoned, though for several more years it continued to house the seat of government in the Kootenays, including the jail and the post office. In 1868, brothers John and James Galbraith purchased the Hudson's Bay Company store and moved it down beside the Kootenay River, where they had established a ferry. You can spend a pleasant hour or so strolling the trails and examining the forgotten relics along the Wild Horse, and then it's an easy drive down to the razzmatazz of restored Fort Steele. This town began life as a small supply settlement where the Dewdney Trail crossed the Kootenay River by means of Galbraith's ferry and where boats unloaded men and supplies bound for the mines. But a skirmish with local First Nations brought it into the forefront of history.

Around 1886, two American miners disappeared from their camp and, on very skimpy evidence, a local Native was charged with their murder and held for trial in the Wild Horse jail. In a scene straight out of a Wild West movie, a troop of band members led by Ktunaxa Chief Isadore stormed the jail, forced the lone constable to give up his prisoner and rode down to Galbraith's Ferry, where they celebrated with wild war dances. The few inhabitants were terrified. Local tribes were already enraged by the newly legislated reservation system and by the fencing of land traditionally used for hunting and grazing their horses. Were these the sparks to ignite an interracial war?

Word was sent to Ottawa and the federal government decided to send out a contingent of 75 North West Mounted Police from the barracks in Fort Macleod, Alberta. The redcoats, under the command of Colonel Samuel Steele, rode to Golden on the brand-new Canadian Pacific Railway, then on horseback beside the Columbia and Kootenay rivers. Their supplies were shipped by riverboat. Colonel Steele built his fort, several sturdy buildings of yellow pine logs, on the flat river bench beside Galbraith's Ferry. He hoisted the Union Jack and set to work to broker peace.

Perhaps this show of imperial force did the trick. In any case, Chief Isadore surrendered the suspects (there were by this time two of them), and after reviewing the evidence (or lack of it), Steele let them go. The police stayed in their fort for just over a year, then packed up and returned to Alberta through the Crowsnest Pass. Thankful for peace, the people of Galbraith's Ferry changed the name of their little town to Fort Steele.

And that was the beginning of the beginning. Fort Steele prospered, first with the start-up of new hydraulic mines up the Wild Horse, and later when other minerals—silver, lead, copper and coal—were discovered in the area. A bridge replaced Galbraith's ferry and stagecoaches connected the town with the CPR at Golden. Population stabilized at around 4,000. But the town had based its growth mainly on the expectation that the B.C. Southern Railway through the Crowsnest Pass would come to its door. When in 1897 the rails bridged the Kootenay River

some 30 kilometres south and stopped instead at a brand new townsite called Joseph's Prairie (today's Cranbrook), the town faltered. This was the beginning of the end. People and businesses drifted to the railway, riverboats ceased to call and by 1902 the population of Fort Steele had dwindled to a mere 300. Hotels, stores, churches and schools stood empty, and boardwalks rotted. While the town was never completely deserted, it certainly had the look and feel of a ghost town, bleaching in the dry Kootenay air, when it was designated a historic park in 1961.

Today, Fort Steele has been reborn as a vintage Victorian frontier town. In summer its boardwalks are lively with tourists, its houses, shops, churches, school and saloons are open, its streets hazy with dust from the stagecoaches, and every morning at ten o'clock there's a re-enactment of the North West Mounted Police raising the British flag over the reconstructed fort. It is all very well done, if a little too theatrical. Give yourself at least half a day to explore the town and the fort and perhaps participate in some of the staged events. The historic park is open daily from 9:30 to 6:30 p.m., but fully staffed only in the summer. Unlike Barkerville, there are no places in town to stay the night.

From Fort Steele, drive southwest almost to Cranbrook, then turn north along Highway 95A, the road to Kimberley. Almost at once, take a right turn and follow St. Joseph's Creek to the Church of St. Eugene Mission, one of the architectural gems of B.C., with a history closely tied to the story of Kootenay mining. The mission, on the banks of the St. Mary River on the large Ktunaxa Indian Reserve, was founded in 1874 by the Oblate Fathers. As a self-sufficient community that included a small log church, a school, flour mill and hospital, this was an outpost of religious fervour in a country still in the thrall of gold fever. When the famous Corsican priest Father Nicholas Coccola took over the mission in 1887, he encouraged his Native flock to join the prospectors in the hills to look for gold, for the mission badly needed a new church. Several years later, Pierre Nicklehead wandered back to the mission with a pocket full of strange rocks. James Cronin, a mining promoter staying at the mission, recognized the rocks as almost solid galena, a mixture of silver and lead. Pierre led Cronin and Coccola to the site of his find in the hills above Moyie Lake, where they staked three claims. Pierre and Coccola immediately sold theirs to a mining syndicate, and the St. Eugene Mine (named after the founder of the Oblate Order) became one of the greatest producers of silver, lead and zinc in the area. With the proceeds of the sale, Father Coccola was able to build two beautiful Gothic churches, a small one at Moyie and this one at the mission. Pierre built a house and changed his name to Pierre Cronin. You can look for his grave in the mission cemetery at St. Mary's Village (now Aqam), where the rows of white crosses are almost lost in the long grass.

It's an amazing story, but even without it, the Church of St. Eugene at Aqam is a wonder. Built in 1897 by experienced carpenters, it is a Gothic glory of delicate white lace,

Spring blossoms at the Fort Steele bandstand.

interpreted in wood, with stained-glass windows from Italy, a tall gabled spire and intricate metal crosses. Awaiting restoration, it can usually be viewed only from the outside, but if you ask at the Aqam band office just across the street, someone might open the doors and give you a tour.

Opposite the church, the big brick building that once housed the 1912 residential school has become the focal point of a major destination resort, with an adjacent casino (the modern-day equivalent of a gold mine) and a large golf course alongside the river, just behind the cemetery. But the Native context has not been forgotten: inside the old school building is the Ktunaxa Interpretive Centre, and beside the parking lot a gift shop sells traditional baskets and jewellery. The people of Aqam also run a cattle ranch and a Christmas-tree farm.

The Aqam villagers live beside another magnificent site, this one totally natural. Cross the bridge over the St. Mary River and turn sharp right. A little way downstream, pale siltstone cliffs are the remains of former lake-bottom sediments accumulated during the waning days of the last ice age, when a huge ice dam blocked the Rocky Mountain Trench. Exposed for tens of thousands of years to wind and rain, these amazing cliffs have been chiselled and sculpted into tall towers and pinnacles. They are similar in looks (and geology) to the well-known Dutch Creek hoodoos along the highway to the north. The Ktunaxa have a story about them. Coyote, the trickster, once gaffed an enormous fish. Mortally wounded, the fish managed to get away and struggle up the river in the Rocky Mountain Trench, where it finally died and decomposed. Its giant ribs fell apart; half became the Dutch Creek hoodoos, the other half the cliffs along the

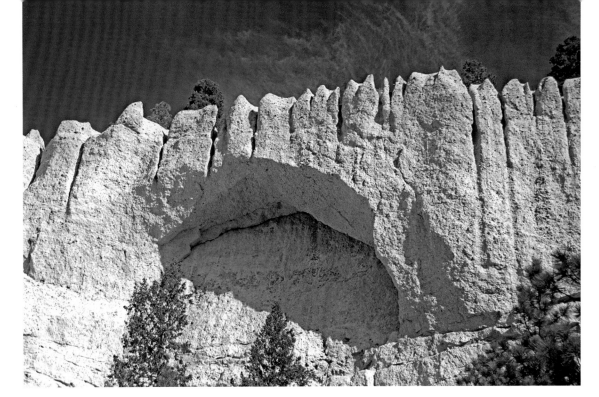

Tall eroded siltstone cliffs, sculpted into towers and pinnacles, line the St. Mary River near the village of Aqam.

St. Mary River. The tops of the cliffs here seem more like ancient castle crenellations than ribs. But let's not ruin a good story.

From here, you have a choice of final destination. Just before the hoodoo cliffs, Mission Road crosses the high plateau and joins Highway 95A north of Kimberley, a shortcut if you are heading toward Radium Hot Springs or Golden. You can instead retrace your steps and go west to the city of Cranbrook or continue along the rural back road (straight on across St. Mary's River bridge) to Wycliffe and north to the town of Kimberley. Here the mines flourished from 1893 to 2001, making it one of the longest-lived mining towns in B.C. Today, with the mines closed, it too has become something of a theme park. Transformed into a Bavarian Village, the town is complete with timbered buildings (one a 400-year-old *gasthaus*, imported piece by piece from Bavaria); a pedestrian *platz*; restaurants serving spaetzle and wurst; *bier gartens* with waiters in lederhosen; and even a larger-than-life cuckoo clock. Amazingly, this doesn't seem bizarre or even out of place because the town does have an alpine setting. However, it hasn't completely abandoned its mining past. Once used to haul ore from underground, the diminutive Bavarian City Mining Railway chugs up the hill to the once-great Sullivan Mine, negotiating 12 kilometres of switchbacks and providing great views for the tourists on board. ❖

B.C.'s Boundary Country was well named: it hugs the international border all the way from the height of land above Osoyoos east to Christina Lake. One of the loveliest and least well known areas of the province, it has a long and eventful history, mostly of mining and railways. B.C.'s rivers flow generally north–south with the grain of the land, but through the Boundary, the Kettle River runs east, and its broad and fertile valley became a natural travel route for Natives, fur traders, miners and railways. Today, Highway 3 cuts through it on its way to the Crowsnest Pass.

In 1860 Charles Wilson, secretary of the British Boundary Commission, rode over the hills that divide the Kettle River Valley from the South Okanagan, following Rock Creek to its confluence. A gold rush was underway on the creek. After describing in detail the "many substantial log buildings, stores, gambling houses, grog shops, butcher's shops etc." in the new mining camp, his diary entry for the last day of August took a poetic, almost rhapsodic turn: "Oh! Valley of the Nehoialpitku [Kettle], how shall I sing thy praises! Those shady groves abounding with grouse! Those grassy plains inviting a gallop! Those green hazel trees overloaded with nuts & those deep pools where monster trout only await the coming of the much loved grasshopper to transfer themselves to the frying pan & lastly the silvery stream babbling along through meadows of the most luxuriant grass …" This description alone invites us to travel through the Kettle Valley.

Keeping close to the river for much of the way, this country road follows its big bend into Washington, then makes a loop along the Kettle's northern tributary, now known as the Granby. The journey begins at the intersection of highways 3 and 33, where the community of Rock Creek sits at the mouth of the creek beside the Kettle River. This small settlement once played

The colours of fall along the Washington State stretch of the Kettle River, with fishermen in action.

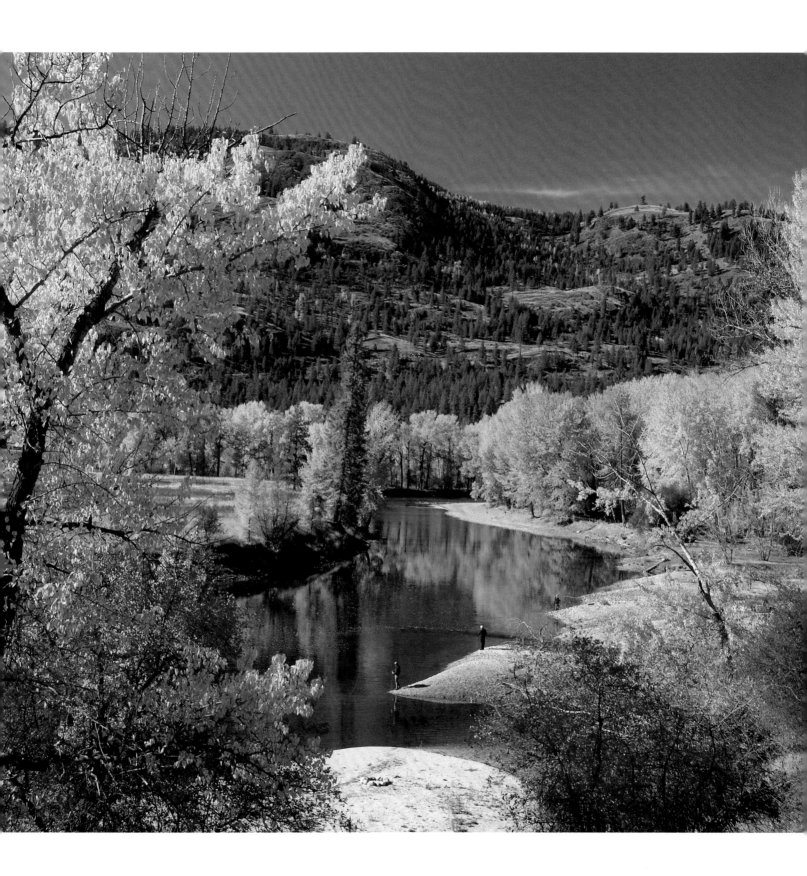

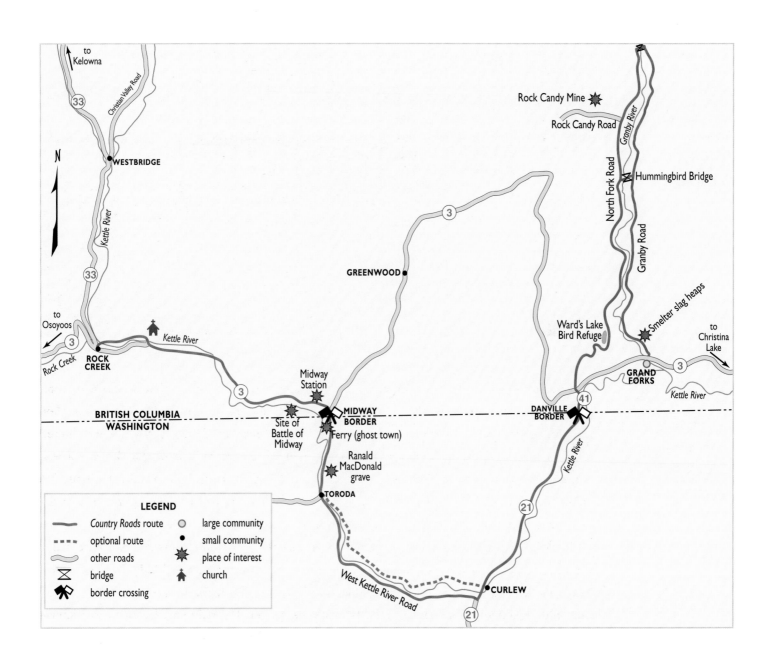

to
Kelowna

33

Christian Valley Road

WESTBRIDGE

N

Rock Candy Mine

Rock Candy Road

Granby River

Kettle River

Hummingbird Bridge

North Fork Road

Granby Road

33

3

GREENWOOD

to
Osoyoos

3

Kettle River

Smelter slag heaps

Ward's Lake
Bird Refuge

to
Christina
Lake

ROCK
CREEK

Rock Creek

GRAND
FORKS

3

Kettle River

3

Midway
Station

DANVILLE
BORDER

MIDWAY
BORDER

41

BRITISH COLUMBIA
WASHINGTON

Site of
Battle of
Midway

Ferry (ghost town)

Ranald
MacDonald
grave

Kettle River

TORODA

21

LEGEND

Country Roads route large community

optional route small community

other roads place of interest

bridge church

border crossing

West Kettle River Road

CURLEW

21

162

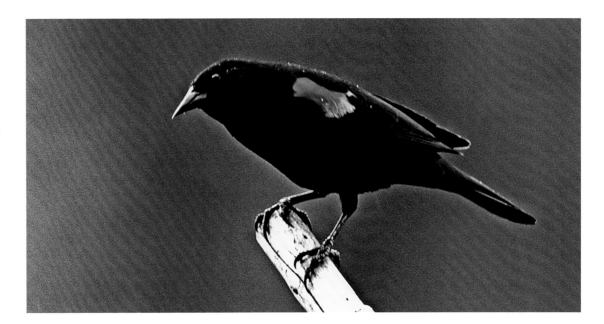

Red-winged blackbird, spotted at Myers Lake.

an important part in the development of the province and its transportation patterns. In 1859, two U.S. soldiers camping at the mouth of the creek found flakes of gold. Gold fever was then rampant in the west, and rumours of new finds spread fast. In October, Adam Beam staked the first mining claim on Rock Creek. Others followed. Six months later, the *Victoria Colonist* trumpeted "Rock Creek a Success," and reported daily gains "from $20 to $100 to the hand." A stampede was underway. Miners, most of them Americans, rushed to the diggings from other less successful ventures, built their cabins beside the Kettle River and set to work.

Back in Victoria, Governor Douglas realized that this invasion of mostly Americans was a threat to British sovereignty and dispatched Gold Commissioner Peter O'Reilly to Rock Creek. At a general meeting called to explain the provincial mining regulations, angry miners hurled not only invective but stones at Her Majesty's messenger. O'Reilly scuttled back to Victoria with tales of a "Rock Creek War"—and life in Rock Creek resumed its unlawful and uproarious ways.

Douglas decided to visit this troublesome camp in person. On September 25, 1860, he recorded only this in his diary: "Visited the town this morning, spoke to the miners and returned to camp." An eyewitness account paints a far more vivid picture. Douglas strode in, wearing his full colonial regalia, to face 300 miners gathered in the rough-and-ready saloon (probably today's Prospector Pub in the old Rock Creek Hotel, reputedly the oldest on its original site in B.C.), prepared to heckle, or worse. Douglas offered them incentives: a wagon road from Hope and a bridge over the Kettle River. But he warned that unless they complied fully with Canadian

law, he would return, along with 500 armed marines. He then shook hands with every miner and they all cheered. This "war" was over.

Douglas made good his promise: The Dewdney Trail from Hope to Princeton was extended to Rock Creek (it's now Highway 3), but by the time the road arrived, only a year after Douglas' visit, the Rock Creek camp was bust. More promising gold prospects had been found in the Okanagan and the Cariboo and the miners drifted on. Only a few stayed to homestead in the valley meadows. Placer miners later attacked the creek again, with huge hydraulic hoses. If you stroll up the trail alongside the creek opposite the Gold Pan Café, you can see the huge heaps of boulders they left behind.

The Kettle River rises far to the north near Monashee Pass and flows down Christian Valley to Westbridge, where it is joined by its tributary, the West Kettle, coming down from near Kelowna. At Rock Creek another tributary, one that gave the settlement its name, also joins the flow. In spring flood, the Kettle is a mighty river, but by the end of summer, it often dries to a trickle too shallow even for rubber rafts to stay afloat.

From Rock Creek, cross the Kettle just north of the pub and take the quiet back road along the north side of the river. Turn right at the T-junction and meander through meadows, past a rusty beehive burner and the Rock Creek fairground to a second river bridge, at the old vanished settlement of Riverside. Across the bridge, the road continues past the original Kettle Valley one-room school and joins Highway 3 at tiny St. Mary's Church. Keep west on the highway to Midway, Mile Zero on the Canadian Pacific's Kettle Valley Railway. It was called Midway because it is midway between the coast and the Rockies, midway between Grand Forks and Osoyoos and midway along the Dewdney Trail between Fort Hope and Fort Steele. The KVR station, built in 1900 just west of the village, has been preserved as a museum, along with a short section of track, a workers' bunkhouse and a lone red caboose.

Midway village sits on the Kettle River at its intersection with two tributary streams: Myers Creek from the southwest, and Boundary Creek from the northeast. Highway 3 follows Boundary Creek into the mining town of Greenwood, climbs to the old rail settlement of Eholt, then loops south again to enter Grand Forks along July Creek. The hills in this part of B.C. were found to be rich in copper/gold ores and the City of Greenwood (it prides itself on being Canada's smallest city), founded in 1895, became the centre of mining and smelting activity that lasted for 15 years. Along its streets, several big old hotels, a grand courthouse and a few ornate mansions reflect the city's once-prestigious past, though its heyday is long gone. High above Greenwood, a huge city called Phoenix was built, thrived for a while and was later erased by an open pit mine. There were mining camps with names like Deadwood and Mother Lode, and smelters near Boundary Falls and Anaconda, just west of Greenwood. For anyone interested in

Lit by a double rainbow, the last remaining
trestle on the VV&E railway crosses a small
creek in the Myers Valley. The trestle was
about 100 years old when it collapsed in 2006.

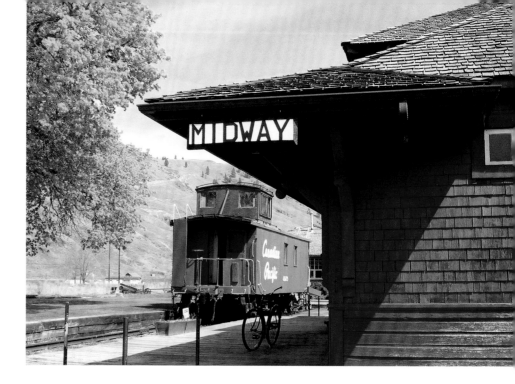

Midway Station, the official Mile 0 on the Kettle Valley Line, is now a museum.

mining history, this part of the Boundary holds much of interest. But our route, which follows the Kettle's main stream south from Midway, bypasses it all.

During the strident years of railway building in B.C., Midway was famous for the battle that erupted between the KVR and its archrival, the American Great Northern Railway, which had a charter to build a line—the Vancouver, Victoria and Eastern—through southern B.C. Already in a cutthroat race to be the first to reach the coast, the two railway companies finally came to physical blows. The altercation started with a dispute over land. In 1905 the VV&E had plotted their line southwest of Midway through land the CPR claimed. The Canadian company constructed a huge fence to keep the American railway builders out. The VV&E gangs pulled the fence down and the CPR built it up again, bringing in a force of 50 armed guards to protect it. It was a stalemate.

After months of legal wrangling, the VV&E filed an expropriation order, brought in a force of a hundred men and gave their rivals one minute to vacate the property. The CPR men downed tools and headed back to the Midway Station, where they called out every available railway worker in the district. The VV&E also sent for reinforcements. It seemed a clash of giants was about to take place in this sleepy little town, and the local police force of one, Charles Thomet, could do nothing to stop it. He called in the provincial police.

In the late afternoon of November 9, 1905, a pitched battle took place. Track was ripped up and workmen on both sides came to blows with axes and picks, breaking a few bones, bloodying a few noses, bruising a few shins. No one was killed. By sundown, the pugilists were exhausted and called a truce. That night the VV&E fenced off their right-of-way with barbed wire, and

Abandoned right-of-way of the VV&E railway, south of Rock Creek.

when the CPR men arrived in the morning to continue combat, they conceded defeat. They headed for the Midway saloons but found them locked and bolted. Undaunted (and apparently very thirsty), the men simply skipped across the Canada–U.S. border to the saloons in Ferry, where the VV&E men were already celebrating their "victory." Both sides raised elbows together. This was the end of the affair; the rest of the war was fought in the courts, and the VV&E was allowed to continue its journey west along Myers Creek, another Kettle tributary and eventually to the Similkameen and Princeton (see Chapter 11).

Buildings of historic interest in Midway include the 1905 two-storey Kettle River Inn, built beside a stretch of the original Dewdney Trail where Myers Creek flows into the Kettle, an old church and a humble little provincial courthouse that dates from 1895. From here, our route follows the Kettle River south into Washington—though not to the saloons!

There is never a lineup at the Midway border crossing. One of the province's smallest, it is open daily from 9 a.m. to 5 p.m. The old community of Ferry across the line once enjoyed 27 saloons and was the rendezvous of choice following the Battle of Midway, but today the town's remains are hard to find; there are only a few buildings standing derelict on the flats across the river. The road south is known appropriately as Customs Road, and it hugs the river's eastern bank. On a hillside above the road lies the well-marked grave of Ranald MacDonald, born in Fort Astoria at the mouth of the Columbia River in 1824, the son of an HBC trader and a Chinook princess. A passionate world traveller, he was one of the first outsiders ever to visit what was then a closed Japan, and the first to teach the English language in that country. After years abroad, he came to Canada and became, for a while, a packer in the Cariboo gold rush.

Possibly more famous in Japan than he is in North America, MacDonald died in 1894, while visiting the mining town of Toroda Creek.

A short way south of the border, the Kettle is crossed by a bridge and both river and road swing almost due east to the little town of Curlew. Turn left at an upcoming intersection (right leads to Toroda Creek) and follow the river. It's a beautiful drive, particularly in fall when the cottonwoods are golden, and there are several places to pull off the road to admire the volcanic rimrocks to the north.

Curlew sits beside the Kettle River where it again changes direction and flows north back into Canada. A highlight of the town is the odd little Ansorge Hotel, built in 1902, its square bay windows at each second-storey corner giving it an off-balanced look. Still filled with original furnishings, this historic monument is open for tours on summer weekends. It claims a very famous guest, Henry Ford, whose signature is captured in the 1917 register. Down the street is a huge general store, packed with goods of all kinds, fascinating for browsers as well as buyers. The wooden bridge across the Kettle River connecting the town to Washington's Highway 21 has recently been upgraded, but luckily it was kept, like the original, as a single-lane bridge, in keeping with the town's pioneer ambience. From Curlew, it's only a few kilometres north to the border crossing at Danville, and the road hugs the Kettle River all the way.

The Doukhobor flour mill outside Grand Forks still produces its stone-ground "Pride of the Valley" flour.

North of the border, the river turns in lazy bends through the City of Grand Forks then runs due east until, just before Christina Lake, it turns south and leaves Canada for good. Fur traders travelling through the Grand Forks area called it La Grande Prairie, for here the valley stretches out, flat and fertile. But the city, founded in 1884 as a supply and smelter town for copper mines in nearby hills, called itself Grand Forks because two streams of the Kettle join here. Incorporated as a city in 1897, it still has a sprinkling of Victorian houses, including the most luxurious, a large, turreted mansion known as Golden Heights, built above the highway at the east end of town. Much of pioneer downtown was destroyed by fires in 1908 and 1911, and replacements were built using locally made brick. The 1912 courthouse and the 1911 post office, now the city hall, are well worth a look. Interestingly, one of the few buildings to survive the fires was the brewery (now Selkirk College), which dates from 1898.

Grand Forks is very much a Doukhobor community. This religious and peace-loving sect came from Russia via Saskatchewan to settle here. Their leader, Peter Veregin, bought nearly 2,000 hectares of land on the grand prairie, and in 1909 families began to arrive. Four years later there were more than 1,000 Doukhobors living in the area. Almost totally self-sufficient and clinging steadfastly to their old culture and language, the people built their own sawmill, grew and ground their own wheat, and made their own bricks for their large, square communal houses, many of which remain. The fur traders have long gone from Grand Forks, the copper mines in Boundary Country fizzled out and the smelters closed—but the Doukhobor legacy is still strong. Many of their brick buildings, including the flour mill, remain; Russian is still taught in schools; they still gather for prayer and wonderful singing; and borscht and other traditional foods are served in local restaurants.

Our journey leaves the Kettle at the junction of Highway 3 and Highway 41, up from the Danville border crossing, and climbs over to the North Fork of the Kettle. Turn west on Highway 3, past Rilkoff's Market, then right (north) on Reservoir Road, which heads uphill through the heart of the old Doukhobor community of Fructova. The road passes the former schoolhouse, now a heritage centre, heads up into a gap in the hills, winding past the old reservoir, and drops down again, past several Doukhobor farms. One of these is the Mountainview Doukhobor Museum, complete with artifacts and authentic furnishings.

At the bottom of the hill, turn left on North Fork Road and head up the valley of the Granby. In 1906 gold and silver ores were mined at Franklin Camp, about 75 kilometres upstream, and at Union Camp, farther north again. These and other mines produced off and on for more than 40 years. Today, with the exception of the Rock Candy mine, a very rich fluorite deposit still open for tourist rock-collecting, the mines are dormant and the valley has lapsed quietly back into agriculture. Beyond Ward's Lake bird refuge, the North Fork Road winds along the valley's

A mountain of black slag is all that remains of the Grand Forks smelter.

western edge with river meadows below and craggy hills rising to the east. Then it descends to run right beside the river. On one of the river bends, now marked by a line of riverfront homes, the settlement of Niagara boomed and went bust along with the mines. High on the hillside above the road, the Trans-Canada Trail runs along the abandoned grade of the Columbia & Western Railway (later the CPR), which turned west up Brown Creek toward the mines around Greenwood. A few kilometres farther, Hummingbird Bridge (the old rail bridge) leads across the river, and this makes a good turn-around spot, though if crystals and geodes are of interest, continue along the west side of the valley to the Rock Candy Mine and north again to a second bridge. East of the river, the unpaved Granby Road leads north, with connections all the way to Edgewood in the Arrow Lakes, and provides access to the huge pristine watershed within Granby Provincial Park. Unless you are in an exploring mood, turn right across the bridge and head south back to Grand Forks.

The chief point of interest along the east side of the river is the site of the smelter, built in 1909 to process ores that came mostly from rich copper mines at Phoenix, near Greenwood. The smelter expanded with the mines to become the largest non-ferrous smelter in the British Empire and the third largest in the world, with a capacity of 5,000 tonnes a day. But when the Phoenix mines ran dry, the smelter closed and the machinery was hauled away. All that is left are the tailings, huge glittering mounds of black granular slag. Today, some of this is being trucked away for re-use, but enough remains to startle the eye—sand dunes of industrial slag in a valley otherwise so pastoral. For a close-up view of these fantastic black heaps, drive into Grand Forks, then turn north along Riverside Drive. Several side streets lead down to the river, where mountains of slag rise straight up from the water's edge.

Grand Forks is a pleasant place to while away the rest of the day. Drop in at the visitor centre and museum for a walking tour brochure—and don't forget to stop for a bowl of genuine Russian borscht. ✤

BULKLEY HIGH ROAD

Telkwa is an old town: it celebrated 100 years of history in 2007. The streets laid out on the north side of the Bulkley River mirror the town's heyday, the first decade of the 20th century. Heritage log houses, stores, a creamery, churches, a school—even a Chinese laundry and bathhouse—are all well authenticated by a very active historical society, whose members hand out walking-tour guides from a museum in the former schoolhouse.

The Bulkley River was named for Colonel Charles Bulkley, the engineer-in-chief charged with building the first telegraph line between North America and Europe. The scheme failed, but it left an enduring legacy: the Telegraph Trail, a tote road through the wilderness forests of the province all the way north from New Westminster on the coast to the Skeena River. This rough trail, hacked out in the 1860s, opened the way for future settlement of the north. In the Bulkley Valley, a small town called Aldermere sprang up beside the trail. Here were many "firsts" for the valley: the first hotel, post office, newspaper and store. But the town didn't last long. It was supplanted by Telkwa, a new settlement at the junction of the Bulkley and Telkwa rivers, where the new Grand Trunk Pacific Railway built its station. Telkwa was eclipsed in turn when the railway chose nearby Smithers for its division point, and the town nearly gave up for good when a major fire almost wiped it out. Smithers became the largest settlement in the valley, but Telkwa kept a firm grasp on its own history.

Highway 16 runs through the heart of Telkwa to Smithers and on to Prince Rupert, but there is another road, one that follows the Telegraph Trail. The Telkwa High Road bypasses Smithers and stays on the north side of the Bulkley River all the way to Moricetown. The road is not very long—only about 50 kilometres from start to finish—but it provides a quiet and very scenic

False-front building along Telkwa's main street, one of several heritage sites.

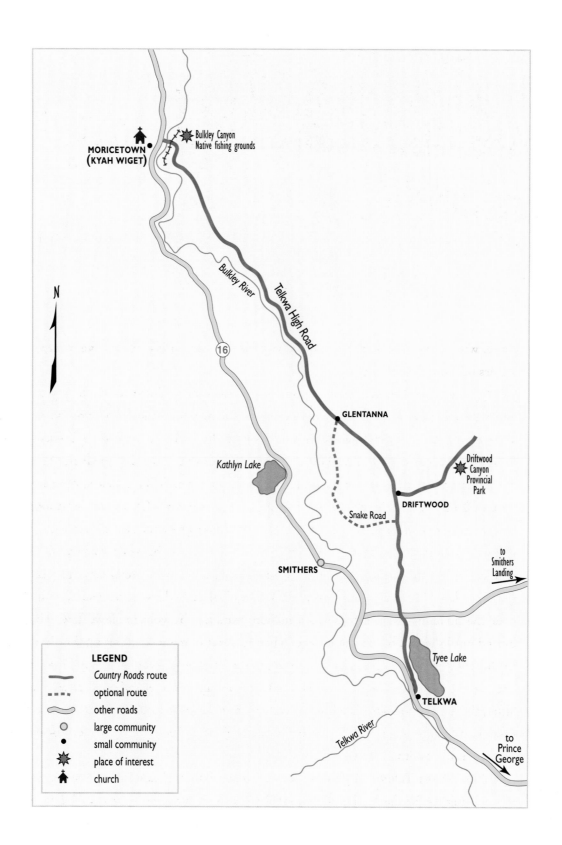

MORICETOWN
(KYAH WIGET)

Bulkley Canyon
Native fishing grounds

N

Bulkley River

Telkwa High Road

16

GLENTANNA

Driftwood
Canyon
Provincial
Park

Kathlyn Lake

Snake Road

DRIFTWOOD

to
Smithers
Landing

SMITHERS

Tyee Lake

LEGEND

——— Country Roads route

- - - optional route

~~~ other roads

○ large community

● small community

✸ place of interest

⛪ church

TELKWA

Telkwa River

to
Prince
George

*Above the town of Telkwa, Tyee Lake reflects the mountain snows.*

route, with a world-famous fossil site along the way and a most impressive climax, the dashing waters of the Bulkley canyon.

The High Road leaves Telkwa just west of town and climbs fairly steeply to Tyee Lake, where a small provincial park provides a sandy beach, good fishing and extensive marshes, with a viewing platform for birdwatchers and a trail leading around the lake to the remnants of the forgotten town of Aldermere. The mountain reflections here are always lovely. The High Road meanders through clumps of aspen forest and grassy meadows, a pleasantly rural landscape. About 18 kilometres along, take the turning east past the old Glenwood School to Driftwood Canyon Provincial Park. Here, surrounded by dense greenery reminiscent of a coastal rain-forest, a deep canyon provides a rare snapshot of this part of the world as it was 50 million years ago. Preserved in the time capsules of sedimentary shales are the remains of plants and animals that once lived in steamy subtropical marshes and lakes. Sediments deposited in these wetlands over the millennia were smothered a million years ago by volcanic lava flow. They remained buried until the end of the last ice age, when torrents of meltwater carved this dramatic cleft at the foot of the Babine Mountains, exposing the ancient deposits and making this a world-famous site. While most of the fossils are of plants, including leaves of redwood trees, cranberry and alder, there are also insects such as the water strider, and the world's oldest species of trout. The fossil beds can be examined, but no collecting is allowed. Excellent specimens from the site can be seen at the Smithers museum.

Return to the Telkwa High Road and cross south to McCabe Road. A short distance along is a parking lot for the Malkow Lookout Trail, a short but steep zigzag road through meadows up to a former forestry tower. The view from the top, west across the Bulkley Valley to the

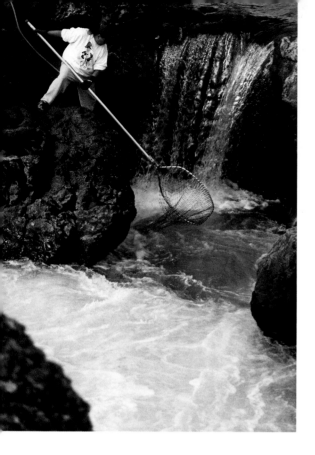

*Dip-netting for salmon in the Bulkley Canyon.*

snowfields on 2,560-metre Hudson Bay Mountain, is spectacular. If you're not a hiker, a similar mountain view can be enjoyed from farther along the High Road. At the old community of Glentanna, about six kilometres beyond Driftwood Canyon Road, Snake Road loops south through undulating farmland. Along here lies Narnia Farms with its organic herb gardens, open to the public in summer, and nearby is Northern Lights Wildlife Shelter, where orphaned or injured bear, moose and deer find refuge. (To arrange a visit, phone 250-847-5101.)

The High Road continues north through forested terrain, then comes suddenly down to the river opposite the village of Moricetown, at one of the most dramatic places anywhere in B.C. In Wet'suwet'en territory, 30 kilometres west of Smithers on Highway 16, the Bulkley River boils through a deep and narrow rock canyon, one of the very best places to watch traditional Native fishermen in action. With security ropes tied around their waists, they stand daringly on the edge of the rocks, in the full spray of the foaming river, to catch salmon with long dip nets. In fall, when the salmon are running, both sides of the canyon are lined with fishermen, and there are usually twice as many spectators, watching from the highway pull-off or from the bridge at the canyon neck. The noise of the river thundering through the gap is deafening, and the silver gleam of leaping salmon is one of the world's great sights. You'll find time passes swiftly here: the river has a mesmerizing effect.

You can cross the bridge to Highway 16 and drive north or south, depending on your destination. But spare a few minutes to explore the village across the way, named for Oblate missionary Father Adrien-Gabriel Morice. The Church of Our Lady of the Rosary was built in 1912, but the village is far older. The Wet'suwet'en name for the village is Kyah Wiget, "Old Village," an appropriate name since archaeological excavations here found signs of habitation dating back 4,000 years. There is a small handicrafts store here, a gas station and a campsite below the canyon. Every June, during Cultural Awareness Week, visitors can enjoy traditional dancing and foods and learn about some of the old ways. ❧

*A lone fisherman braves the morning mists in Bulkley Canyon near Moricetown.*

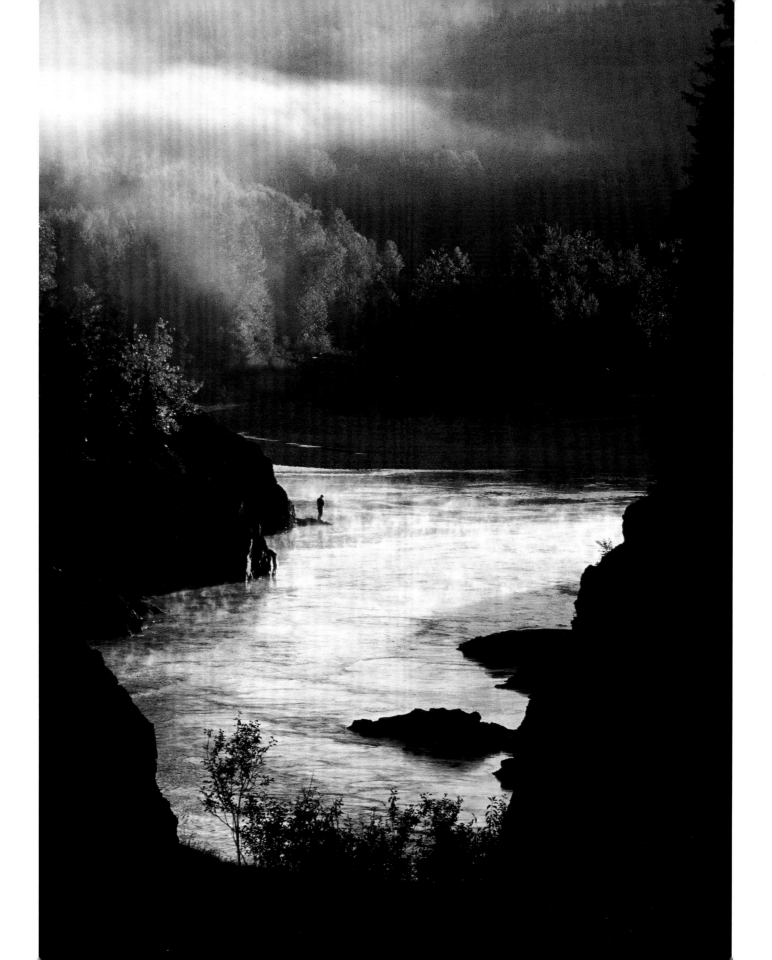

NORTH OF THE SOUTH

*Very close to the Trans-Canada Highway* but separated from it by a calming river, this country road on the north side of the South Thompson provides a pleasant alternative for travellers heading east from Kamloops. On this road, you can drive more slowly to savour the scenery, and stop safely just about wherever you choose, happy to be away from the traffic buzzing by on the opposite shore.

From Kamloops, branch off the Trans-Canada onto Highway 5 as it turns north to cross the South Thompson River. Almost at once, turn east onto Shuswap Road, at the Secwepemc Native Centre where the former red brick residential school, built in 1889, has become the focus for a Heritage Museum and Park. Close to where the North and South Thompson rivers join, the land has been a village site for thousands of years. Archaeologists digging here have unearthed artifacts dating back 6,000 years, and from other nearby excavations, most likely of seasonal fishing camps, as far back as 11,000 years. While the village kekulis or winter residences of the ancients have gone, they left "footprints" in the form of circular depressions in the ground. Early Kamloops settlers reported seeing hundreds of them on the terrace where today's heritage park recreates the traditional lifeways of the Secwepemc people. Trails wind beside the river, past a garden of traditional food plants, four reconstructed pit houses, and a typical summer village complete with fish traps and drying and smoking racks. A visit here and to the museum in the Chief Louis Centre will make a good start to this journey along Shuswap Road. Passing through two biotic zones, it begins in the Dry Interior, an arid landscape of sagebrush and sandy scrubland, and ends, as you would expect from its name, at Shuswap Lake in the Interior Wet Belt. The transition is gradual, but by the time you are halfway there, the sagebrush is gone and pine forests have replaced the grassland.

*The west end of Shuswap Lake in the fall; migrant ducks make this a good site for birding.*

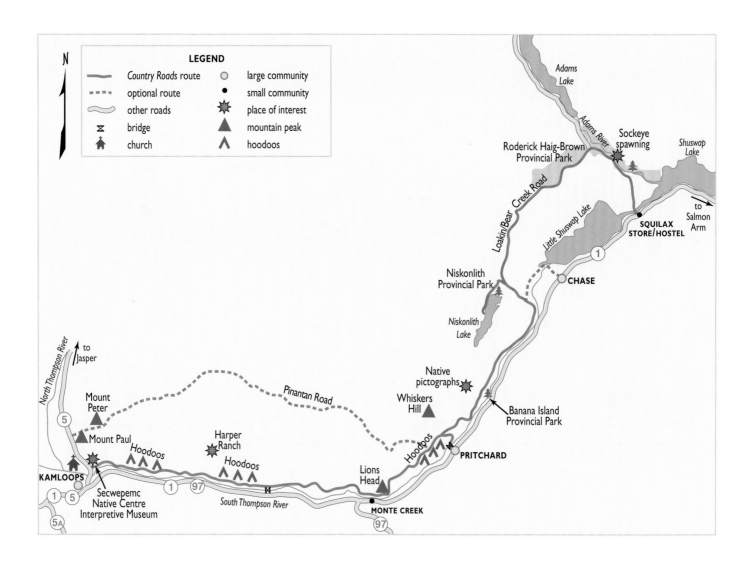

At Shuswap Lake, the forests have become mostly cedar and hemlock and the land has a well-watered look.

The valley of the South Thompson is rich in Native history: there are village remains on Banana Island and at Monte Creek, and pictographs near Niskonlith. Recovered from an ancient mudslide at nearby Gore Creek, a skeleton, complete except for its skull, was dated at approximately 8,500 years old, one of the oldest human remains found in Canada. (The bones were later repatriated to the Secwepemc band for reburial and appear to have been lost.) The area between the two rivers (North and South Thompson) is also famous among entomologists. In the hot, dry talus slopes below the face of Mount Paul a scientist found "ice bugs" (grylloblattids), primitive cousins of the crickets. These were previously believed to live only on the high glaciers of the Rockies, but the 1936 find spurred a scientific hunt and today some two

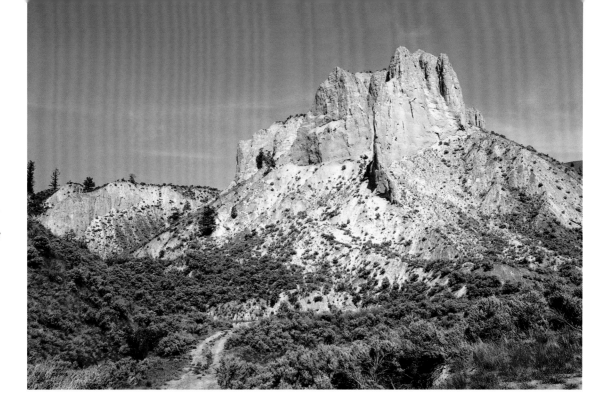

*Pale siltstone hoodoos north of the river — castles in the air above a sea of sagebrush.*

dozen different species of these rock crawlers have been found, in terrain ranging from glaciers to deserts.

Near Kamloops, under the rock slopes of Mount Paul, Shuswap Road provides access to residential areas and to popular hiking and bike trails. One of them, Moonscape Trail, makes a 12-kilometre loop through the terraces and hoodoos of white silt that are such prominent features of the landscape here. The road eases along between the silt cliffs and the river, and there are several places to park and stroll for a closer look at the fantastic castle shapes, their pinnacles and towers fretted by rain and wind and slashed with deep desert ravines. A short side road about 10 kilometres from Highway 5 leads up a gully between some of the most interesting of these silt castles. You can drive a short way and go on foot for further explorations. Be watchful: there are rattlesnakes here.

The formations date from the melting days of the last ice age, when Glacial Lake Thompson formed behind a huge ice dam in the valley. Great quantities of silt, brought down in annual spring runoffs from the hills, were left behind when the lake drained. There is so much silt — in places, more than a kilometre wide and deeper than 40 metres — that geologists are puzzled. The deposits today are only a fraction of the original sediments, which could have been as deep as 300 metres, deposited during 100 years of glacial meltdown. Where did this huge amount of fine-grained silt, containing quartz, feldspar and garnet, come from in so short a time? One explanation, say geologists, is a glacier burst (or jokulhaup), whereby immense torrents of pent-up water are suddenly released, usually when an ice dam collapses. But

no likely sources have been discovered, either for the silt or the ice dam. It's a geological mystery.

Between the cliffs and the slowly surging silk of the river lie long, arable fields, beautiful in shades of purple from alfalfa or pungent yellow from mustard; where irrigation stops, sagebrush and desert weeds return. The contrasts are exhilarating. Farther along, a track, unfortunately now a private road, sidles up a steep valley leading to the historic Harper Ranch, founded in 1862. Here Jerome and Thaddeus Harper raised beef and sent it on the hoof to feed the gold camps of the Cariboo. The brothers went on to found the famous Gang Ranch in the Chilcotin.

At the river here, 50 hectares of wetlands, sponsored in part by the Harper Ranch, preserve habitat for waterfowl and western painted turtles, and in winter, for trumpeter swans. Across the river from this protected area, the bank is lined with houses, each with its wharf and boats, an interesting contrast. At one of the docks sits a former tourist paddlewheeler, the *Wander-Sue*, which apparently no longer wanders anywhere.

About 16 kilometres from the start of the road, the clay cliffs diminish and a huge intrusive lens of limestone on the volcanic hills behind has given rise to a cement plant, connected to Highway 1 by a bridge. East for several kilometres, the quiet side of the river has been adopted by small ranches, houses, a golf course, a turf ranch, vegetable gardens and the South Thompson Inn, a luxurious resort that makes a good base for explorations. Just beyond a horseshoe curve where a short road provides access to the river, towering silt cliffs are home to a summer colony of swallows.

Across the river is the small community of Monte Creek and the old railway station once known as Ducks. (This is the spot where Bill Miner held up and robbed a CPR train back in the 1890s; see Chapter 9 for details.) Nearby, a fairly new provincial park preserves the site of an ancient Secwepemc village, with remains of round and square pit houses, some of them connected by tunnels, as well as underground ovens and some possible burials. Relics of later history in the park include traces of the fur-brigade trail, the site of an old reaction ferry and a pioneer church and schoolhouse. There are no tourist facilities here at present, though an interpretation centre is planned.

The prominent rock bluff to the east is called the Lions Head, and here Shuswap Road leaves the river and loops around the fields of Lions Head Ranch into pine forests and out again onto high bench land. The hot climate in this area is ideal for the cultivation of ginseng: several fields are tented with black plastic. The Pinantan Road goes north (via Pinantan, Paul and Hyas lakes) to Highway 5, a possible return route. A little farther, under the shoulders of Whiskers Hill, a road leads south to cross the river at Pritchard, a small community settled in 1912 by Walter Pritchard, who left his job as driver for the Okanagan Stage Lines to open a store and a hotel.

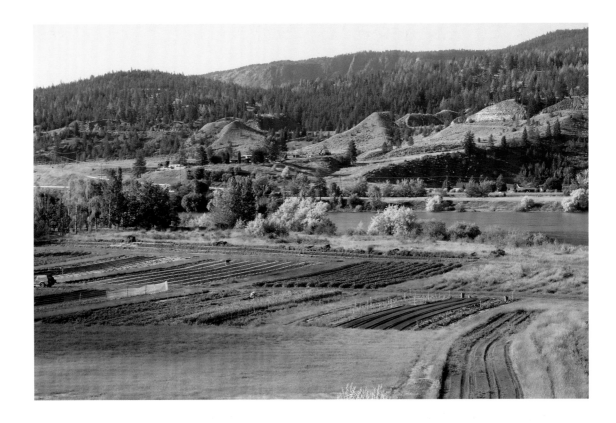

*Market gardens beside the South Thompson.*

*On the busy south side of the river, a tourist paddle-wheeler wheels no more.*

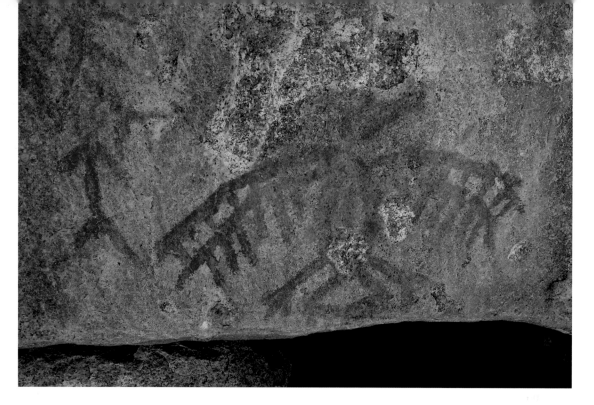

*On a ridge high above the South Thompson, Native pictographs of a thunderbird and other figures are painted on over-hanging boulders.*

The small riverside park and the wooden humpback bridge provide good viewpoints over the river, great places to watch the hundreds of trumpeter and tundra swans that congregate on the South Thompson in winter. Upriver, Banana Island Provincial Park, accessible only by canoe or kayak, is a prime waterfowl nesting ground and the site of numerous Native kekulis.

From Pritchard, return to the Shuswap Road, cut around the steep rock bluff of Whiskers Hill and continue east through irrigated ranchlands. Beyond the forest road to McGillivray Lake, a sharp rock outcrop breaks the north horizon at the top of a steep open slope bright with summer sunflowers—lupines, cinquefoil and roses. At the foot of the outcrop, near a spring-water seep, overhanging boulders have created two small, shallow caves. It's a steep 40-minute uphill hike to these interesting rocks, but it's very worthwhile and not for the view alone. At this likely lookout spot, ancient Native pictographs are painted in red ochre on smooth cliffs above the caves. Most noticeable is a thunderbird, but look carefully and you will also see a long line of bear tracks, a human figure, deer and a pattern of arrows. Do not touch any of the figures: they are fading and the rock beneath them tends to spall. This is a rare and precious site, one that is considered sacrosanct by the Niskonlith Band. It is a privilege just to be here.

Back on the road, drive a few kilometres farther to where a gigantic conglomeration of sticks on top of a pole is the nest not of an osprey, as you might imagine, but of a Canada goose. This nest is at the junction with Loakin/Bear Creek Road, which provides access to Niskonlith Lake Provincial Park. The road up to the park leads to a good viewpoint over Little Shuswap Lake, then travels through forest for several kilometres to a well-marked junction. Turn left for a visit

to Niskonlith Lake, whose clear blue waters are fringed by forest and meadows known for their spring display of wildflowers—chocolate lilies, huge banks of starry arnica, lupines and Indian paintbrush. The Loakin/ Bear Creek Road continues past the park road to provide a forested 14-kilometre unpaved route to the Adams River sockeye spawning grounds in Roderick Haig-Brown Provincial Park. If you make this trip in October, you may decide to take this shortcut and spend some time walking the 15 kilometres of riverside trails to witness thousands of returning sockeye in their scarlet and green spawning attire. There's an excellent visitor program, many interpretive signs and viewing platforms.

You can also reach the Adams River by another route. From Niskonlith Park, return to the Shuswap Road and continue east for another four kilometres, past the Adams Lake cemetery, to the Native settlement of Sexqeltqin. Cross the river to the pioneer village of Chase, which sits at the mouth of Little Shuswap Lake. It's a pleasant village, just far enough away from Highway 1 to escape the traffic's roar. East along the highway, the old general store at Squilax (Black Bear), now a youth hostel, plays host to a colony of 600 little brown bats that live in the attic and behind the store sign. They are nocturnal creatures, so if you want to see them fly, dusk is the best time. The Squilax area seems to be a hot spot for bats. There are 11 species here and most of them roost under local bridges. An abandoned church near Quaaout used to house a colony of 2,000 and when the church burned down in 1993, leaving the bats homeless, 15 special bat houses were erected near the site. These provide living space for about 500 bats and visitors can join local volunteers on Sundays when they monitor the houses and check on the bat population. (You can find the details at the Squilax Store/Hostel.)

Beyond the Squilax Store, the Anglemont Road overpass leads to the Adams River and on to resorts on the north shore of Shuswap Lake. At Quaaout, the First Nations people have built a luxury lodge, but visitors can also choose to sleep in a tipi and immerse themselves in Native culture. ❧

*Chocolate lilies grow in the woods beside Niskonlith Lake.*

# FORT ST. JAMES AND BEYOND

*Highway 27 from Vanderhoof to Fort St. James is not exactly a country road,* but it is not heavily travelled and is included here because it leads not only to a huge and beautiful lake, but to one of the most historic places in all of British Columbia. Here at the south end of Stuart Lake, Simon Fraser established a fur-trading post in 1806, two years before he began his epic journey down the Fraser to the Pacific Ocean. His Stuart Lake Post, later known as Fort St. James, is now a national historic site where the greatest number of original wooden fur-trade buildings in Canada have been preserved. The sturdy log constructions have been restored to their 1892 condition and there are costumed guides to ease visitors back into history. A visit to the fort alone would justify a detour off Highway 16, but beside the lake is another wonderful landmark, the Church of Our Lady of Good Hope, built by the Oblates in 1873, one of the oldest and most beautiful churches in British Columbia. And if you care to drive farther along the lake, you can visit two First Nations villages and see some extraordinary pictographs.

The early development of the B.C. Interior owes much to the fur trade and the explorations of its employees—adventurers such as Simon Fraser, sent west into uncharted territory to find a navigable river route to the Pacific. In 1808, he began his journey from a temporary base on Fraser Lake and canoed east down the Nechako to its junction with another great river. Mistaking this for the Columbia, he followed it doggedly to the sea. The river, of course, was the Fraser, the same one that Alexander McKenzie, another fur-trade hero, had explored 15 years earlier before heading west through the Chilcotin to make the first documented overland journey to the Pacific. At the confluence of the Nechako and the Fraser, another trading post, Fort George, was later established, and farther south down the Fraser, Fort Alexandria marked the beginning of overland trails to Forts Kamloops, Hope and Langley, and south down the Okanagan

*The long wharf below the fort is still in use. Huge Stuart Lake stretches north into the wilderness of what was once "New Caledonia."*

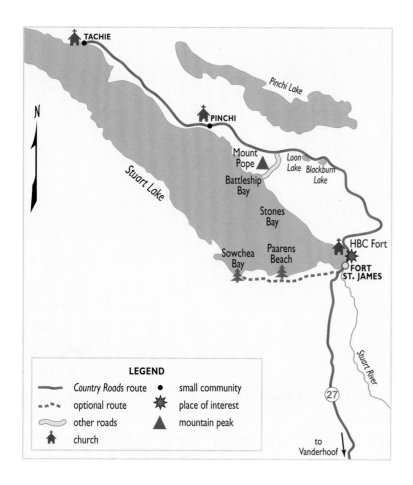

**LEGEND**

| | | | |
|---|---|---|---|
| —— | *Country Roads* route | ● | small community |
| - - - | optional route | ✦ | place of interest |
| ～～ | other roads | ▲ | mountain peak |
| ⛪ | church | | |

Valley. Most of these fur-trade forts later became towns and cities; many of these trails became highways.

The post that Simon Fraser built on Stuart Lake was the second to be established in what was then known as New Caledonia. (Fort McLeod, at the north end of McLeod Lake, was the first, built a year earlier in 1805.) The Stuart Lake post was planned right from the start as headquarters of the New Caledonia department of the fur-trade empire and around it grew the first permanent European settlement between California and Alaska. It became a base for later explorations of the north: in the 1850s, Franklin Pope stayed here while searching out a route for the Collins Overland Telegraph (nearby Mount Pope is named after him) and, later still, miners and settlers alike bought supplies at the Hudson's Bay fort store.

Highway 27, the 60-kilometre road connecting Highway 16 to Fort St. James, crosses the farms and fields of the Nechako Valley west of Vanderhoof and heads north to cross the mouth of the Stuart River, where wildlife enthusiasts can watch salmon swimming upriver in the fall and, in winter, huge flocks of trumpeter swans. The nearby First Nations village of Nak'azdli

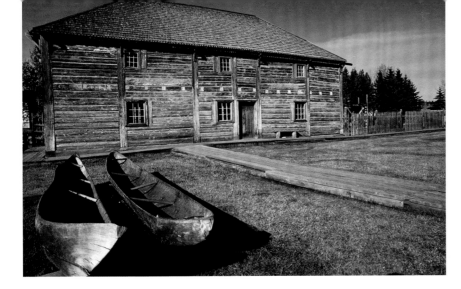

ABOVE

*The original wooden buildings of the old trading post of Fort St. James are still protected by a palisade, but are open for tourists.*

ABOVE, RIGHT

*The store is realistically stocked with blankets and barrels and real furs.*

was already established at the south end of the lake when the fur traders arrived and built their fort right beside it. To reach the historic site today, take Chief Kwah Road toward the water.

Stuart Lake is huge and beautiful, almost 70 kilometres long and 10 wide and subject to high winds and sudden squalls that make travel by small boat perilous. Nevertheless, it was an important link on the voyageurs' highway, part of an unbroken chain of rivers and long lakes that extends for more than 400 kilometres. This water route, vital to the commerce of the early fur trade, much of it now protected within Stuart River Provincial Park, is popular today among recreational paddlers.

Fort St. James (the trading post) is a beautiful place: its old squared-log buildings, redolent with history, bathe in the warm afternoon light, and the view across the lake is fine indeed. You will want to spend some time here, for this is where much of B.C.'s history began. Take the guided tours to the various buildings if you can; park personnel are well versed in fur-trade life and will help to bring the past alive. The heart of the post is the store, stuffed with baled goods, barrels of salt fish and piles of local furs; outside are wooden canoes, similar to those the voyageurs used on their trips down the lake. The long wharf here dates from 1894 and was regularly used by lake transport steamers until 1914. A walk on the beach in front of the fort, looking across the wide open reaches of water and sky and mountains, gives a hint of the huge loneliness of this land. How homesick some men must have been, gazing across the lake into the wilderness of forest and rivers, so far from home.

From the fort, return to town and make a left turn onto Stuart Drive, which leads around the lake to Cottonwood Park, where there is an old Junkers float plane set up to commemorate the early days of the bush pilots, who in a more recent era also helped to open up the country. From here Lakeshore Drive leads to a stunning landmark, seen from far out on the lake: the white mission Church of Our Lady of Good Hope. After it was built, many of the local Natives settled nearby and their children attended the mission school. Many of them are buried

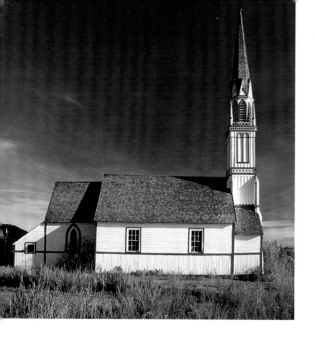

*Our Lady of Good Hope, one of the grandest Gothic churches in the province, was built by the Oblates in 1873.*

in the huge cemetery, up the hill. For a long while, the famous missionary Father Adrien-Gabriel Morice lived and worked here. In the small log cabin behind the church, he printed prayer books and newspapers in Dakelh, the language of the local Carrier people, which had no written form until he invented one. He also wrote several books in English, including *The History of the Northern Interior of British Columbia, Formerly New Caledonia, 1660–1880*, published in 1904 and still a reference classic today. Remodelled in 1905 by Father Coccola (who built the St. Eugene Mission near Cranbrook), the church has an exceptionally tall tower crowned by an impressive and elaborately detailed spire.

Around the curve of the bay is the long dock of Cottonwood Marina. Here, you can arrange a boat trip to visit First Nations pictographs, painted in red ochre on lakeside cliffs and only visible from the water. Farther along the lake are the Native villages of Pinchi (Binche) and Tachie (Tache). To reach them, drive north a short distance on Germanson Lake road (it continues north for many kilometres to Manson Lake and Germanson Landing on the Omineca River— and beyond), then turn left onto Tachie Road, which runs beside two small lakes, Blackburn and Loon, behind the headland of Mount Pope. There's a trail to the top of this steep mountain, an excellent viewpoint. Beyond, a side road leads down to the lake at Battleship Bay recreation site, named for an offshore island that does indeed look like a battleship.

At Pinchi village, 25 kilometres along the road, the Church of the Holy Cross, a small, simple building of squared logs, dates from 1871. The Church of St. Cecilia at Tachie, a further 20 kilometres, was built a year later, but was moved from its original lakeside and remodeled in 1913. This remarkably large building, painted white with red trim, has a bell that was shipped over from France and made the long journey from Victoria by steamship up rivers and lakes, reaching its final destination by dugout canoe. From Tachie the road cuts inland and makes a long, rough trek northeast to the end of Takla Lake, an expedition not within the scope of this book. Return to Fort St. James, explore the town—and enjoy the sunset over the lake, a popular fishing venue for large rainbow, char and lake trout, and burbot. There are two provincial parks, Paarens Beach and Sowchea Bay, both with lakeside campsites, along the southern shore. ❖